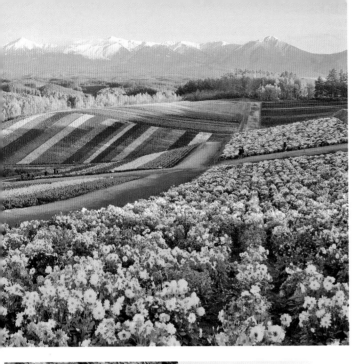

Chūgoku 174

Shikoku 204

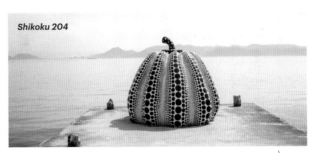

Kantō 68

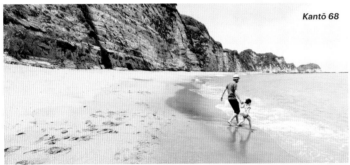

Tōhoku 36

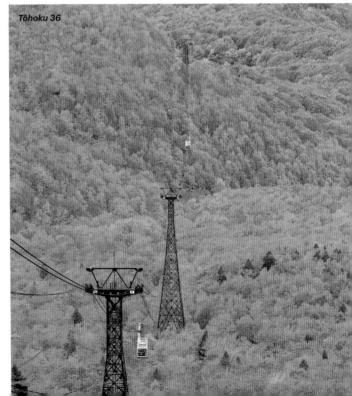

Kansai 138

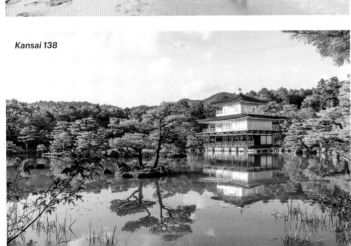

Japan

Japan cuts a swathe through latitudes and climates, with snow-covered mountains in the north and tropical island beaches in the south. Its landscapes have been shaped by boiling rock, water, and irresistible tectonic forces from the Pacific Rim of Fire. Volcanoes and hot springs pepper the land, which periodically shudders and shakes.

Japan also sweeps through time, fusing tradition and futurism like few other nations. Its unique culture has been shaped by millennia of influences that can be discerned wherever you look, from Zen rock gardens and Shinto shrines to Kyoto's geisha dances. It is an island that has been unusually closed-off for centuries and they do things differently here.

As a result, the country has always mesmerised, if not even bewildered, visitors. Japan super-fan Anthony Bourdain once said 'I think all of us understand that we don't understand anything about Japan.'

This book of photography aims to depict the most beautiful aspects of Japan's natural world and its most fascinating traditions and innovations. We witness how sakura, the annual wave of cherry blossom, inspires crowds to follow its progress across Japan, we meet macaque monkeys soaking in hot springs and watch chefs prepare intricate edible marvels. Cranes dance as trains speed across extraordinary bridges. Neon metropolises with crowded crosswalks contrast with silent groves of giant bamboo and still lakes.

We've organised the book by region from Hokkaidō to the islands of Okinawa. Whether you've explored Japan before or hope to visit it for the first time, a pictorial journey through this country will fascinate and inspire.

CUNARD

◆◇◆

Library

Out of respect for your fellow guests, please return all books as soon as possible. We would also request that books are not taken off the ship as they can easily be damaged by the sun, sea and sand.

Please ensure that books are returned the day before you disembark, failure to do so will incur a charge to your on board account, the same will happen to any damaged books.

Japan

BEAUTIFUL WORLD

Contents

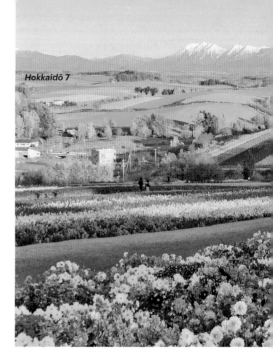

Hokkaidō 7

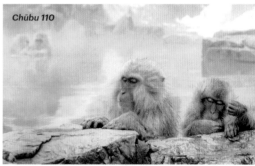

Chūbu 110

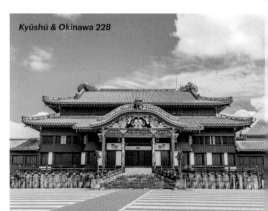

Kyūshū & Okinawa 228

*SEA OF
OKHOTSK*

HOKKAIDO
Kamikawa • Sounkyo
Biei • Akan National Park
• Kushiro-shitsugen
Sapporo ◎ National Park
Niseko •
• Shikotsu-Toya
National Park

• Hakodate

Aomori • Mt Hakkoda
Oirase Gorge •

Akita • • Towada-Hachimantai National Park
TOHOKU
• Hiraizumi
Naruko Gorge •
Yamagata • Matsushima Bay
Niigata ◎ Mt Zao • **Sendai**
Kita Shiobara • • Fukushima
CHUBU • Lake Inawashiro
Toyama • Hakuba
Kanazawa • • Nagano
Shirakawa-go • Matsumoto
Izumo • Yasugi Takayama • **Tokyo** • Narita
• • • Tottori Yamanashi ◎ Chiba
CHUGOKU Himeji *Mount Fuji* Yokohama
Okayama • Kyoto **KANTO**
Nagato • **Hiroshima** Naruto • Osaka
Kitakyushu • Takamatsu • Mie
Hirado • **Fukuoka** *Iya Valley* Tokushima
Beppu • **Kochi** • Wakayama
Nagasaki • **SHIKOKU** *Kumano-gawa*
Kumamoto **KANSAI**
KYUSHU

Chiran •

SEA OF JAPAN

*EAST
CHINA
SEA*

Yakushima •

PACIFIC OCEAN

Kume-jima • • Okinawa-jima
Tokashiki-jima • • Naha

OKINAWA

Iriomote-jima *Ishigaki-jima*
Taketomi-jima

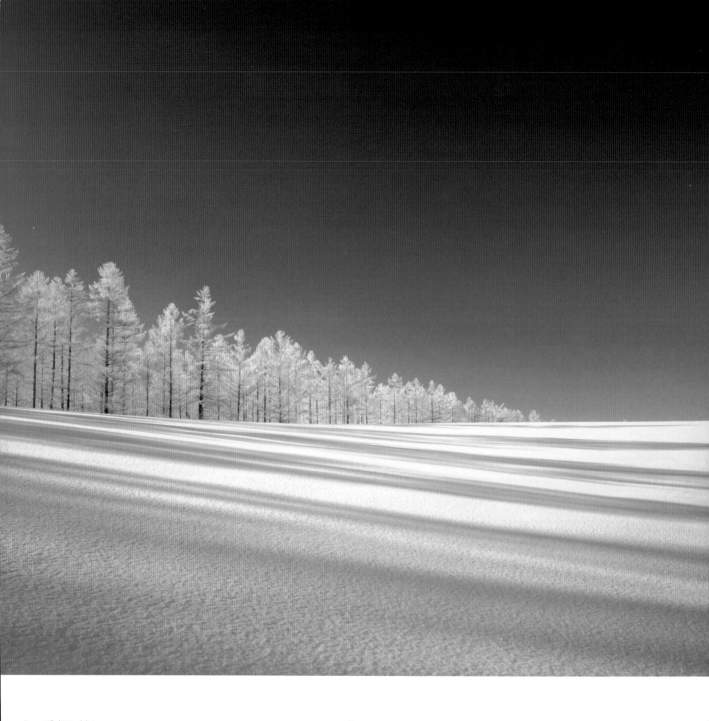

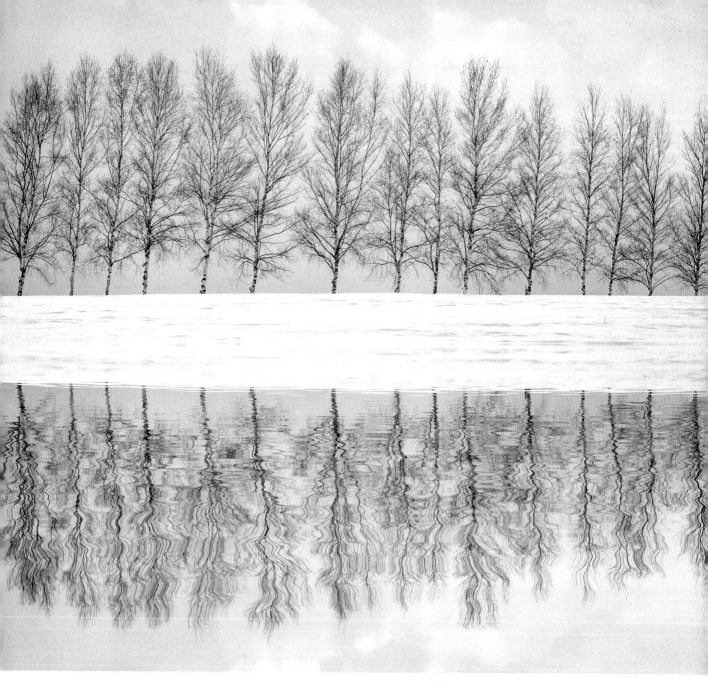

Kamikawa › Wintry scenes at a snowfield in Biei

Hokkaidō

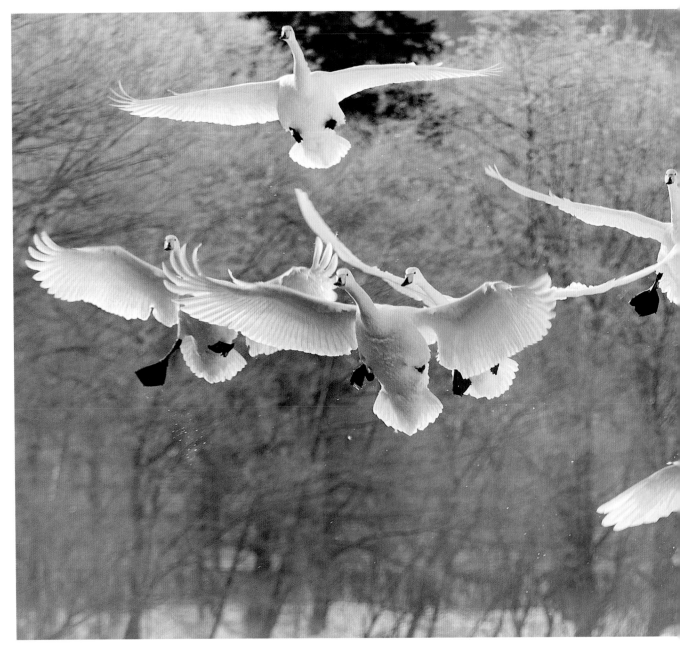

Hokkaidō › Whooper swans migrate to the region in winter

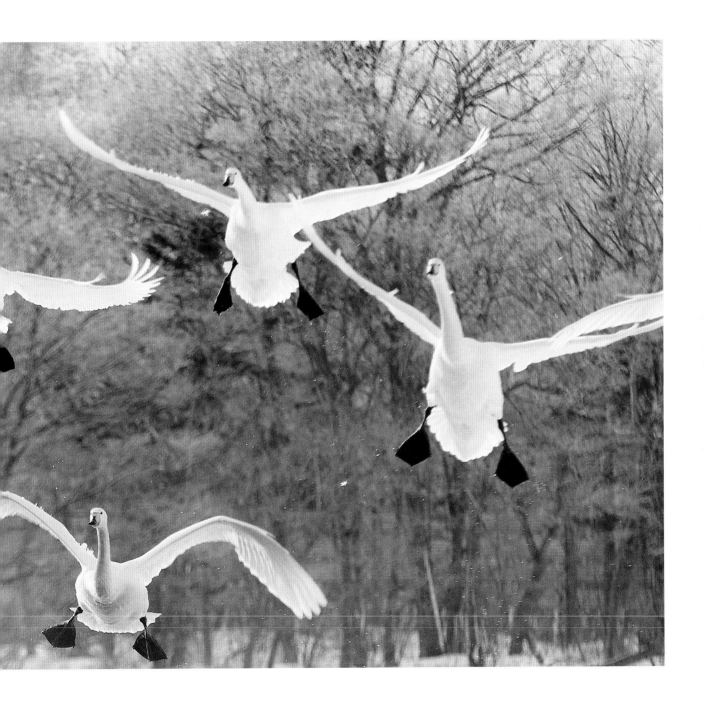

Hokkaidō

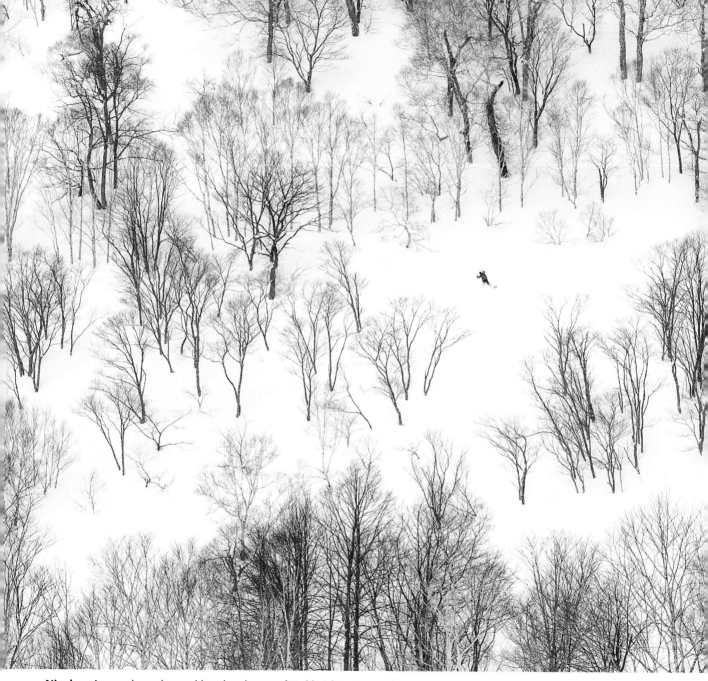

Niseko › A snowboarder tackles the slopes of Hokkaidō's major ski resort

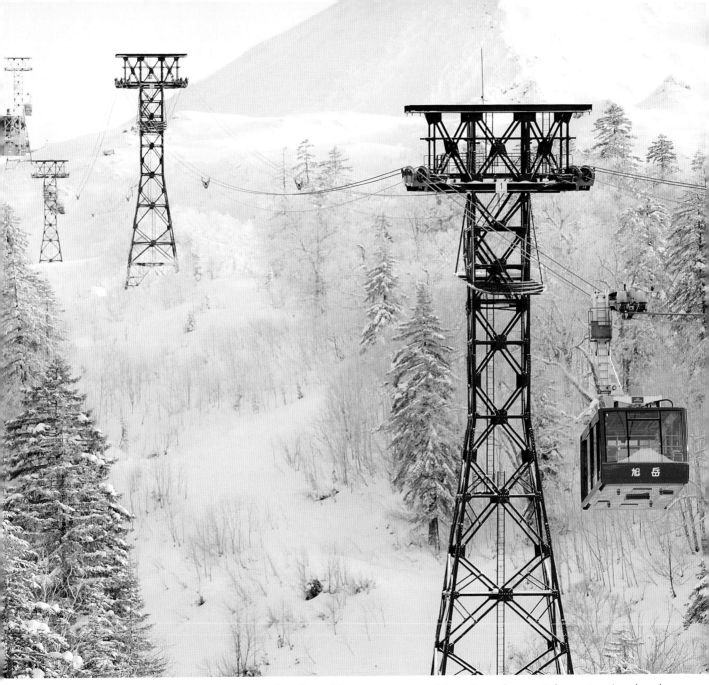

Daisetsuzan National Park › Cable cars transport skiiers through Japan's largest national park

Hokkaidō

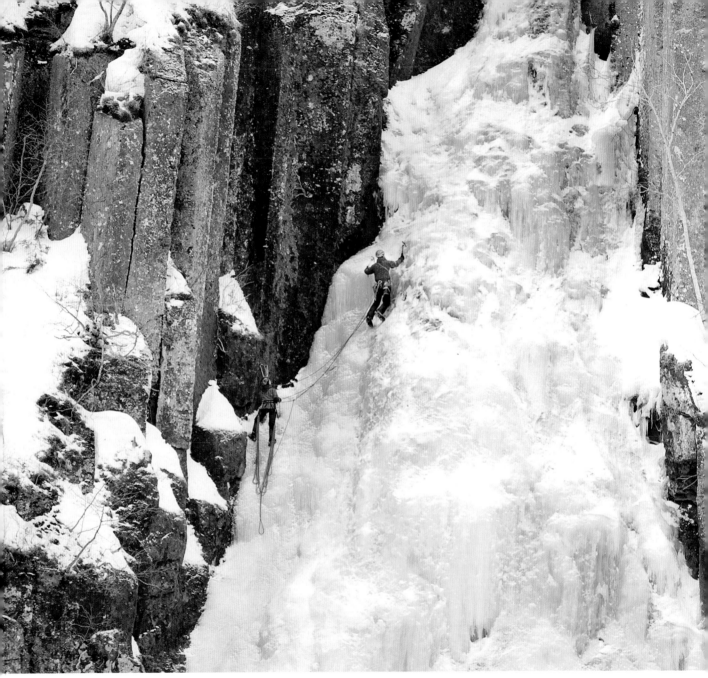

Daisetsuzan National Park › Ice-climbers cling to the face of one of the gorges in the Sōunkyō range

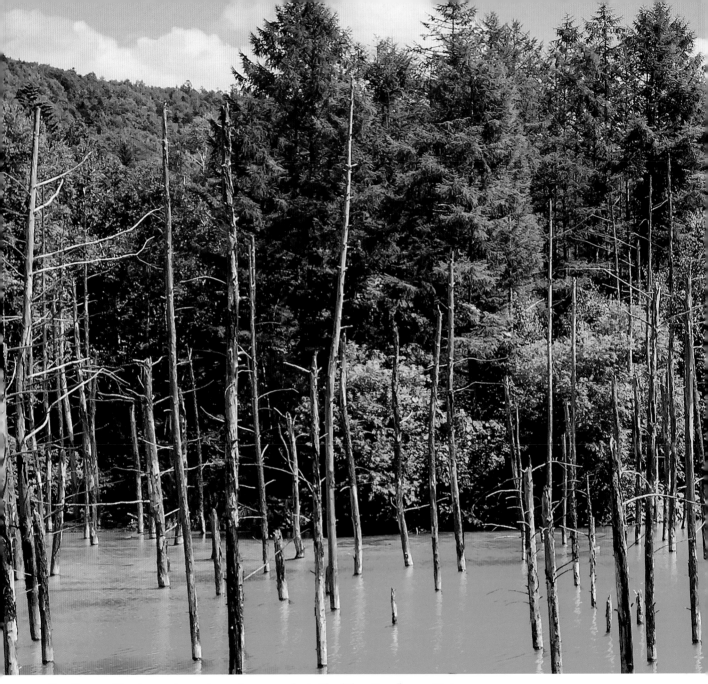

Kamikawa › The turquoise waters of man-made Aoiike (Blue Pond) near Biei

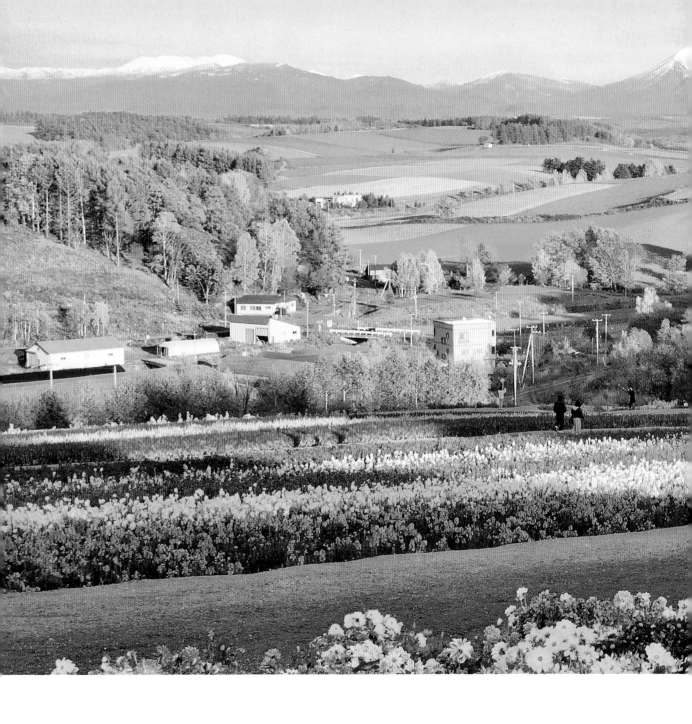

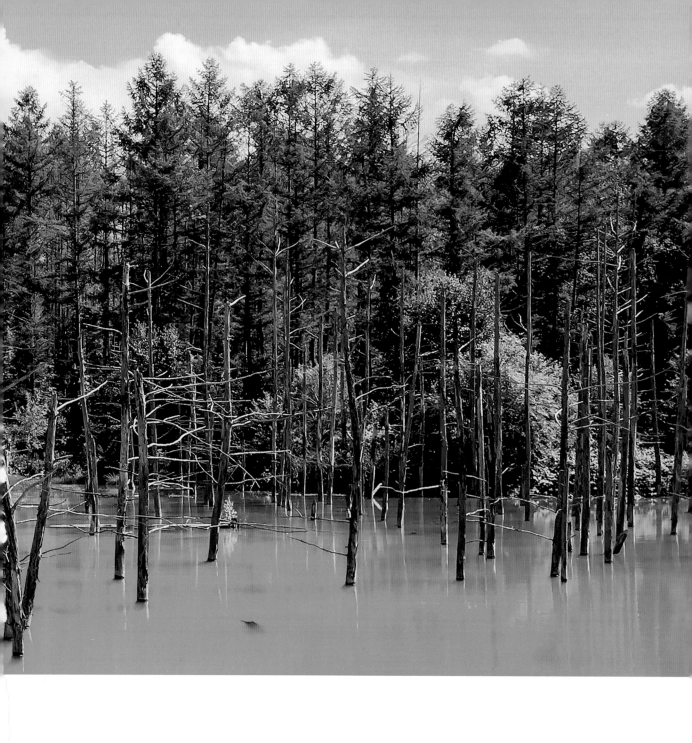

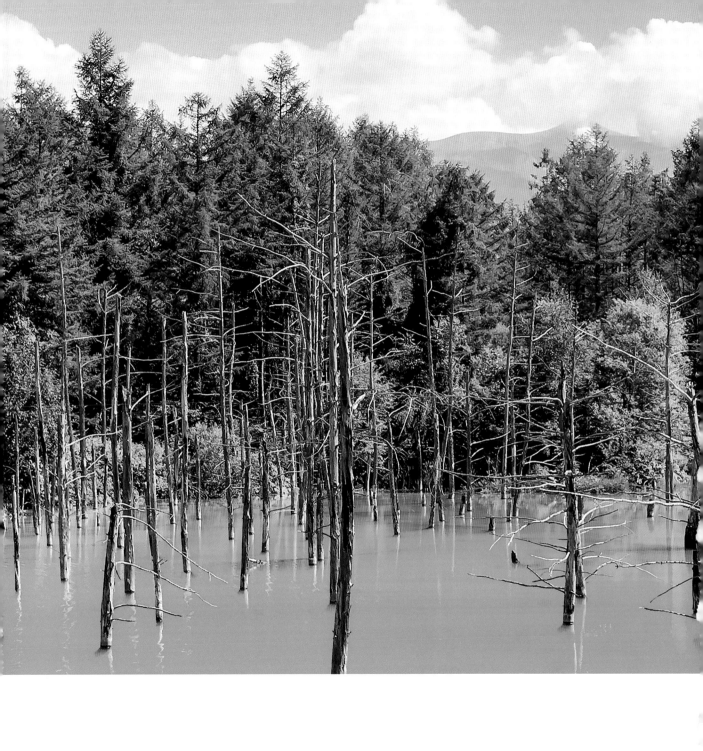

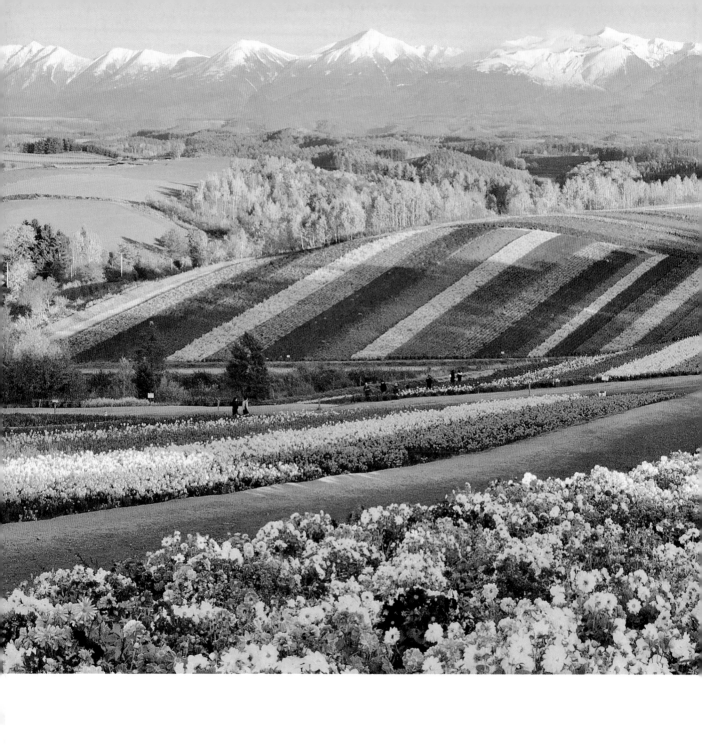

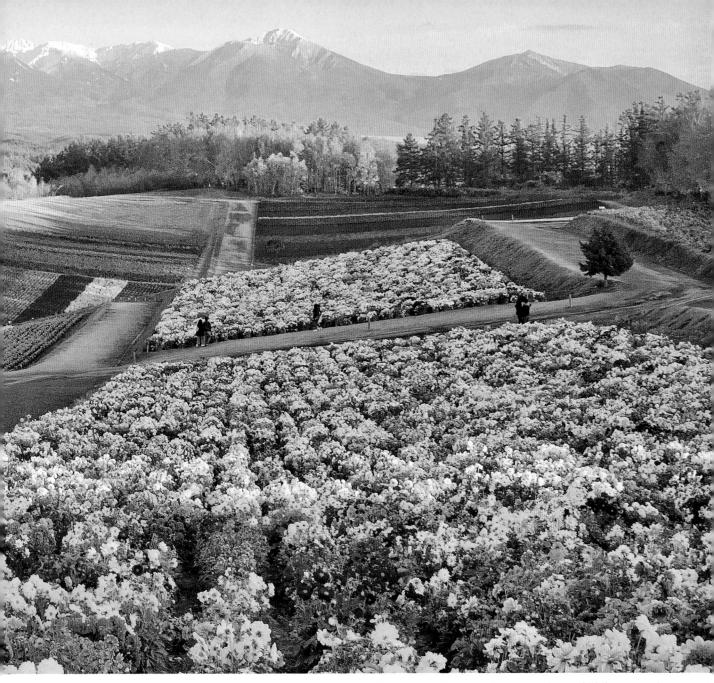

Kamikawa › The vivid flower gardens of Shikisai-no-oka

Hokkaidō

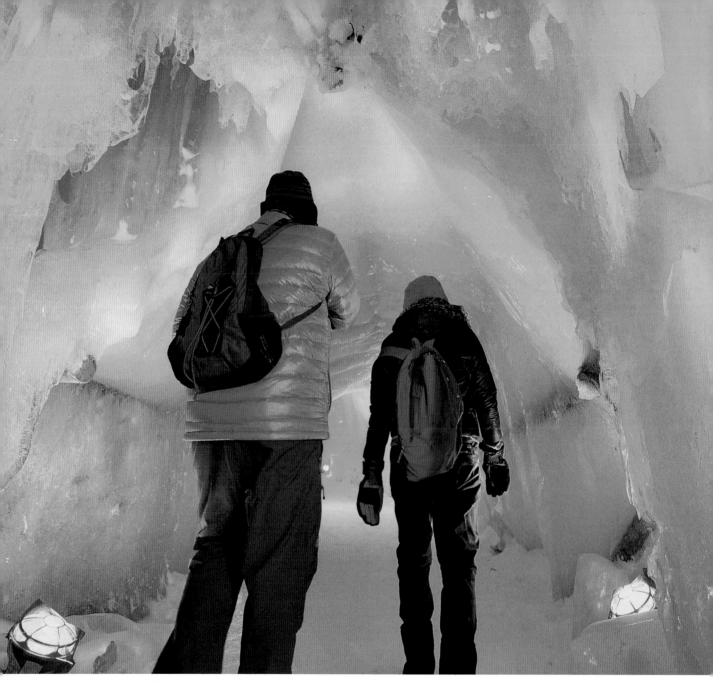

Hokkaidō › Colourful attractions at ice festivals in Sapporo (above) and Sōunkyō (right)

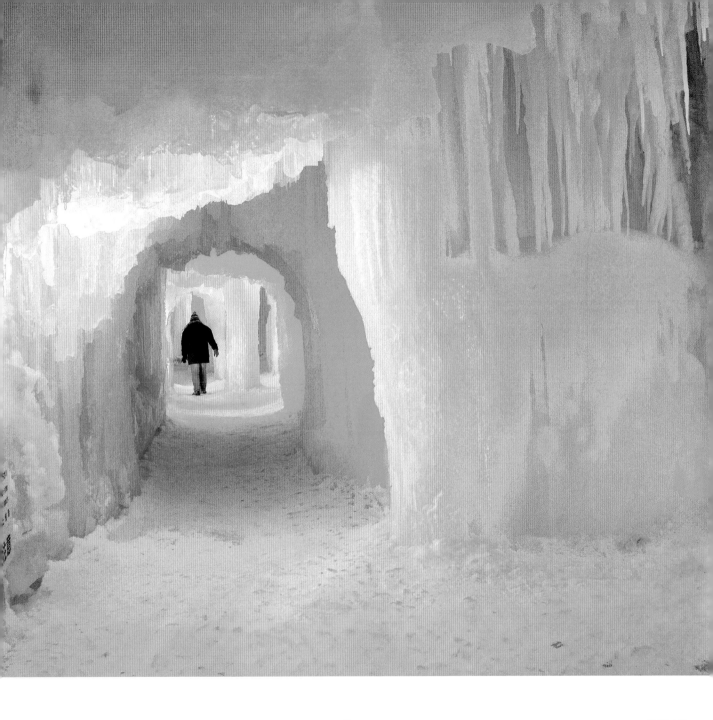

Hokkaidō

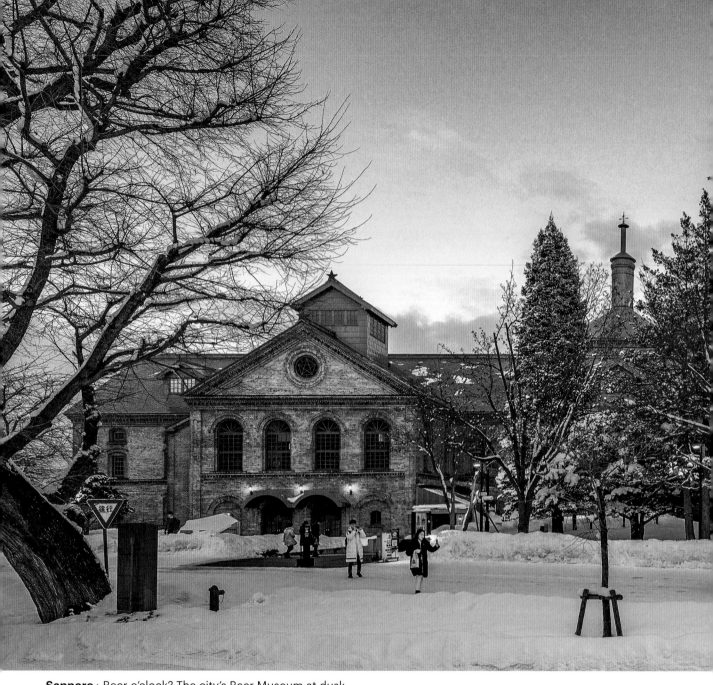

Sapporo › Beer o'clock? The city's Beer Museum at dusk

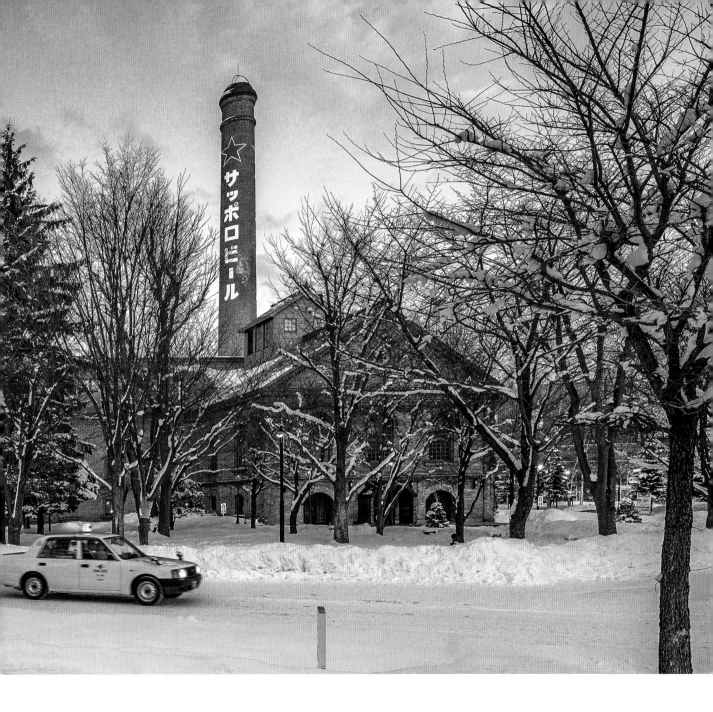

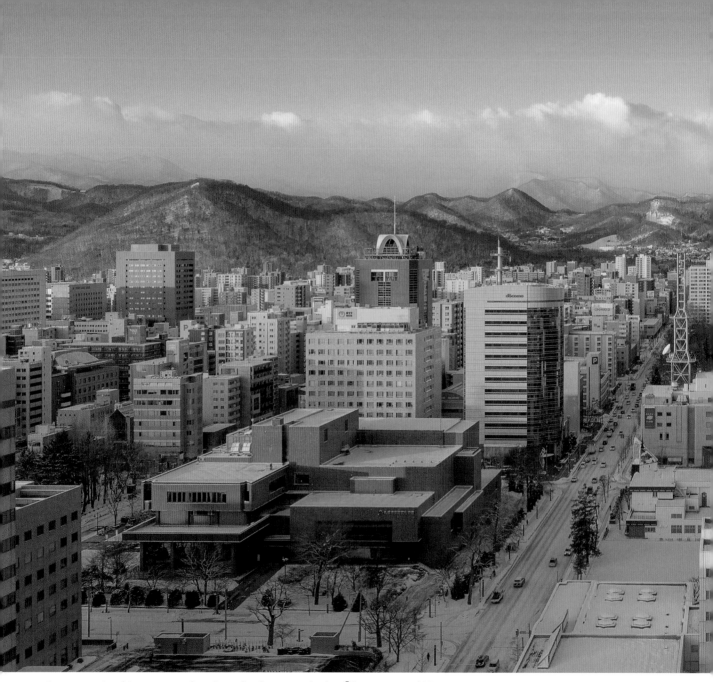

Sapporo › Looking across the city suburbs towards the Ōkura-yama ski jump

Hokkaidō

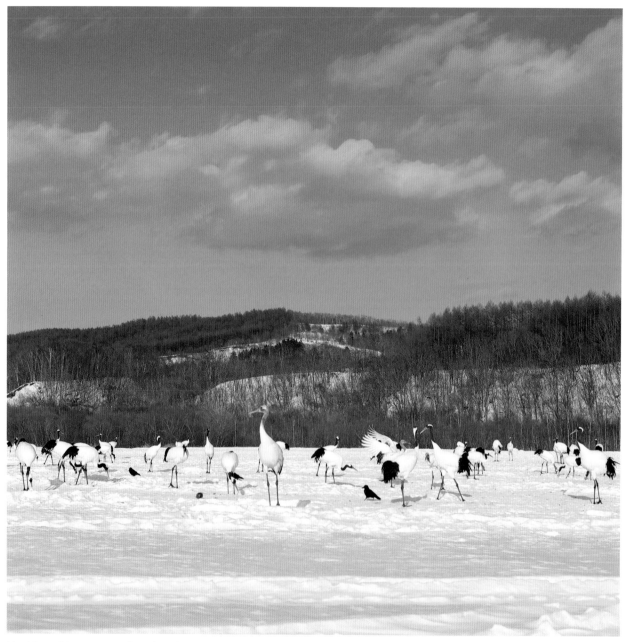

Kushiro-shitsugen National Park › Red-crowned white cranes in the Hokkaidō snow

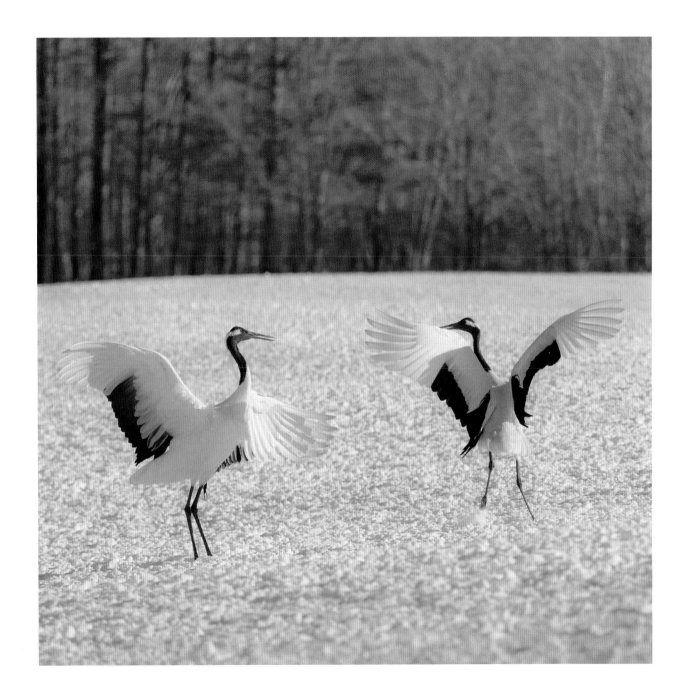

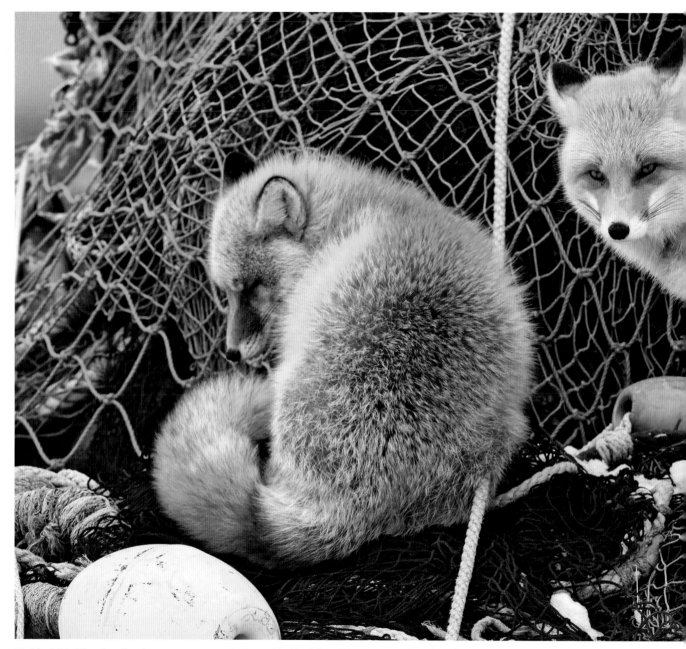

Hokkaidō › The Ezo fox is most commonly found in Kushiro-shitsugen National Park

Hokkaidō

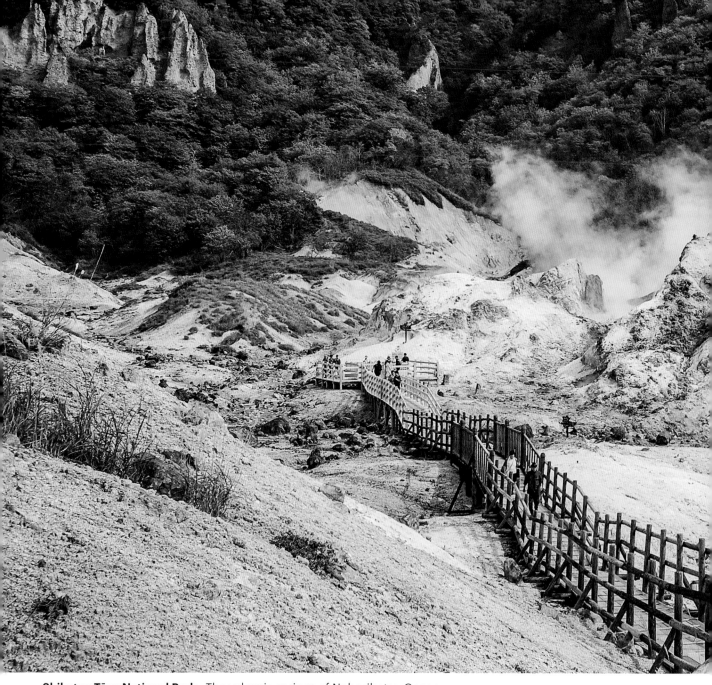

Shikotsu-Tōya National Park › The volcanic springs of Noboribetsu Onsen

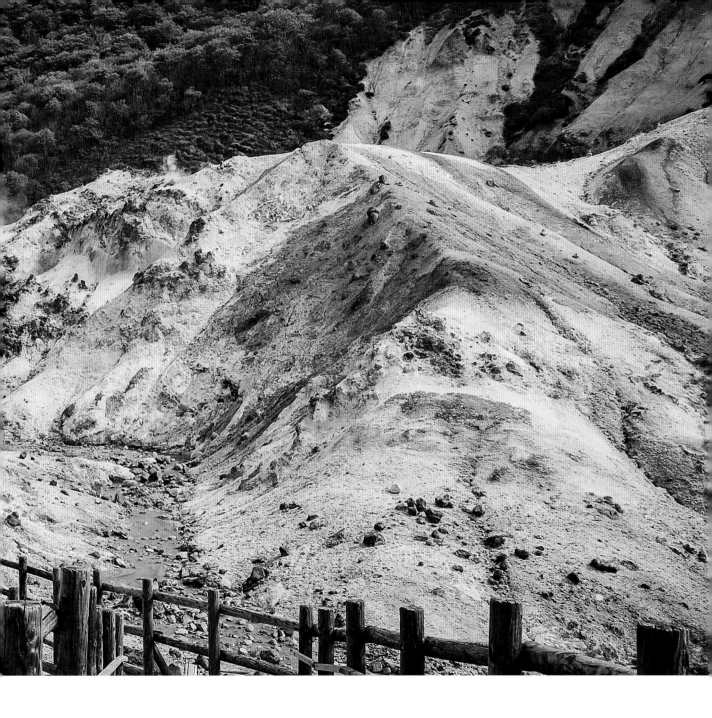

Hokkaidō

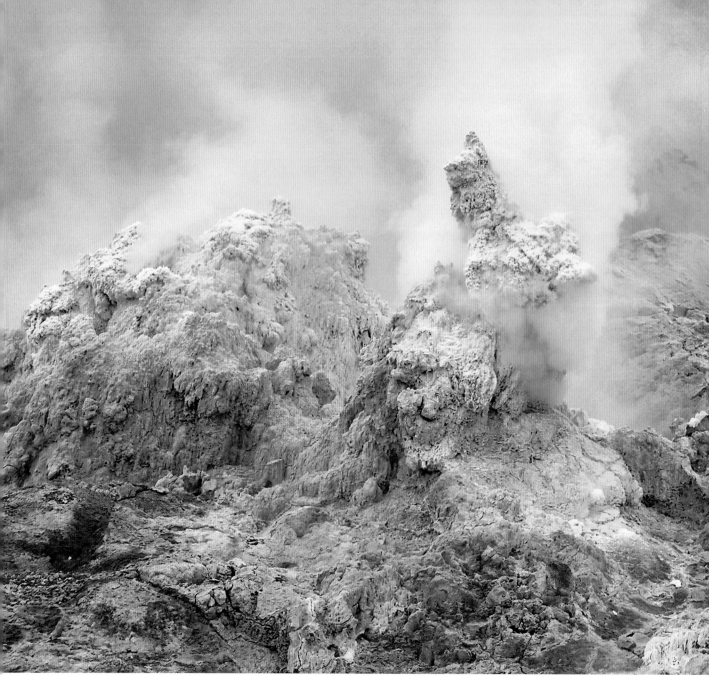

Akan National Park › Yellow-stained sulphuric vents at Iō-zan volcano near Kawayu Onsen

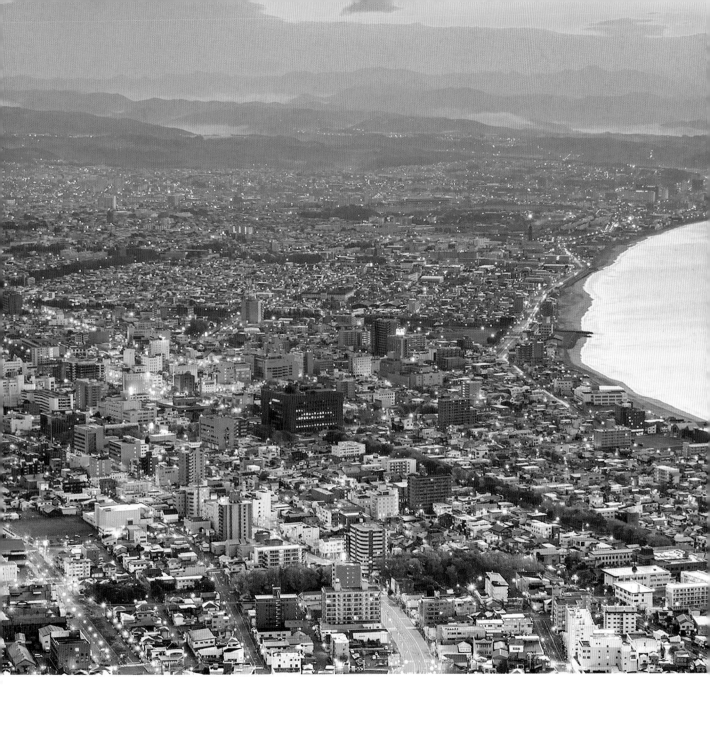

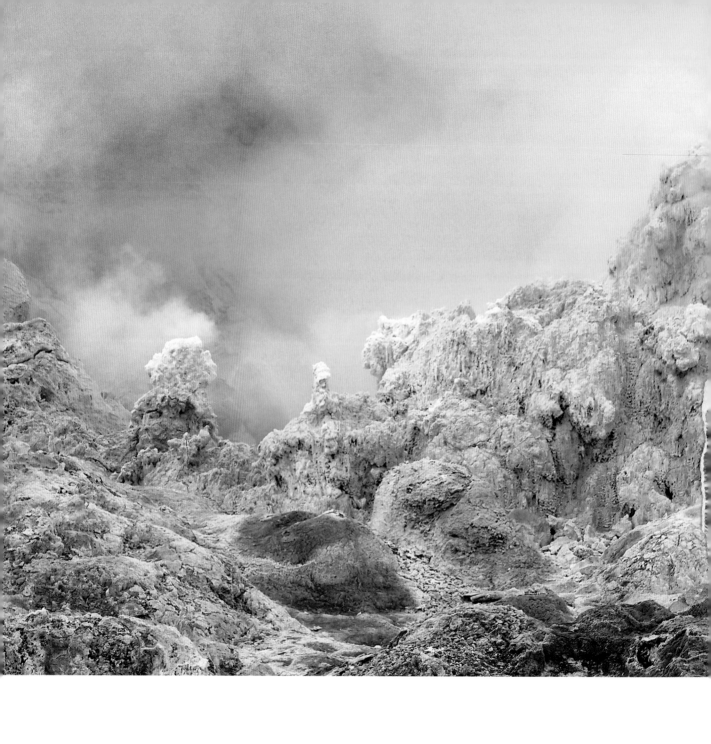

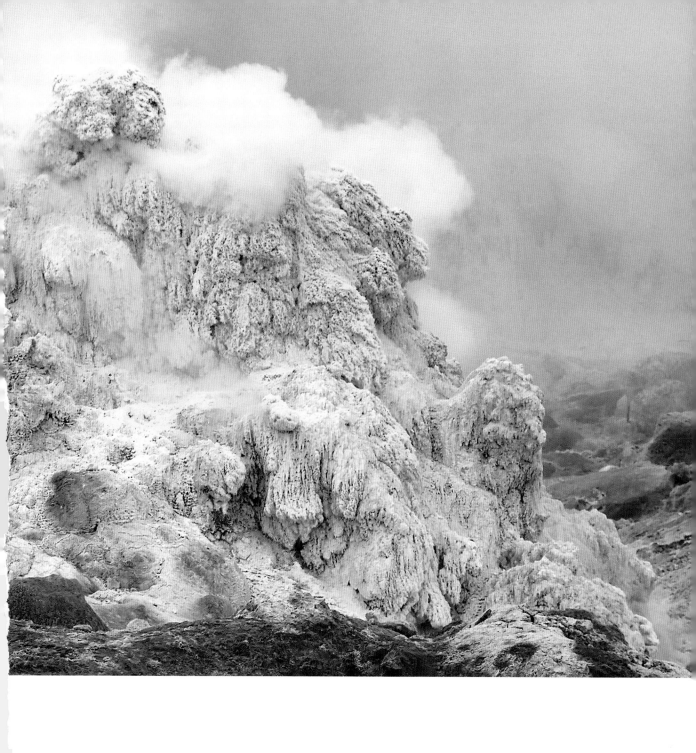

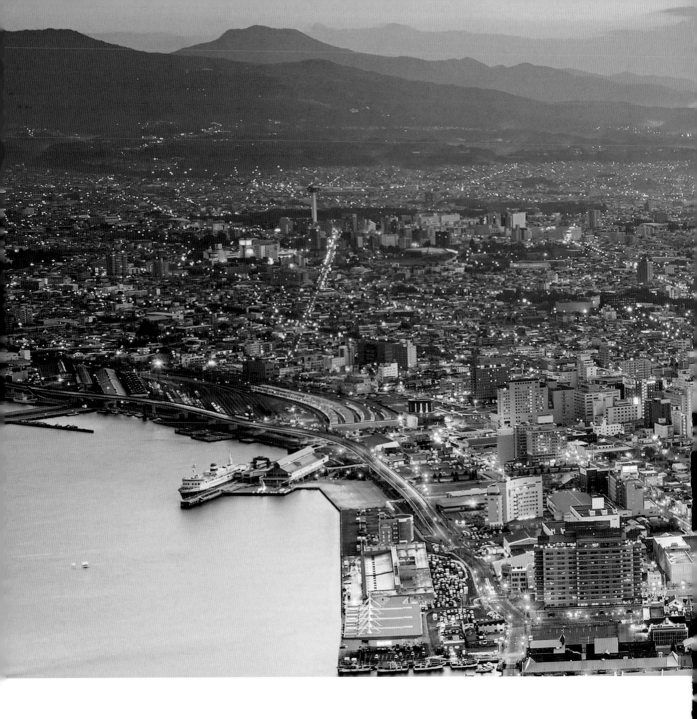

Hakodate › Dawn rises over the port city, as seen from Mt Hakodate

Hokkaidō

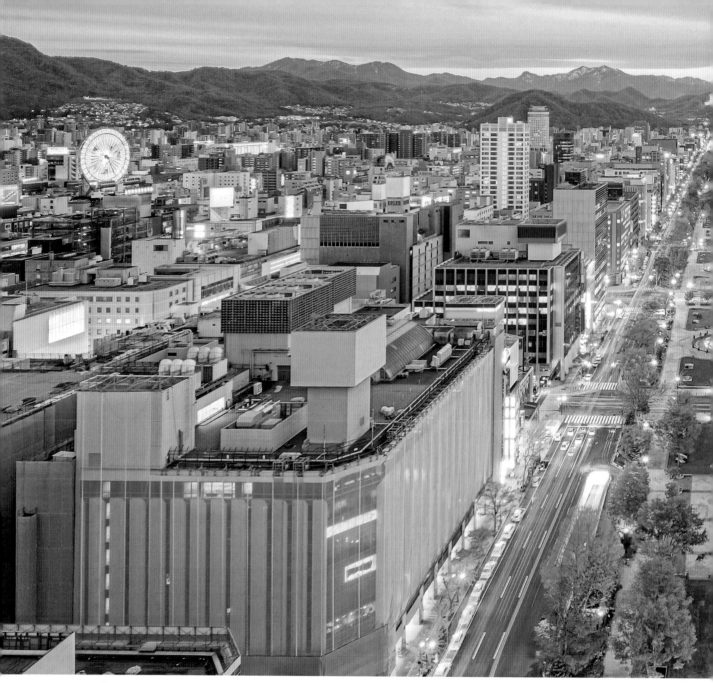

Sapporo › Ōdōri-kōen park cuts through the centre of Hokkaidō's largest city

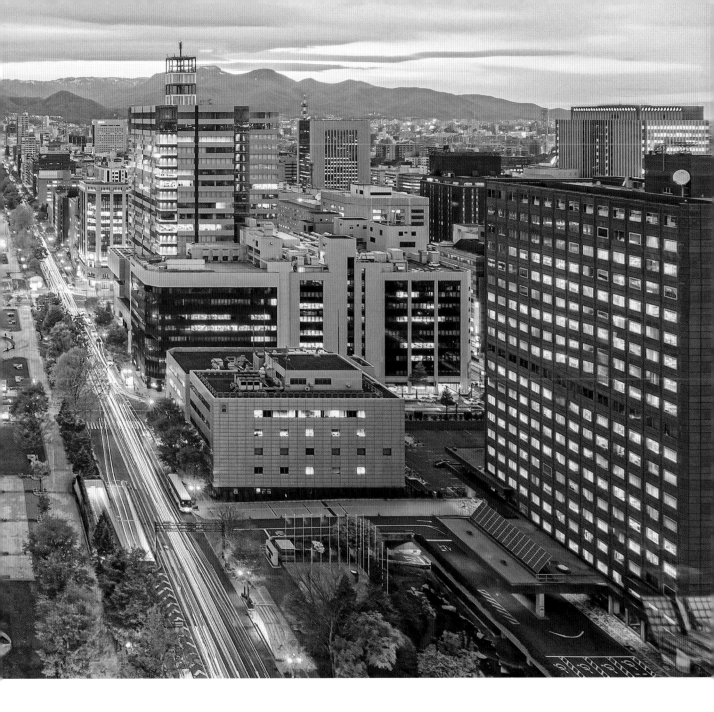

Aomori › Iga-menchi (squid croquettes) are served at the Tsugaru Akatsuki Club

Aomori › Flatfish sashimi atop a bowl of rice, a regional delicacy

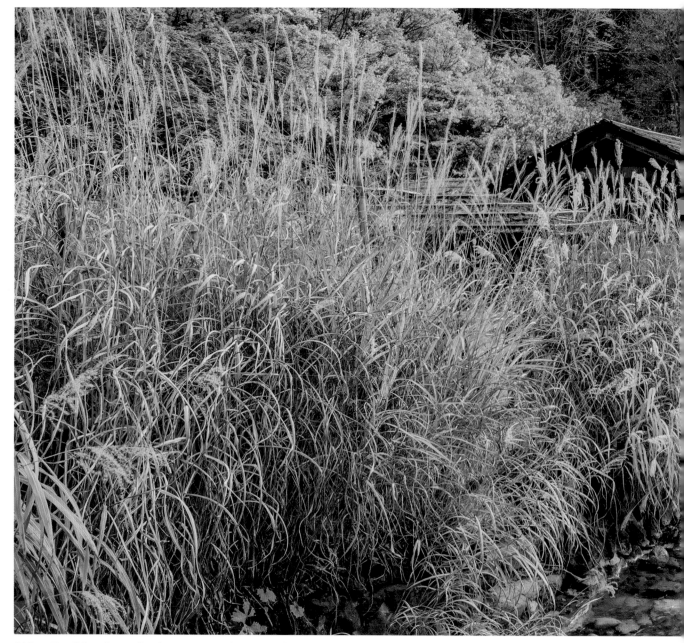

Akita › Traditional wooden huts among the trees of Nyūtō Onsen village

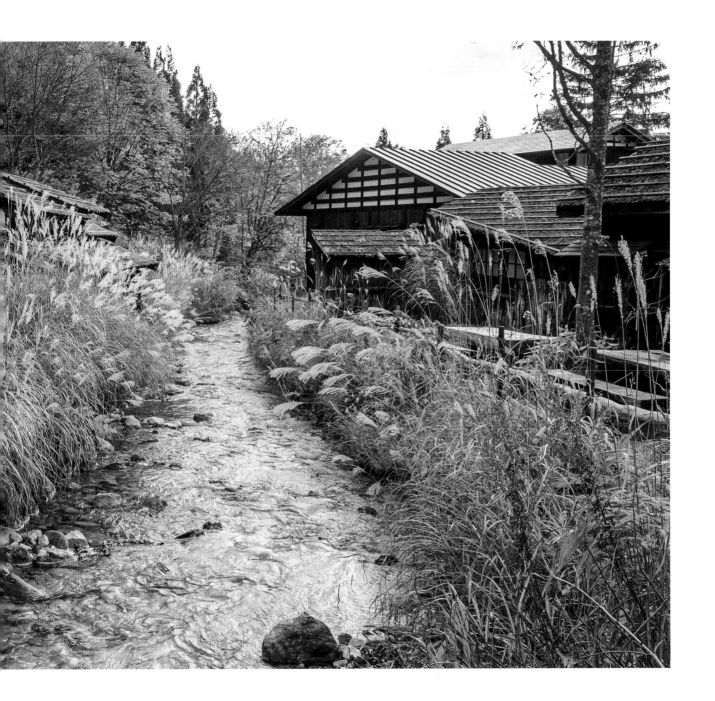

Tōhoku

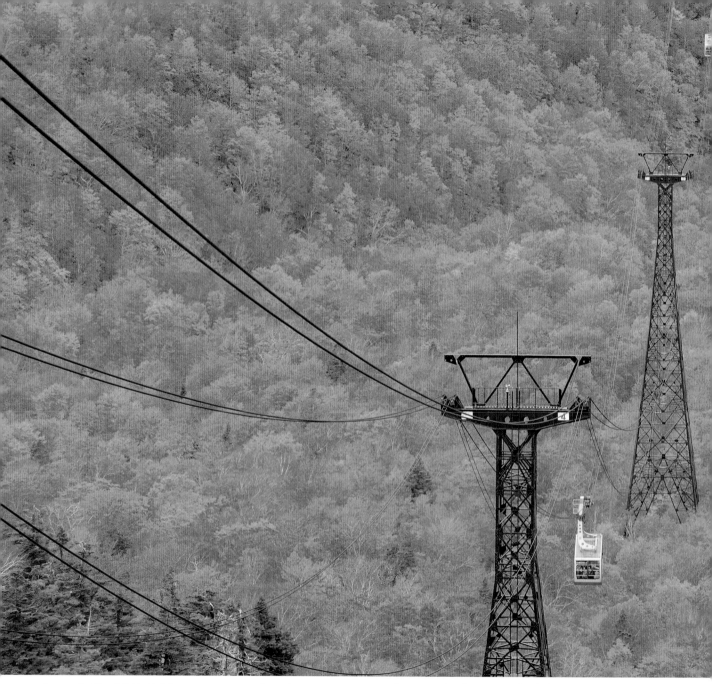

Aomori › The Mt Hakkōda ropeway, seen here in autumn, runs to the summit of Tamoyachi-dake

Tōhoku

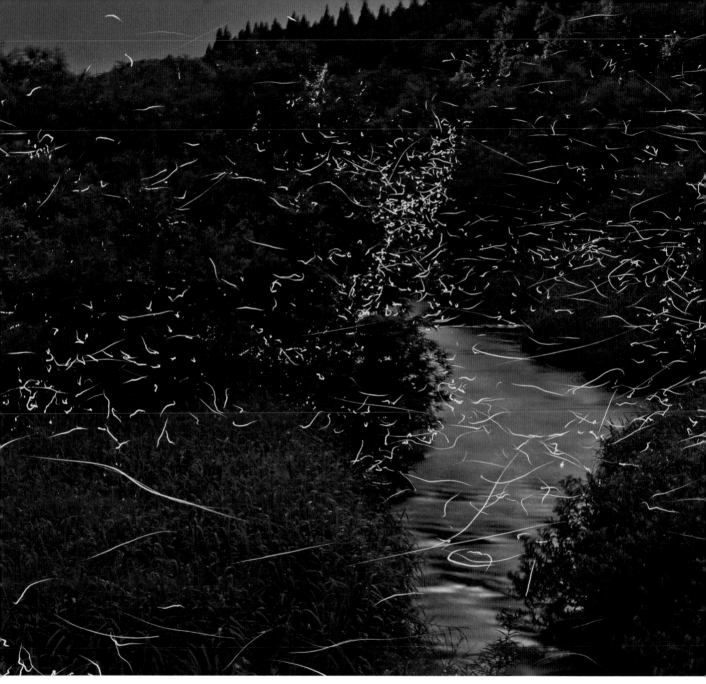

Matsuo-kyo › The mesmerising nocturnal spectacle of fireflies at Hotaru Doyo Koen

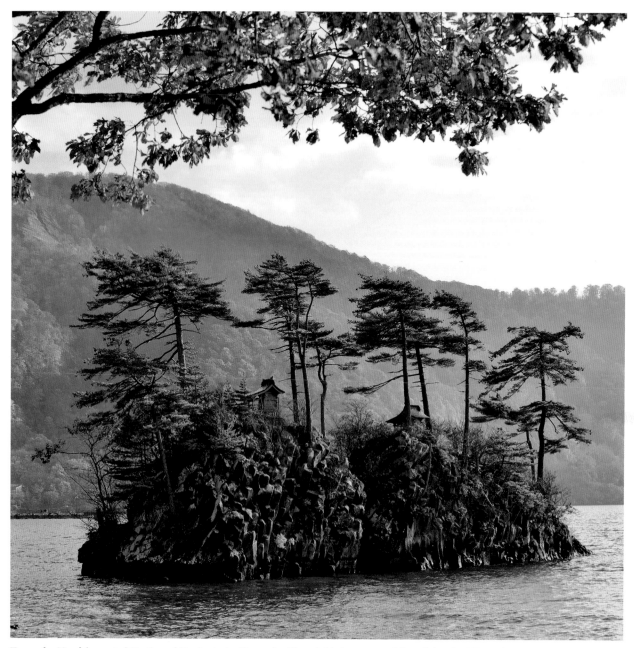

Towada-Hachimantai National Park › Lake Towada, Honshū's largest caldera lake, is 327m deep

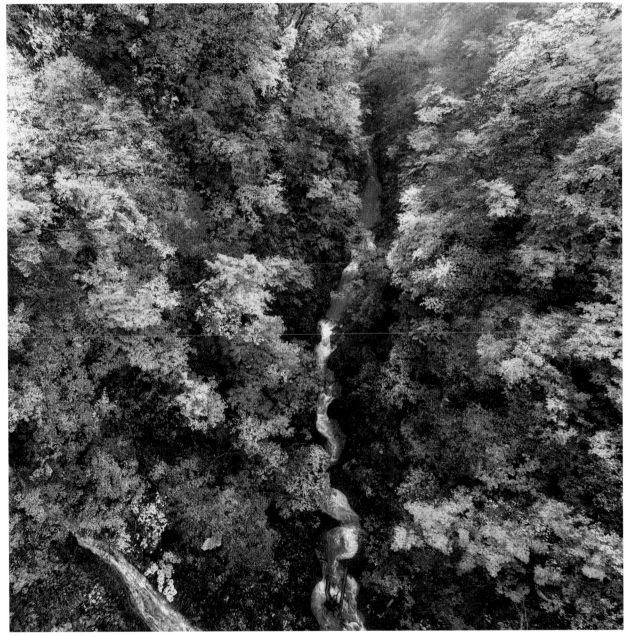

Miyagi › Maple trees present their autumnal show in Naruko Gorge

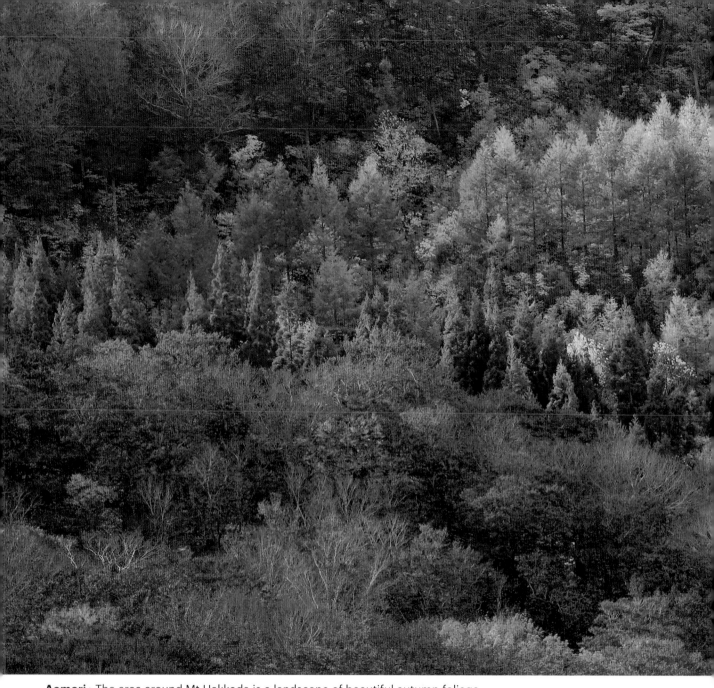

Aomori › The area around Mt Hakkoda is a landscape of beautiful autumn foliage

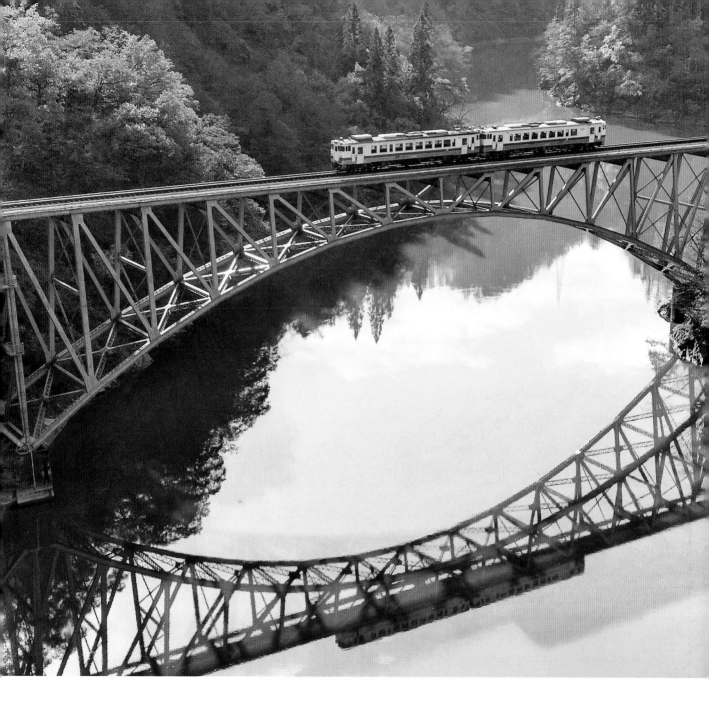

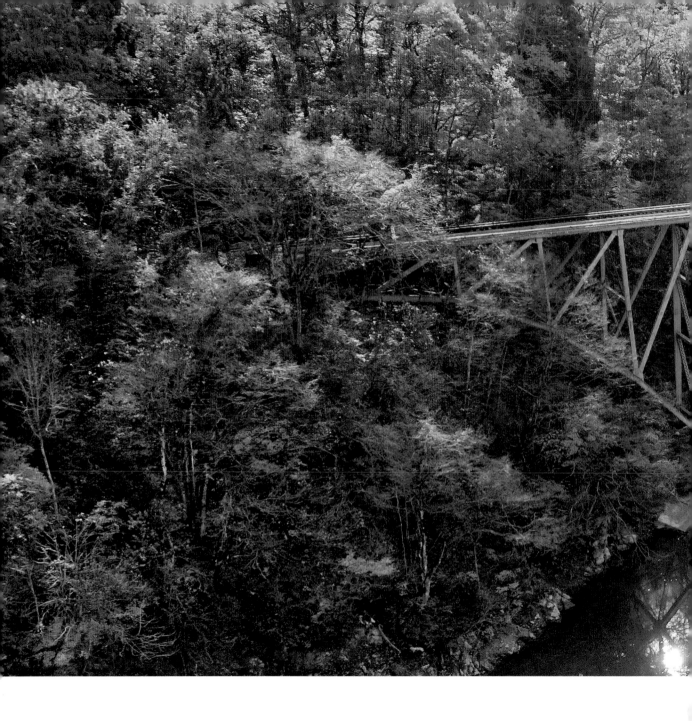

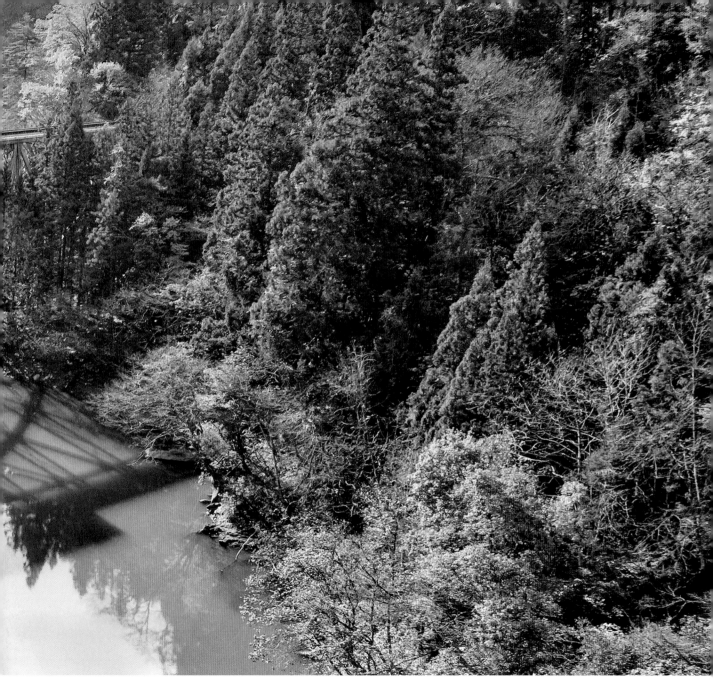

Fukushima › Crossing the Tadami river on route from Aizu-Wakamatsu to Oku-Aizu

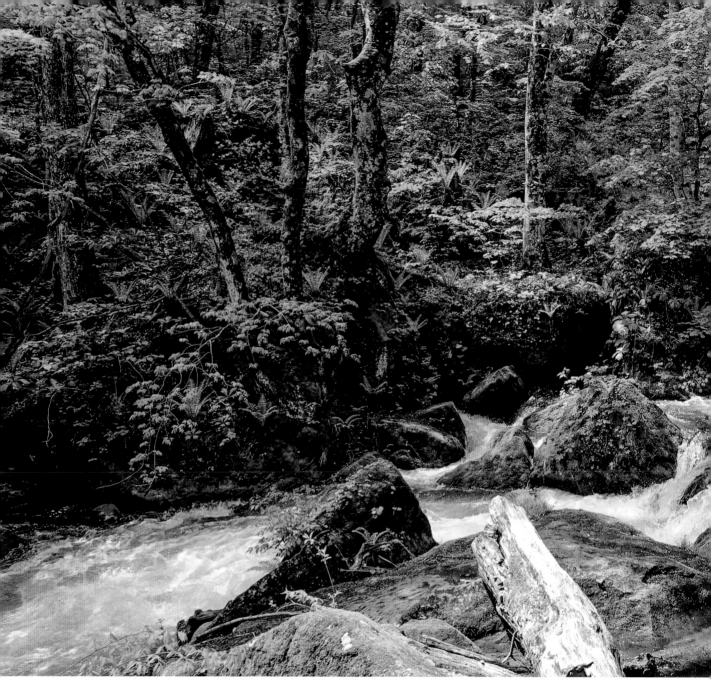

Aomori › A stream cascades through the verdant Oirase Gorge

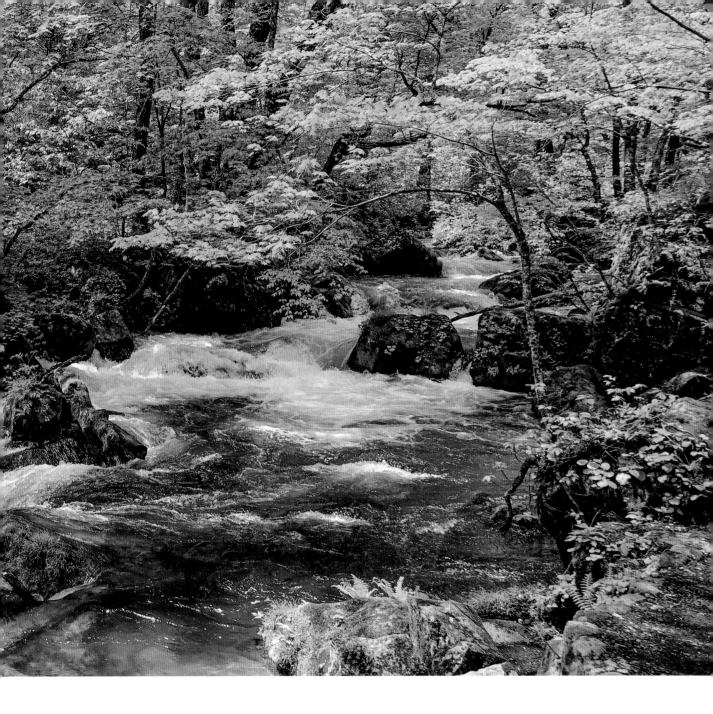

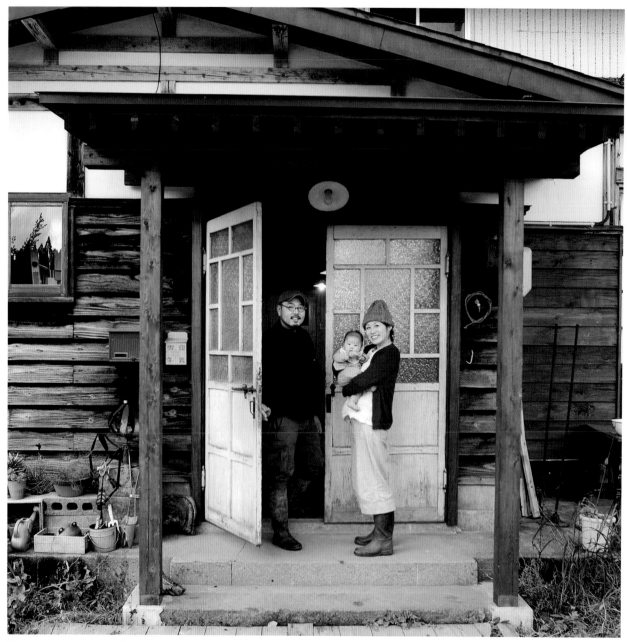

Yamagata › A young family on the doorstep of their farmhouse near Mogami

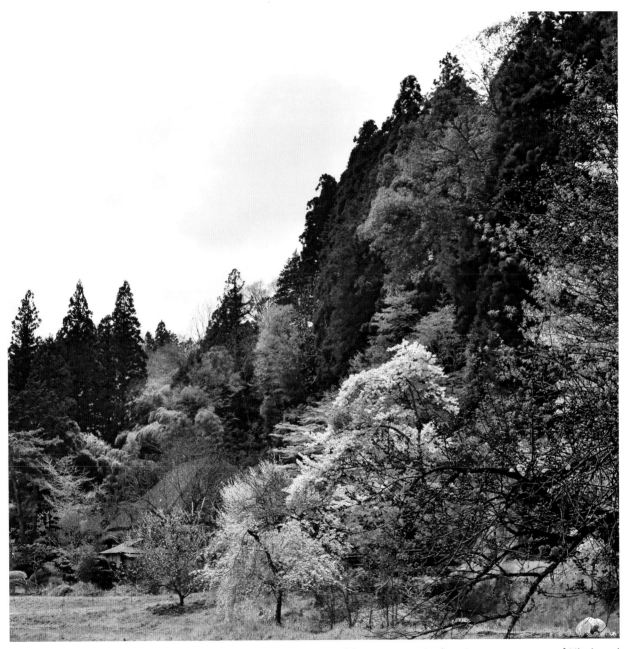

Iwate › Cherry blossom trees in the picturesque town of Hiraizumi

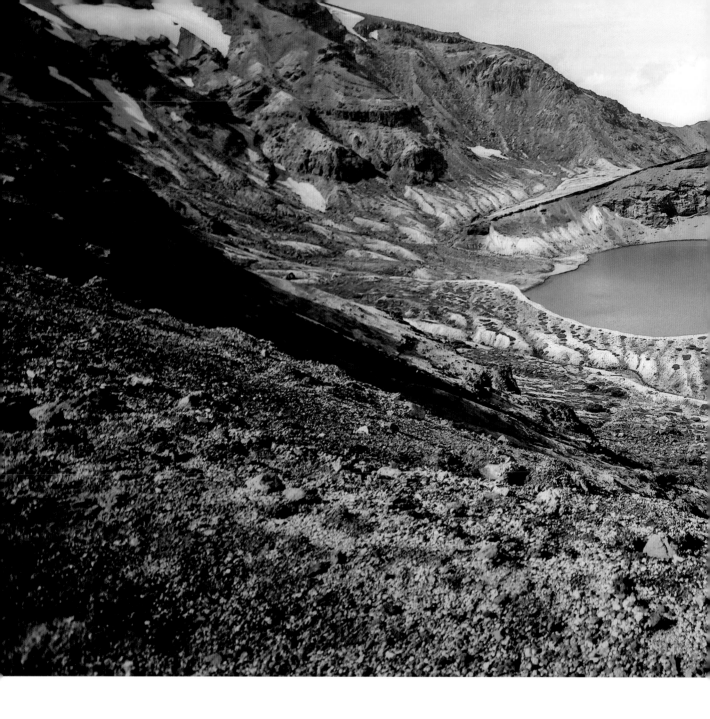

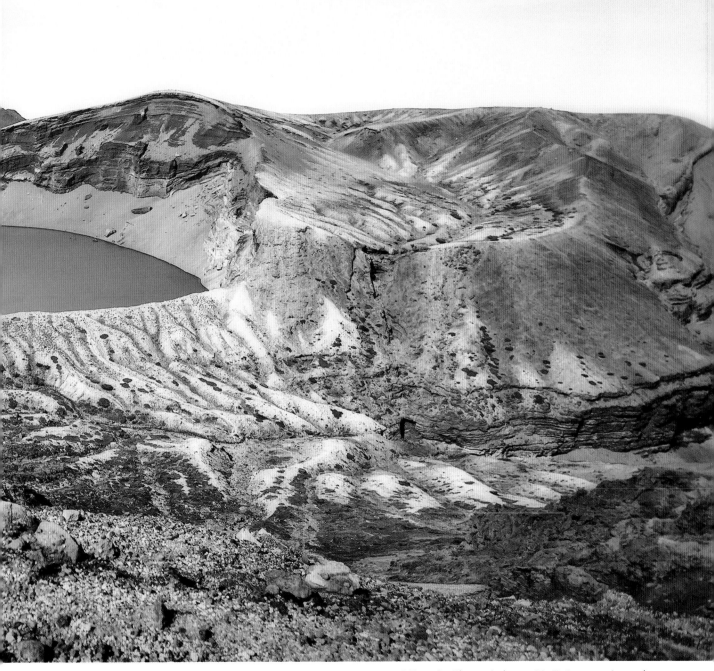

Miyagi › Okama Lake on Mt Zaō, an active volcano

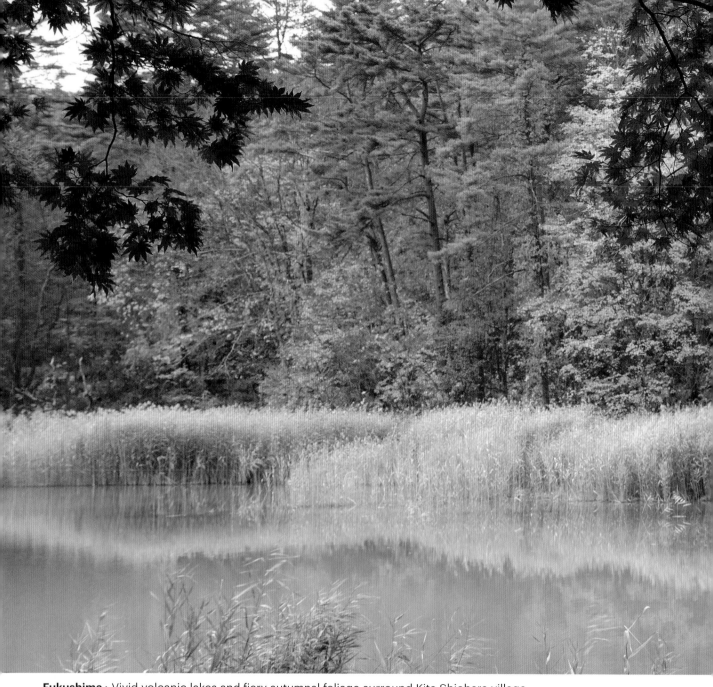

Fukushima › Vivid volcanic lakes and fiery autumnal foliage surround Kita Shiobara village

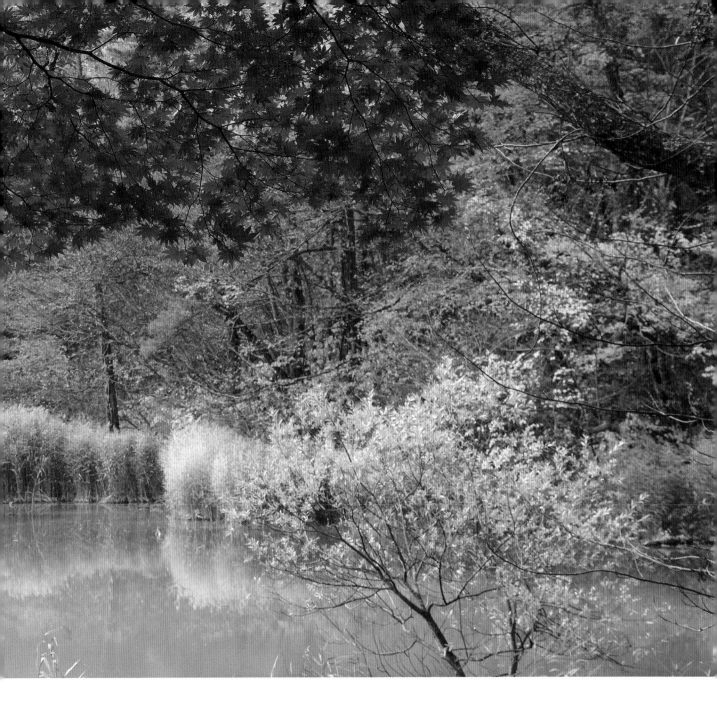

Tōhoku

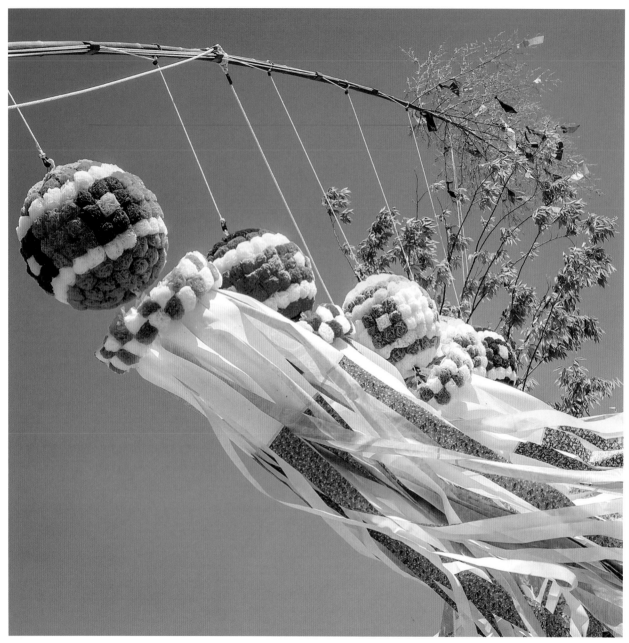

Sendai › Colourful decorations flutter in the wind during the Tanabata Matsuri festival

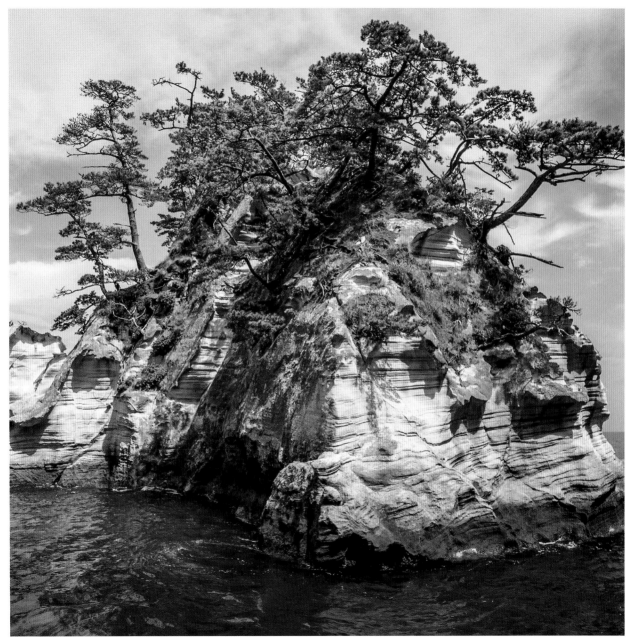

Matsushima › One of the 260 pine-strewn islets that populate Matsushima Bay

Tōhoku

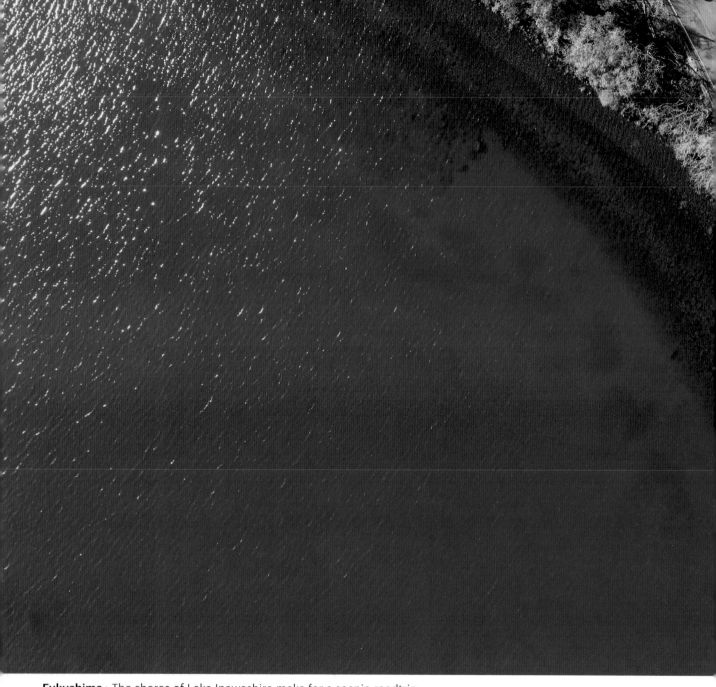

Fukushima › The shores of Lake Inawashiro make for a scenic roadtrip

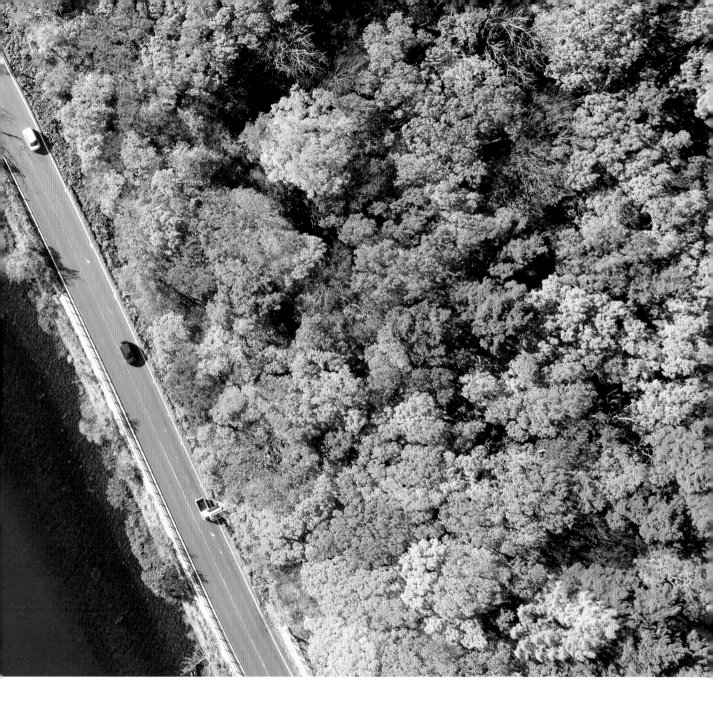

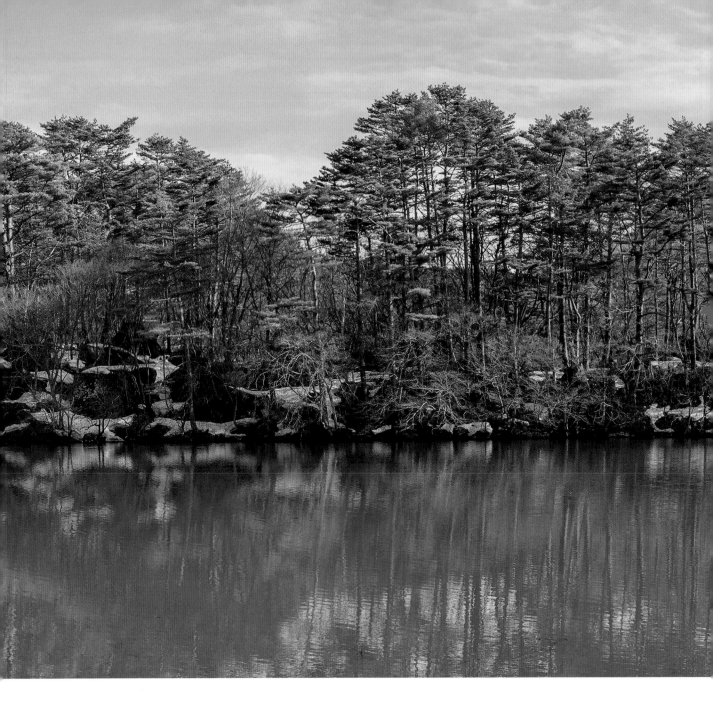

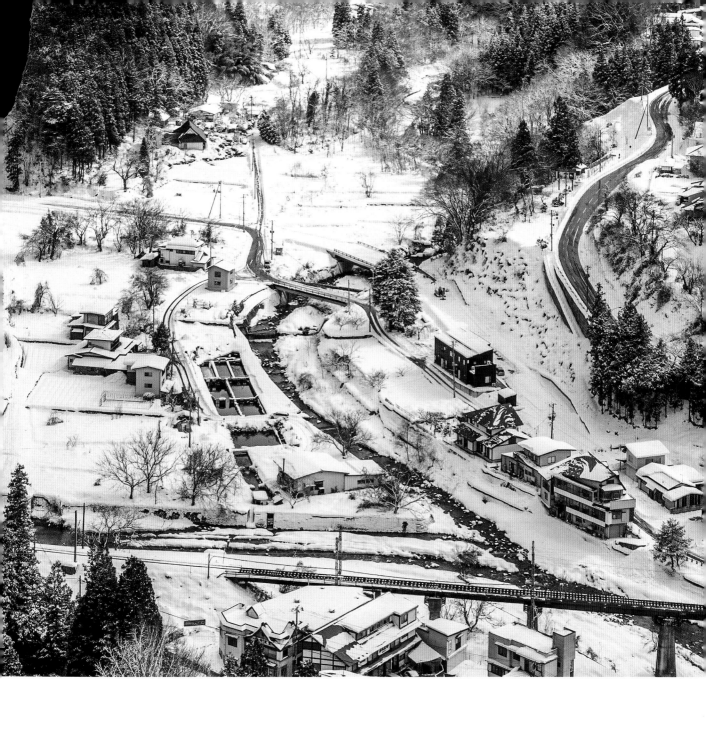

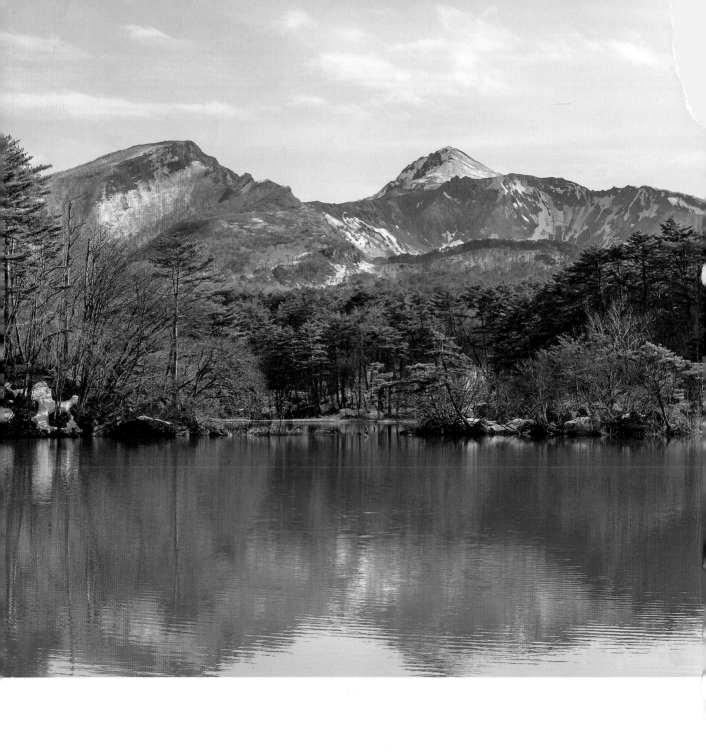

Fukushima › One of the Five Coloured Lakes at the foot of Mt Bandai

Yamadera › Snow covers the town, best known for its famous temple in the mountains above

Yamagata › Religious pilgrims ascend to Yudono-san-jinja, one of the holiest Shintō shrines

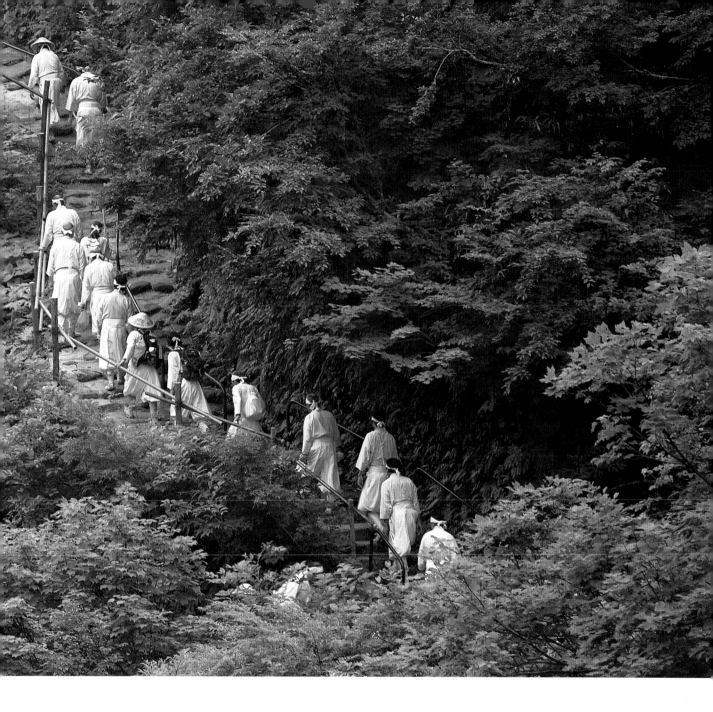

Chiba › Toying with the tide at one of the prefecture's many beaches

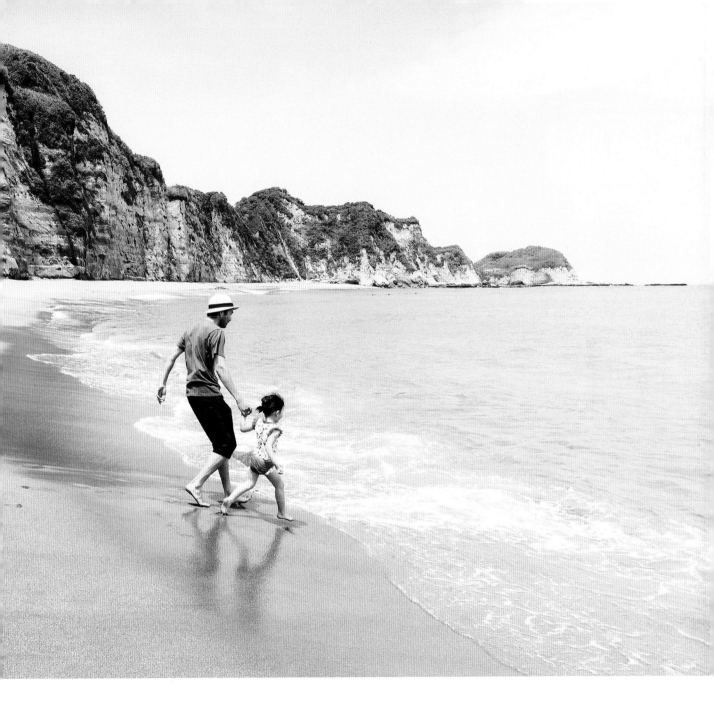

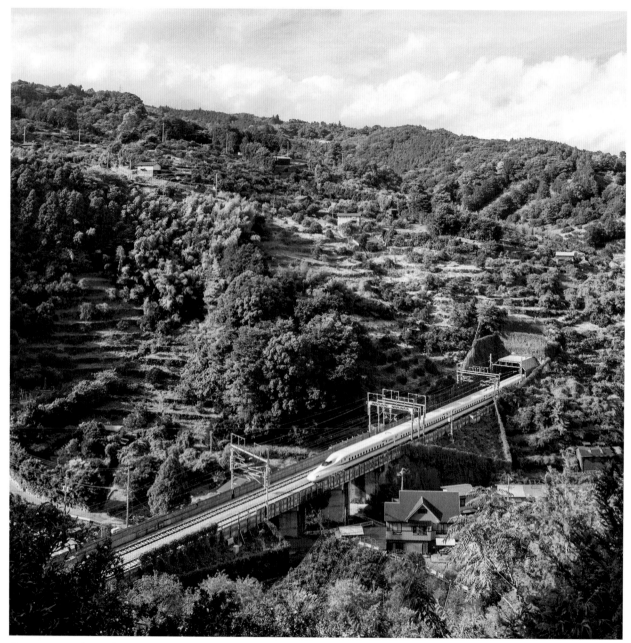

Kanagawa › The Tōkaidō shinkansen races through the countryside en route from Tokyo to Osaka

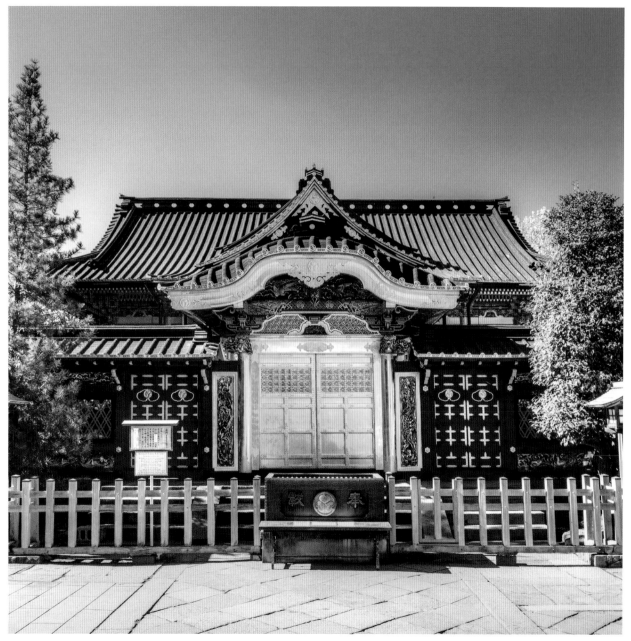

Tokyo › The gold-fronted Tōshō-gū shrine in Ueno park

Kantō

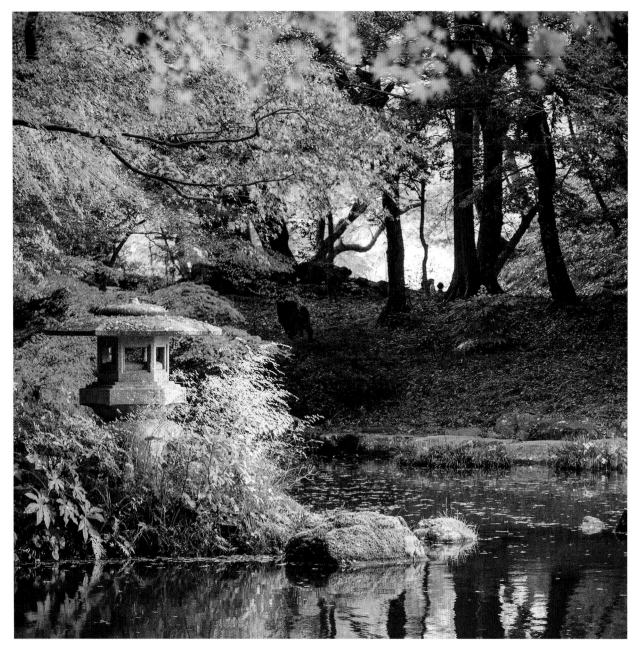

Narita › Among the serene temple grounds of Narita-san Shinshōji

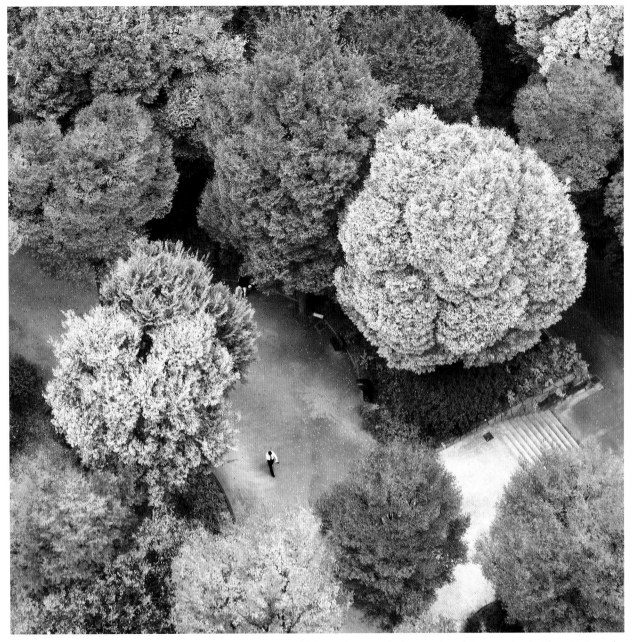

Tokyo › Autumn brings colourful canopies to the city's parks

Kantō

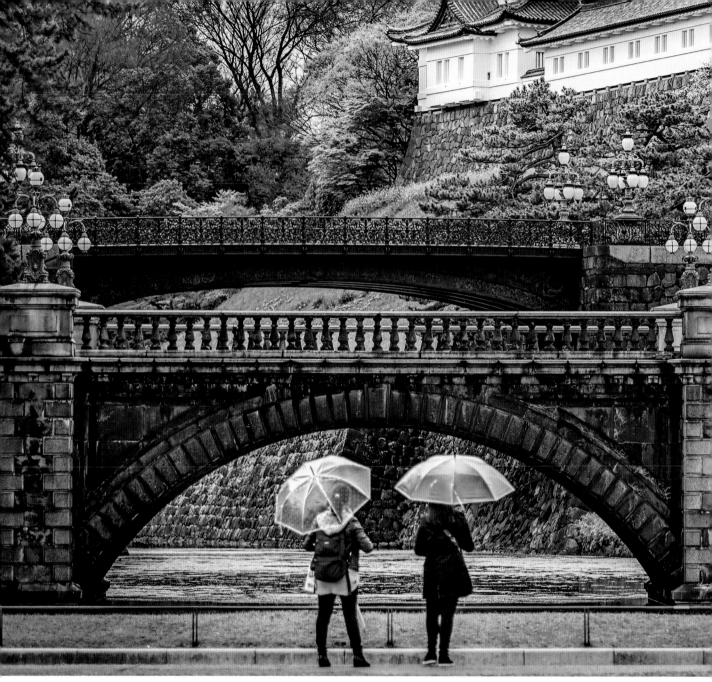

Tokyo › Two onlookers admire the Imperial Palace, the primary residence of Japan's Emperor

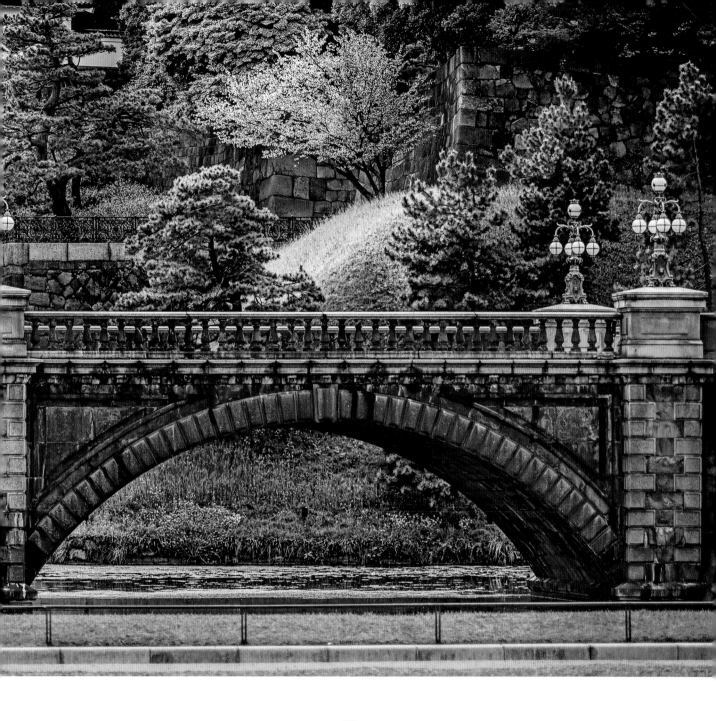

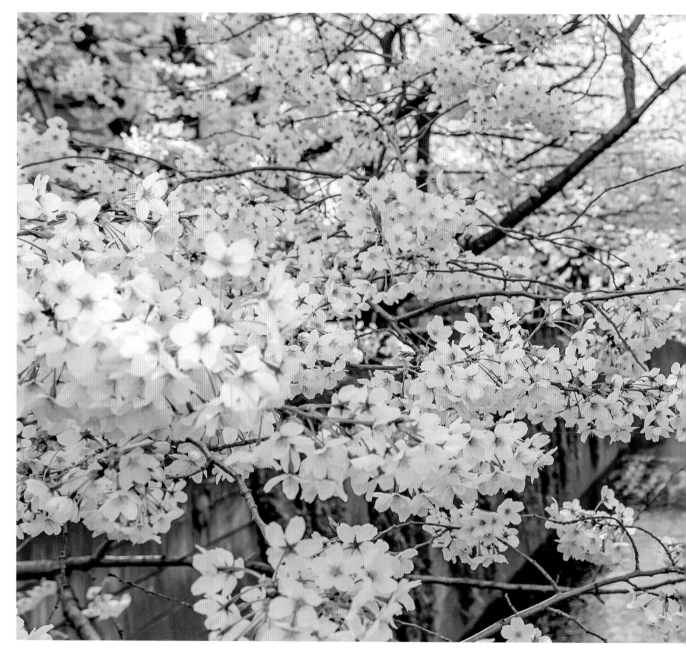

Tokyo › Cherry-blossom trees line the Meguro river

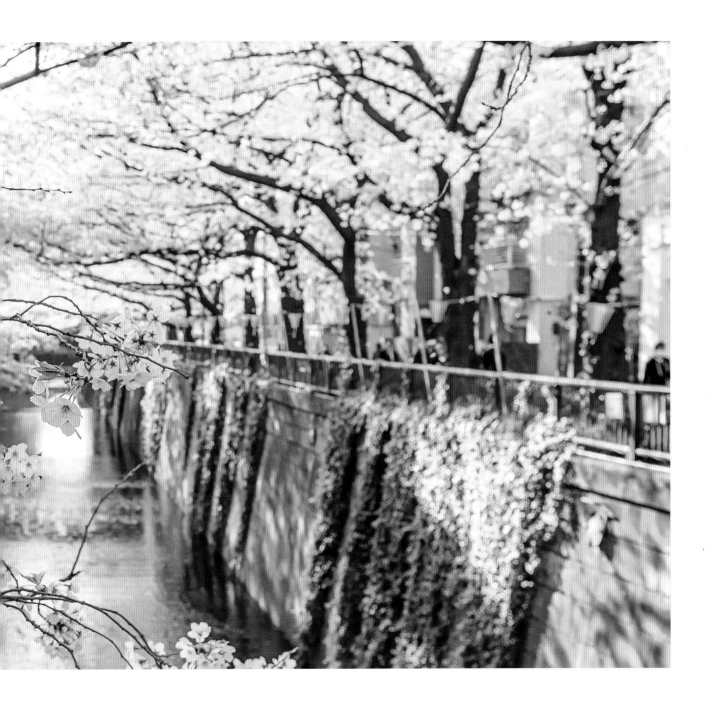

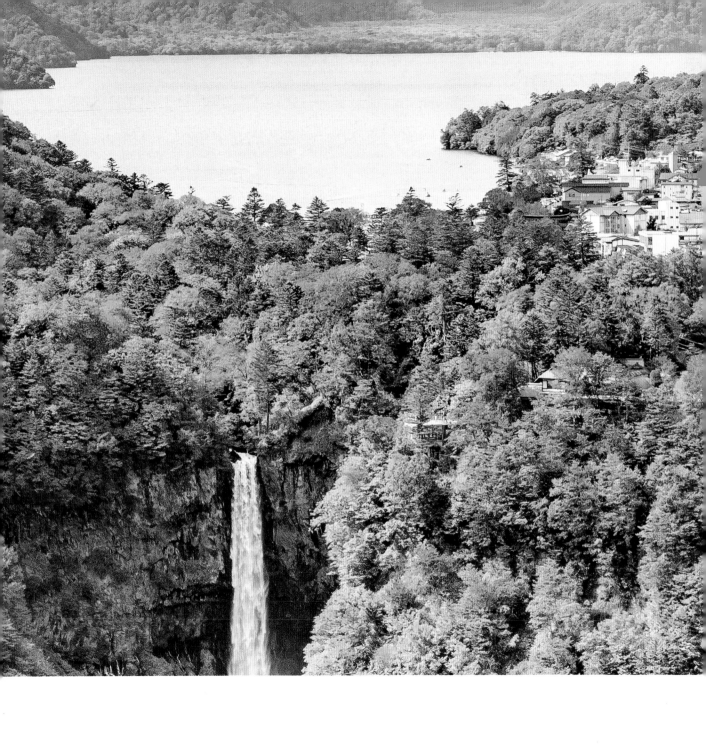

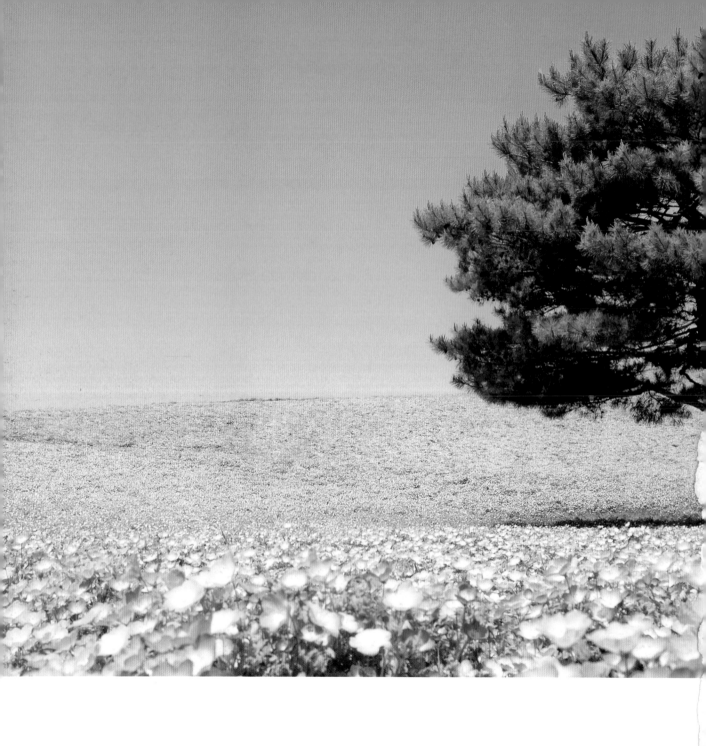

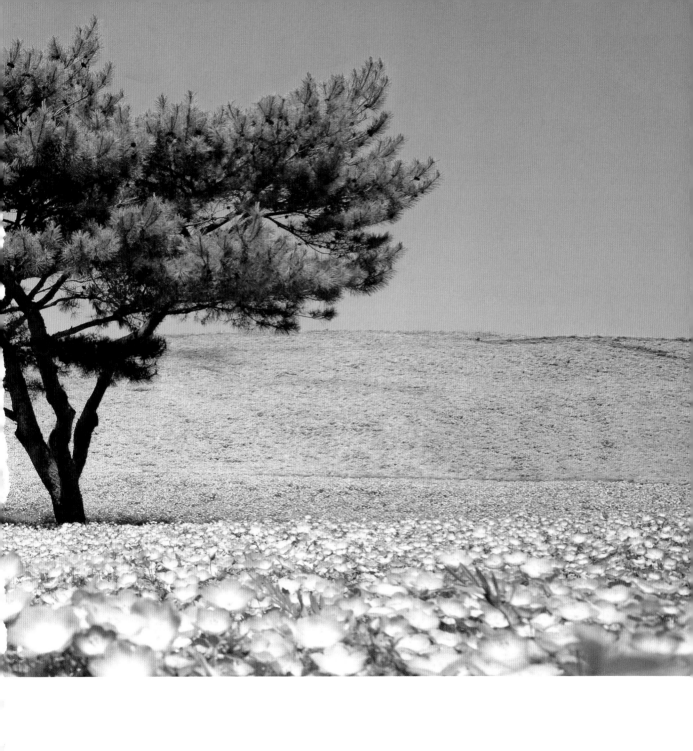

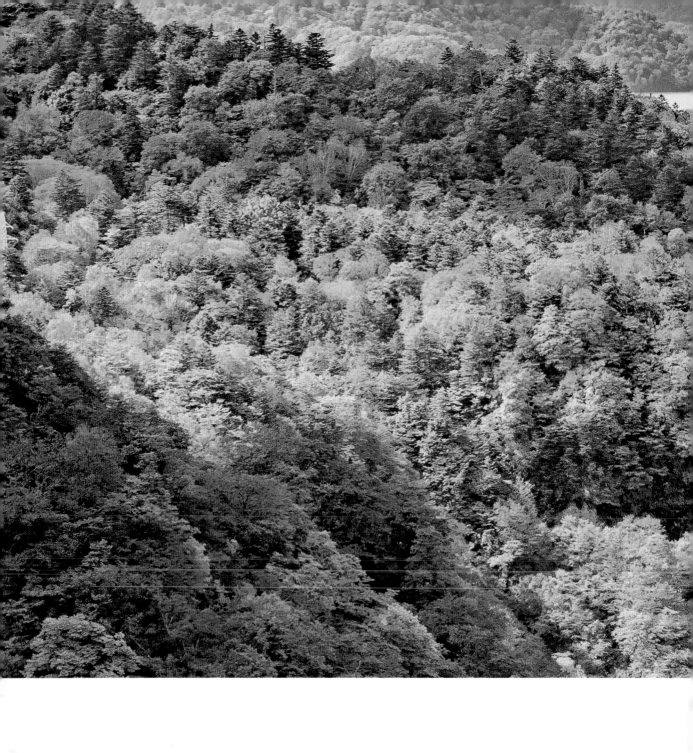

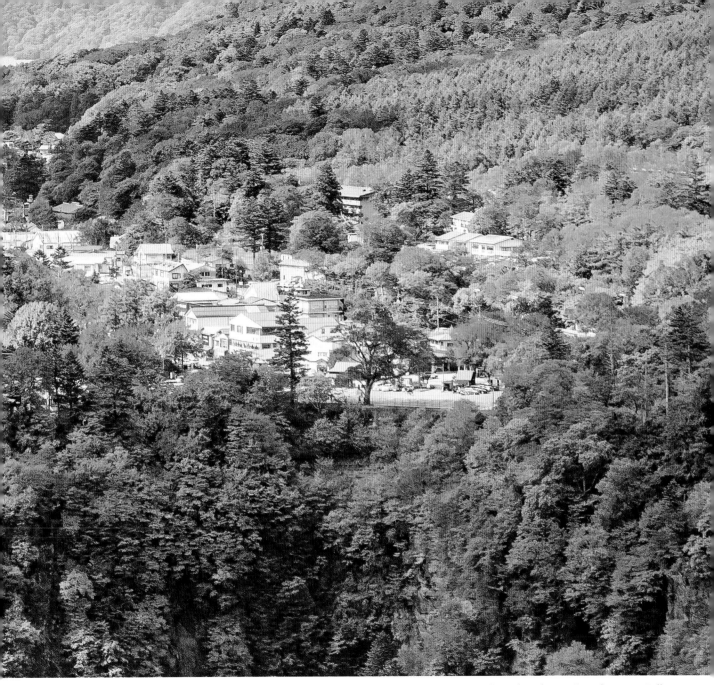

Nikko National Park › Lake Chuzenji and Kegon Falls

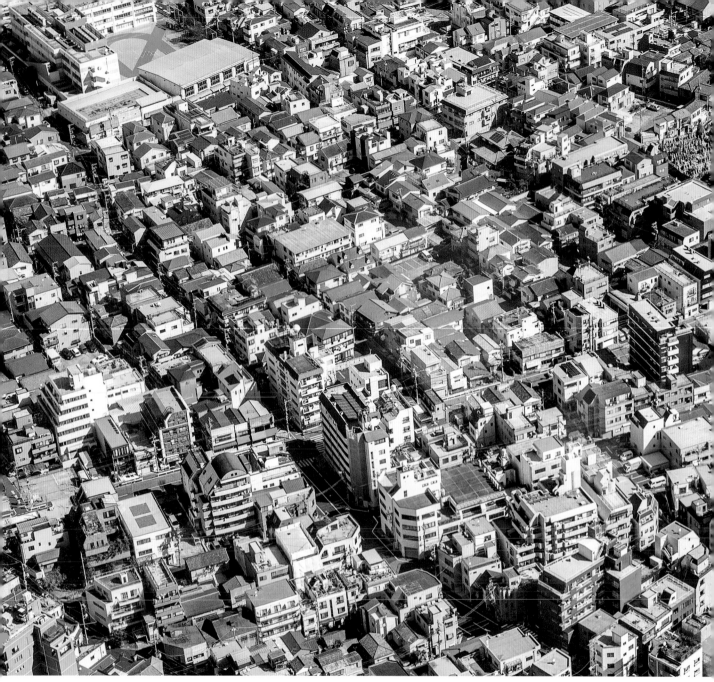

Tokyo › A vast, sprawling capital, Tokyo is one of the world's biggest cities

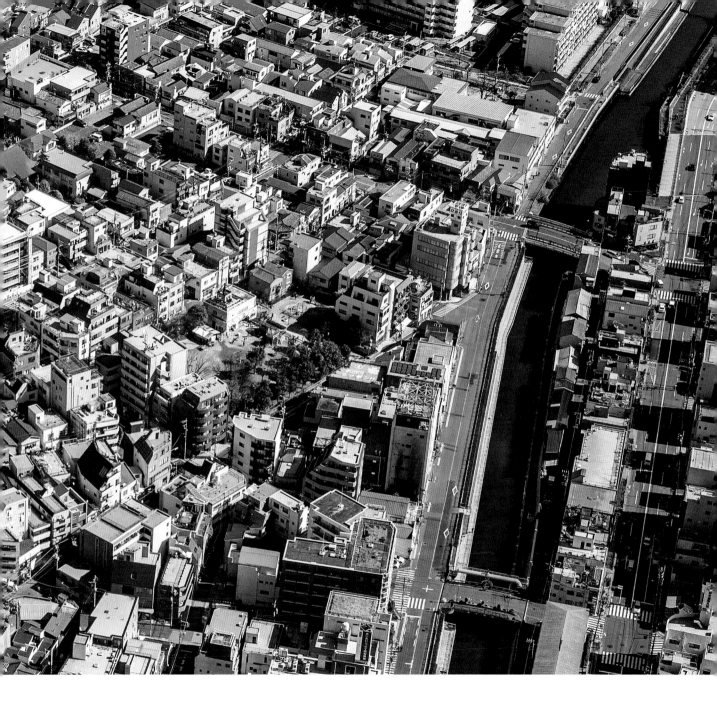

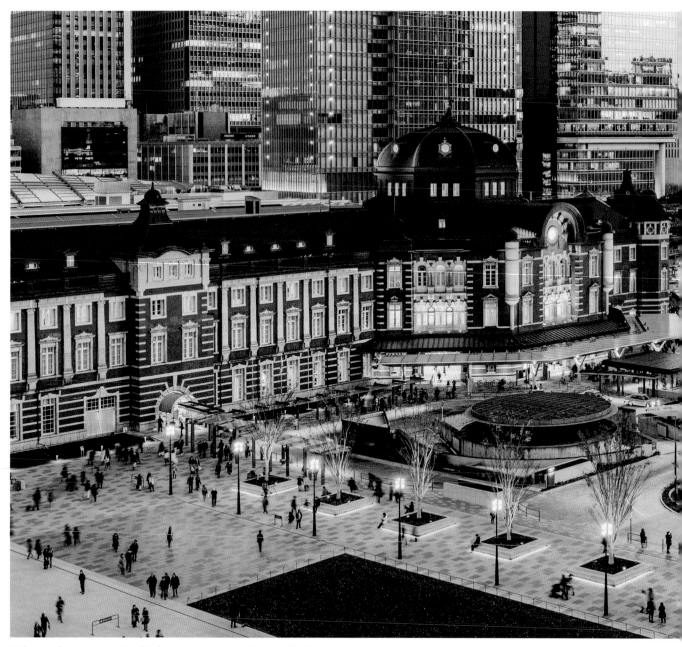

Tokyo › The city's main shinkansen terminus, Tokyo Station at night

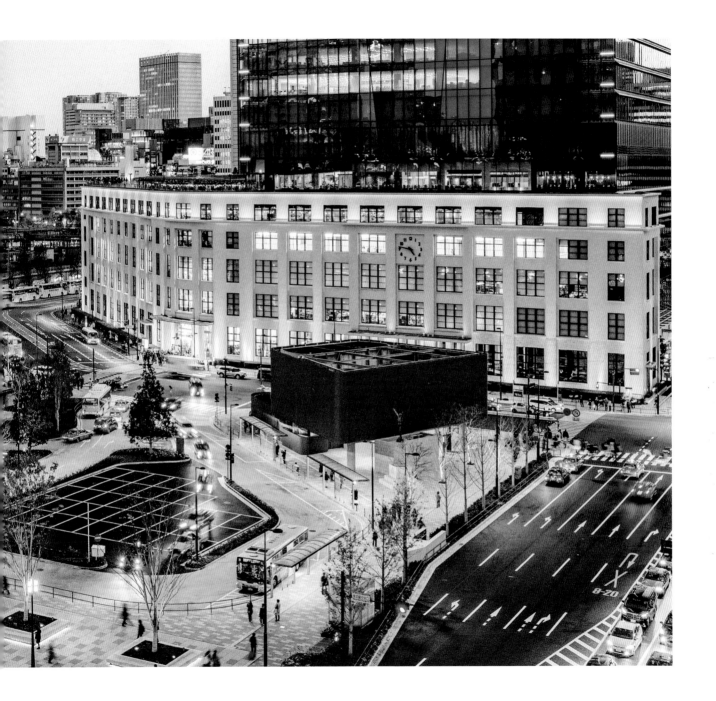

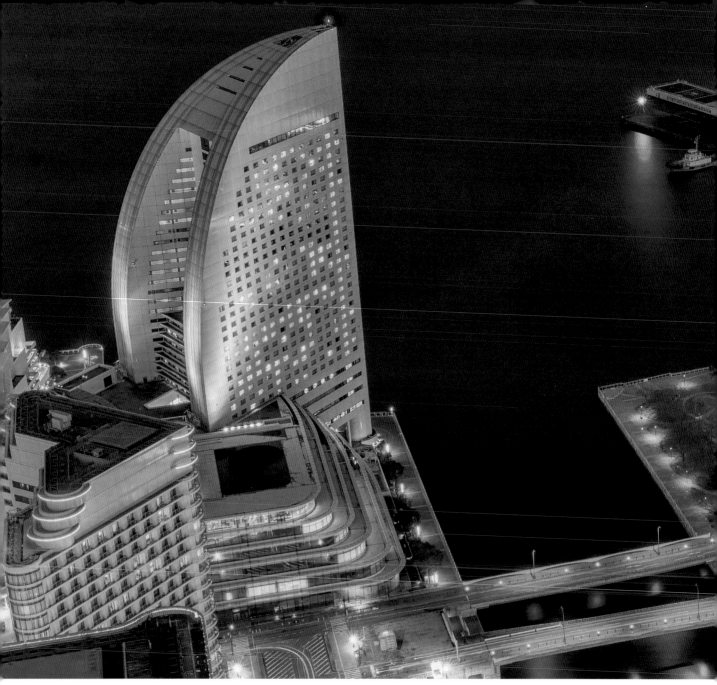

Yokohama › Portside in Yokohama is the Cosmo Clock 21, one of the world's tallest Ferris wheels

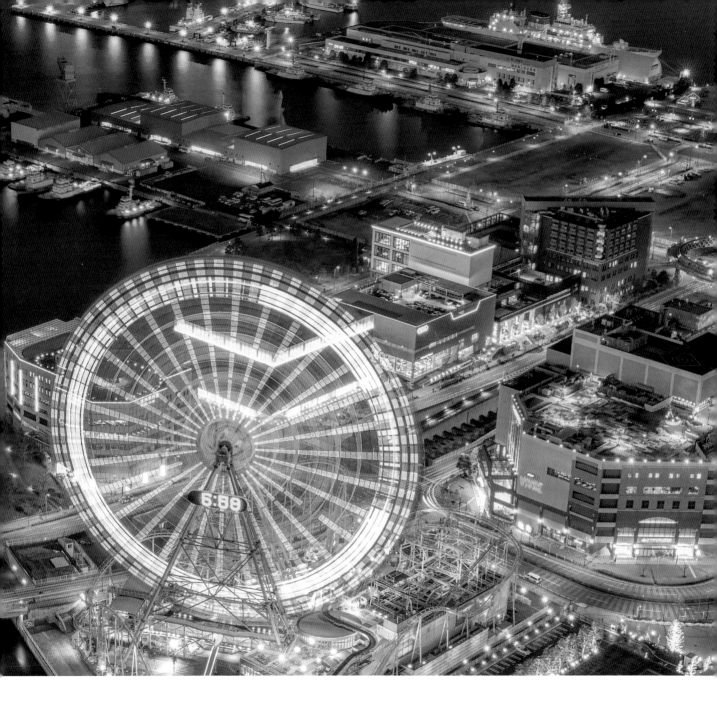

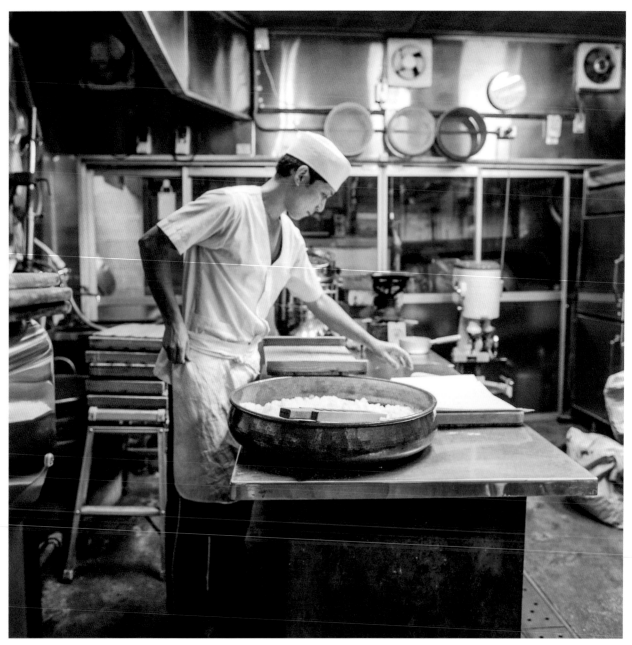

Tokyo › A chef prepares and mixes dough to make the Japanese sweets, wagashi (right)

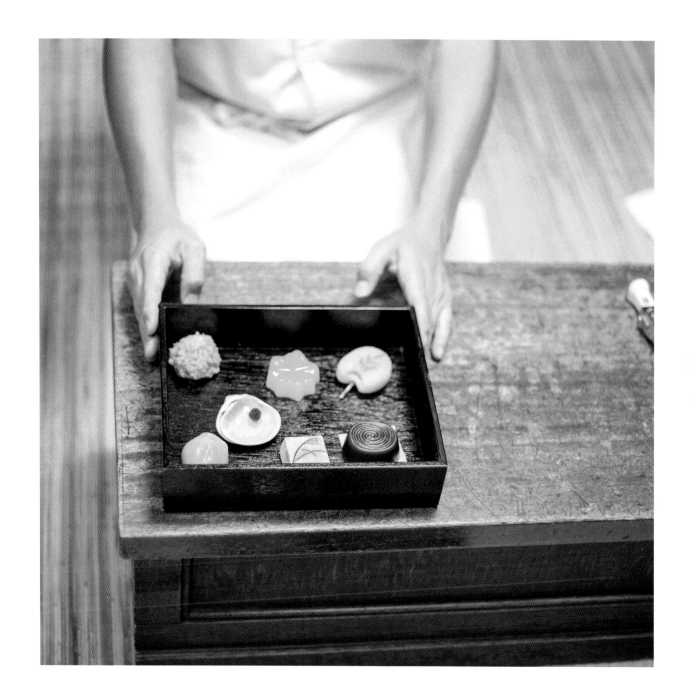

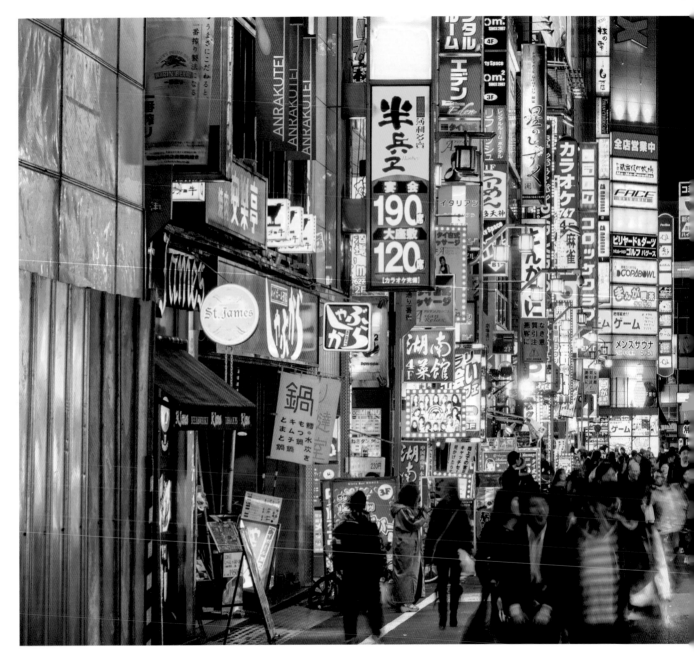

Tokyo › Neon-lit Kabukichō, the city's nightlife hub

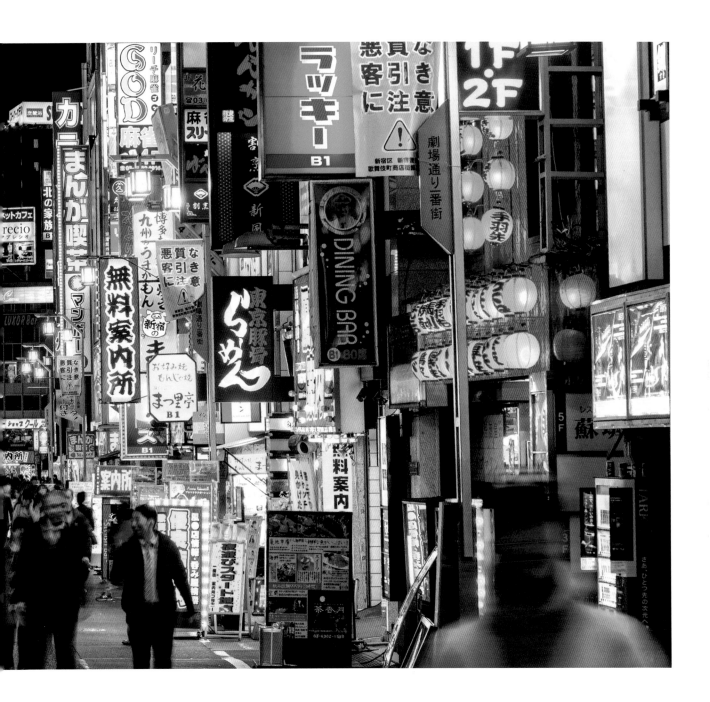

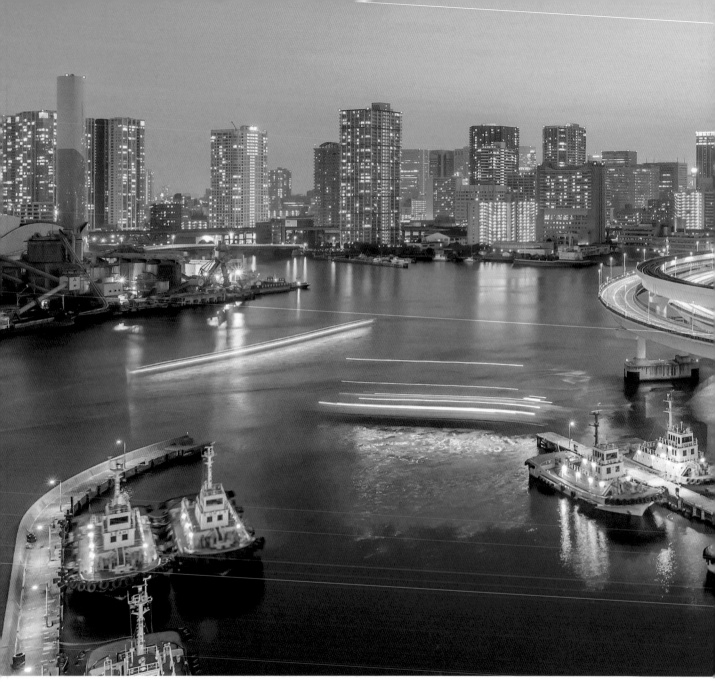

Tokyo › Night falls over Tokyo Bay

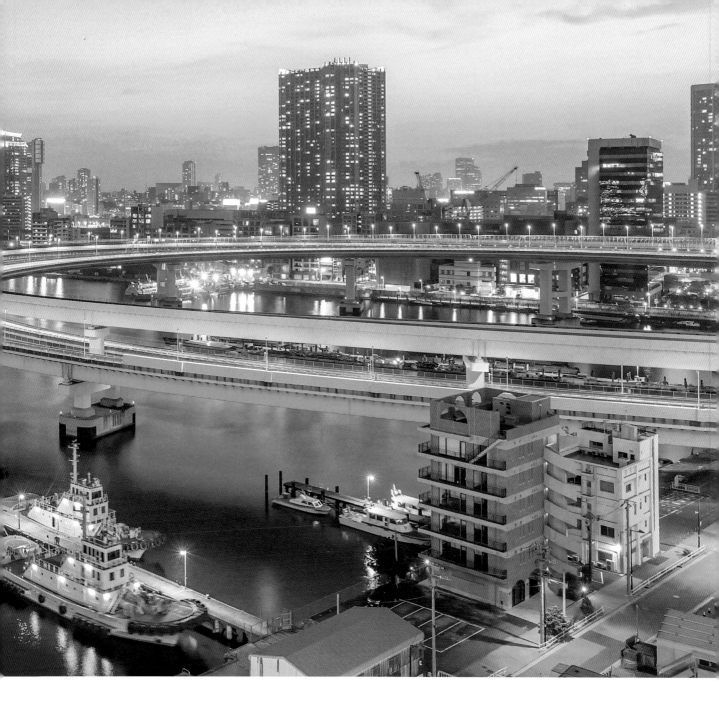

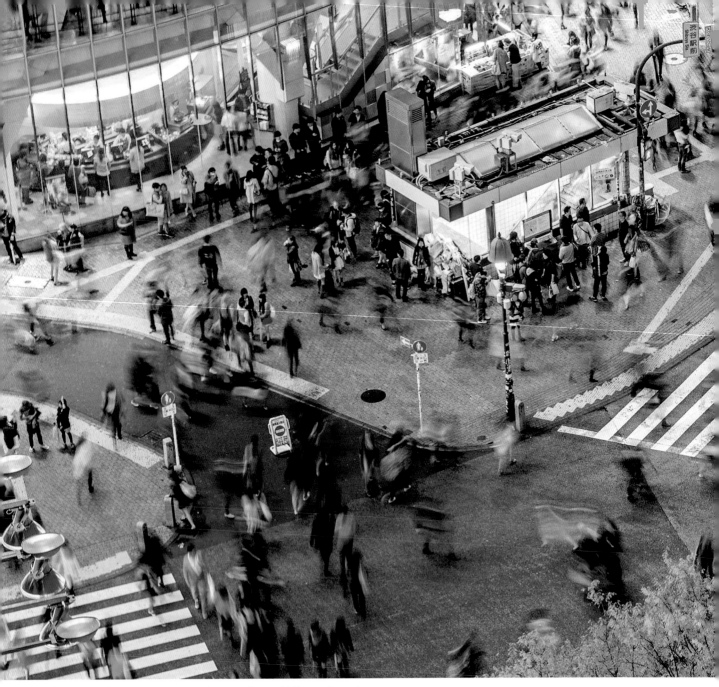

Tokyo › Pedestrians traverse the ever-busy Shibuya Crossing

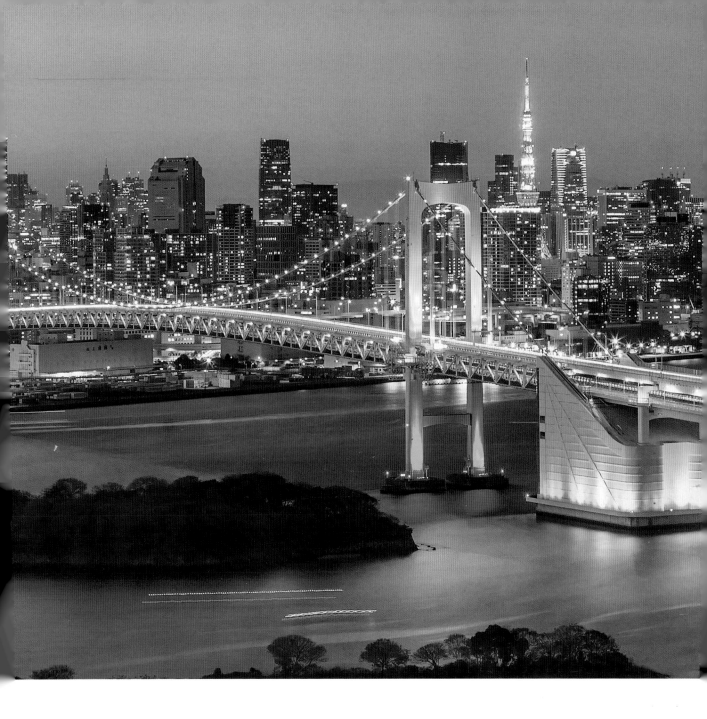

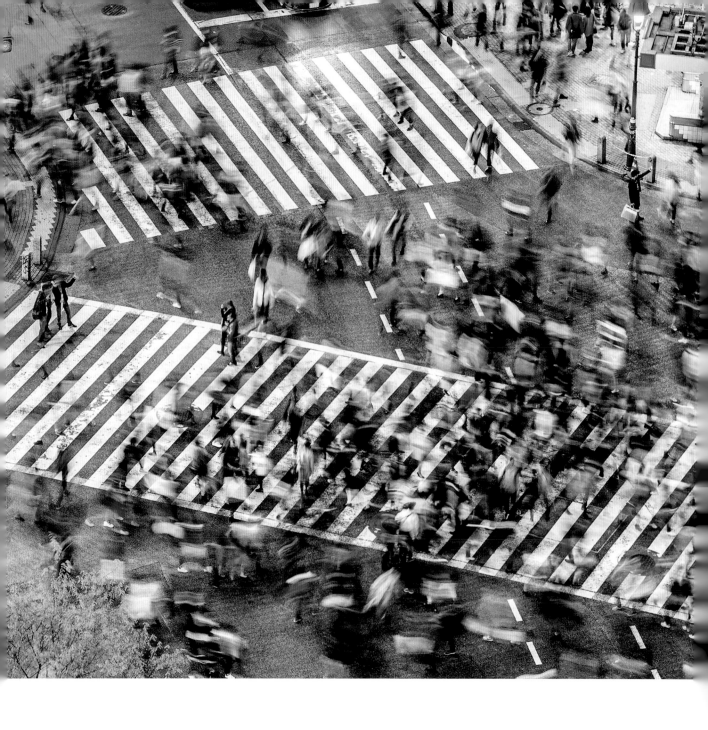

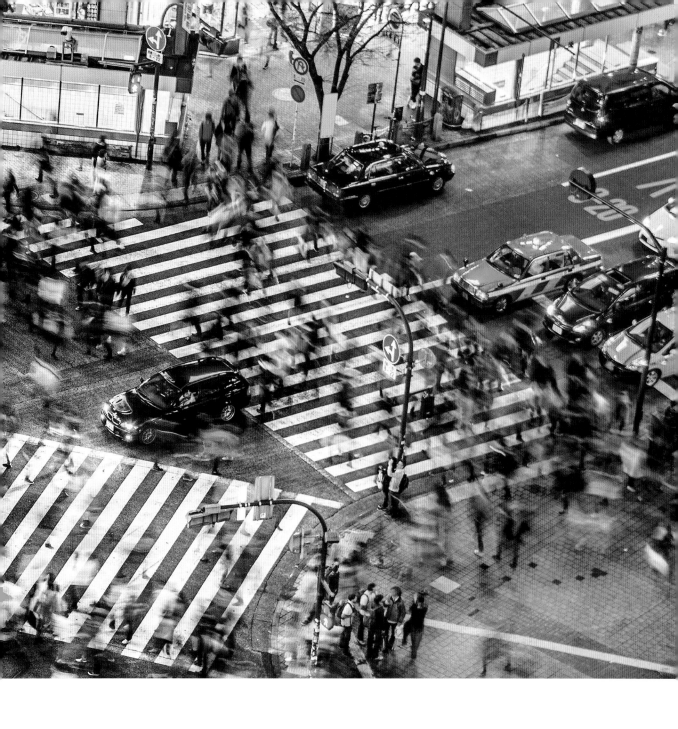

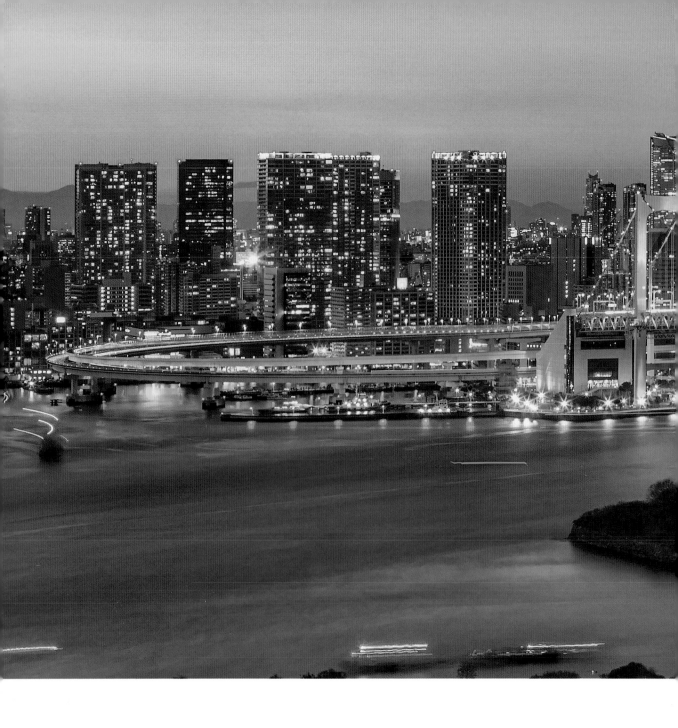

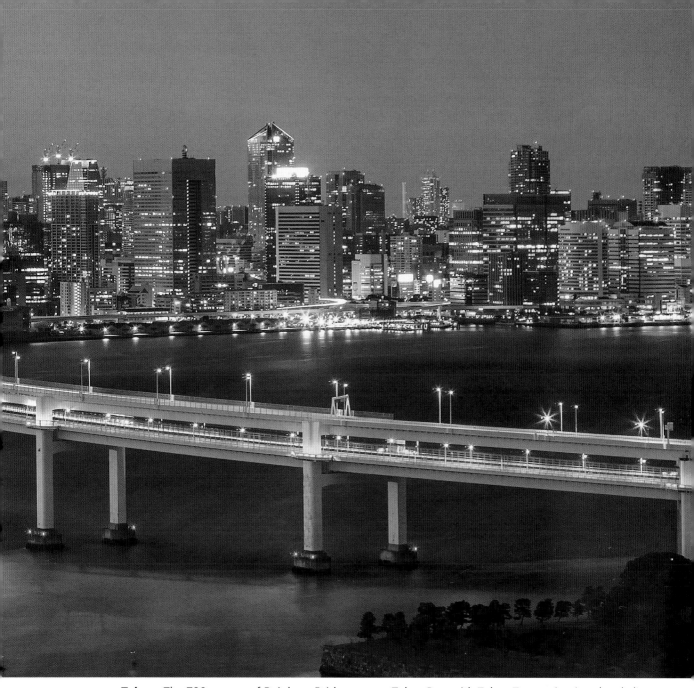

Tokyo › The 798m span of Rainbow Bridge across Tokyo Bay, with Tokyo Tower piercing the skyline

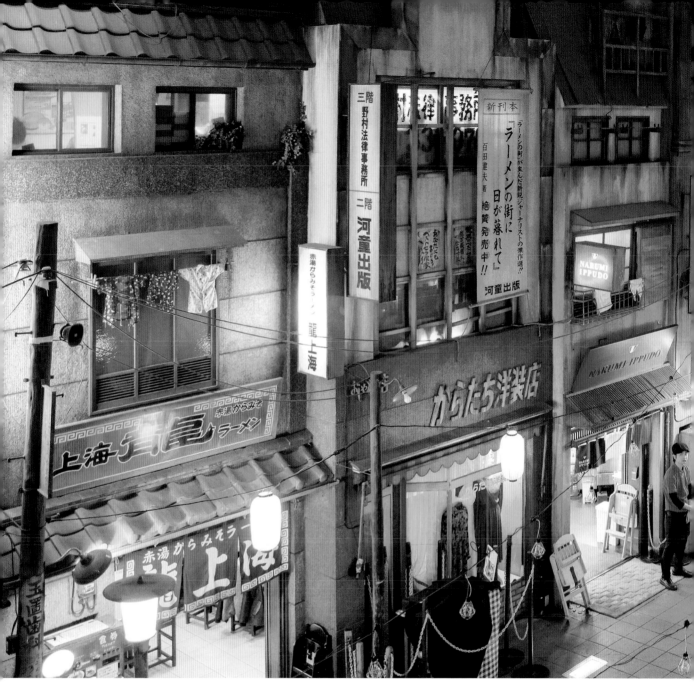

Yokohama › Shin-Yokohama Ramen Museum, a 'food-themed amusement park'

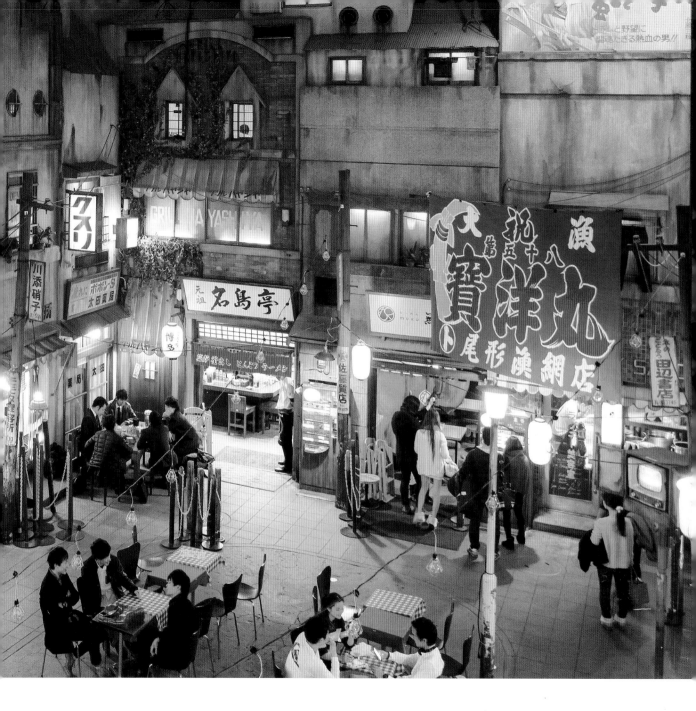

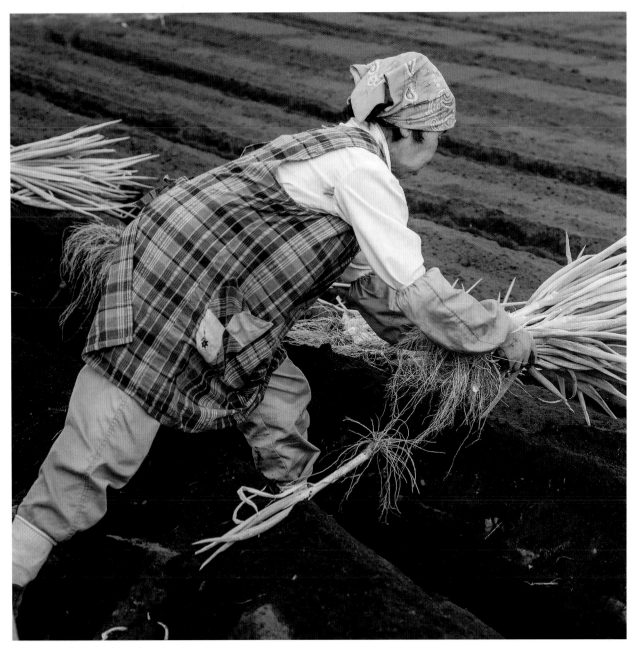

Chiba › A farmworker plants onions in summer

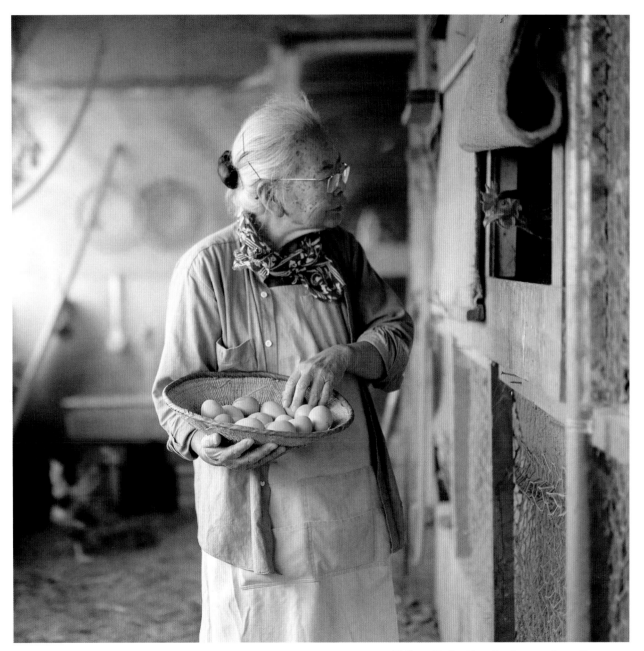

Chiba › Collecting fresh eggs from the coop

Kantō

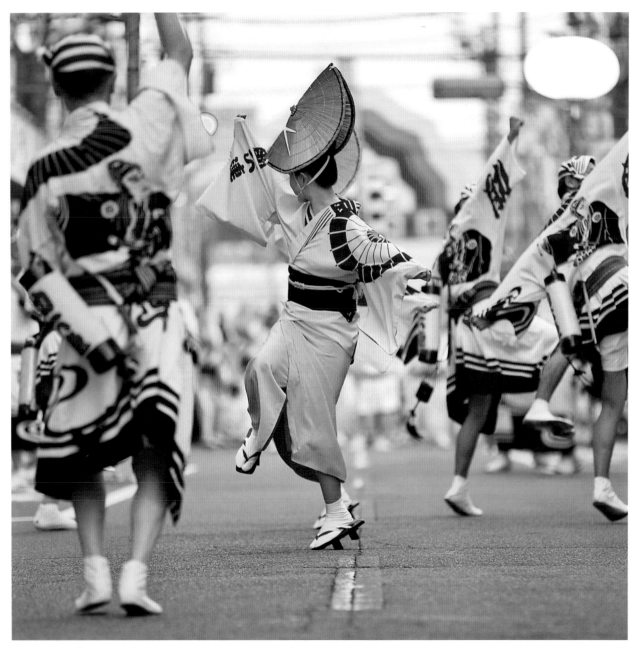

Yamato › Celebrating the Kanagawa Yamato Awa Odori dance festival

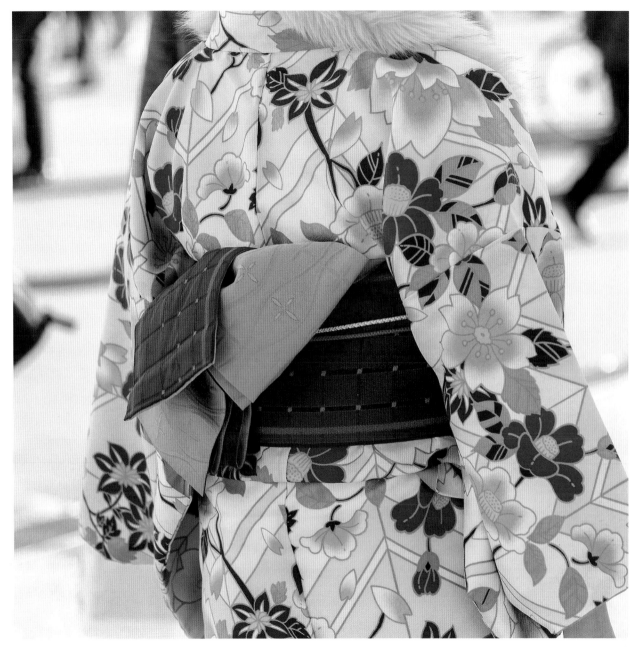

Tokyo › A woman in traditional kimono dress and obi (belt)

Kantō

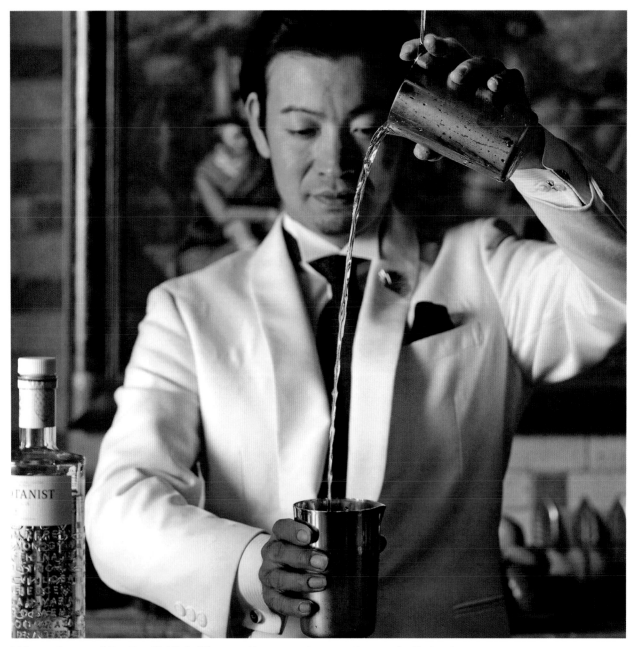

Tokyo › Owner of Bar Ben Fiddich, Hiroyasu Kayama, mixes another cocktail classic

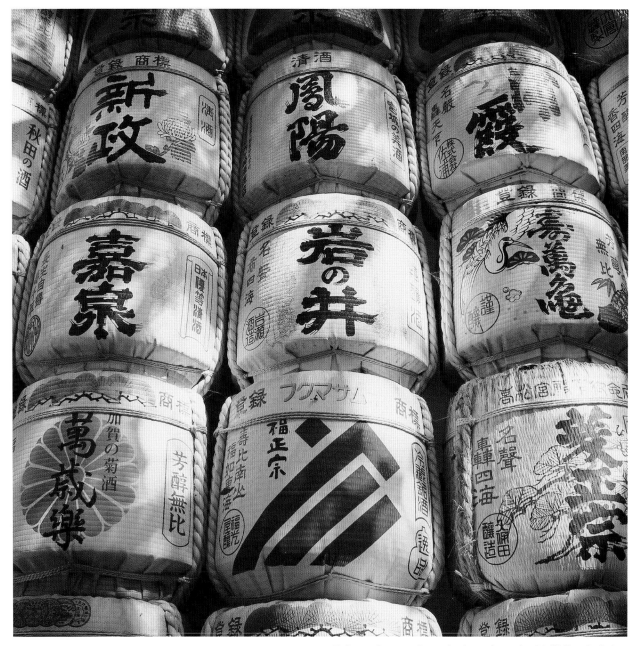

Tokyo › Decorative sake barrels at the Meiji-jingū shrine

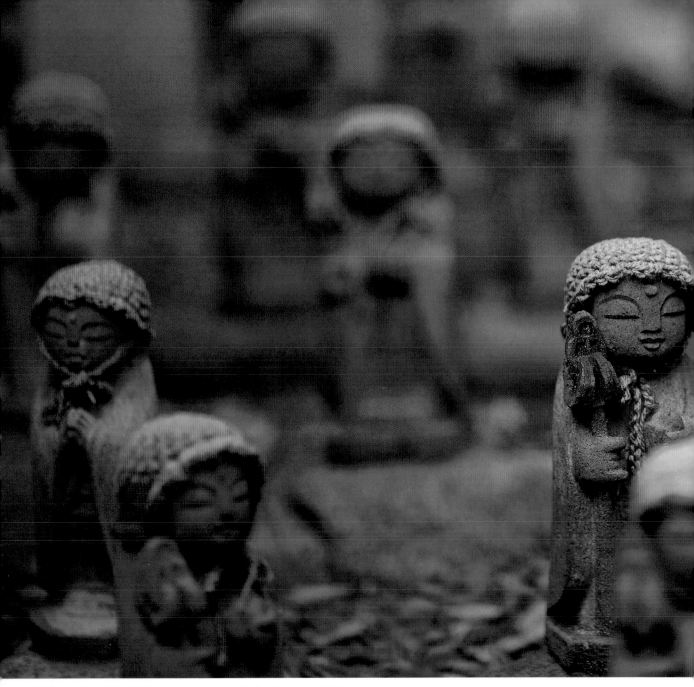

Tokyo › Small Buddhist jizo statues at Daienji temple in Meguro

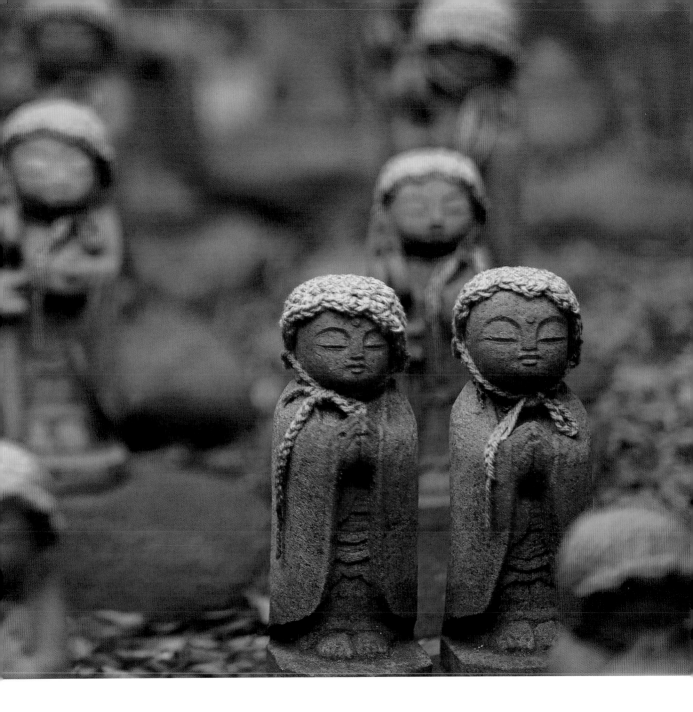

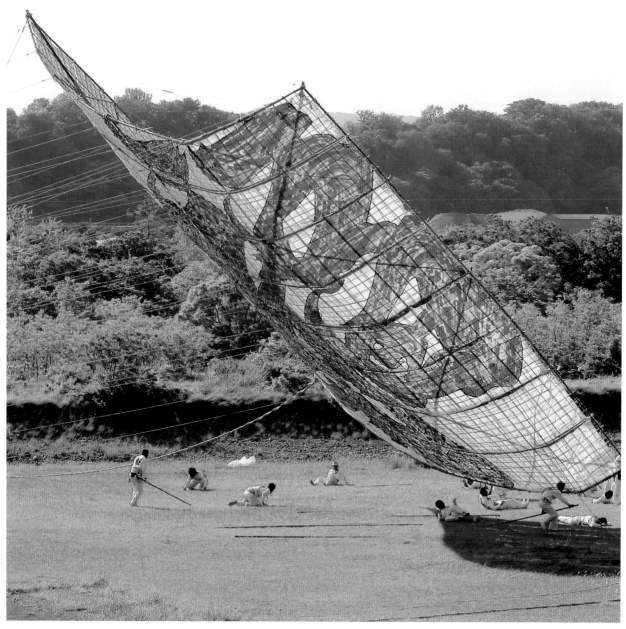

Kanagawa › An impressive entry in the Sagami Giant Kite festival, held every May

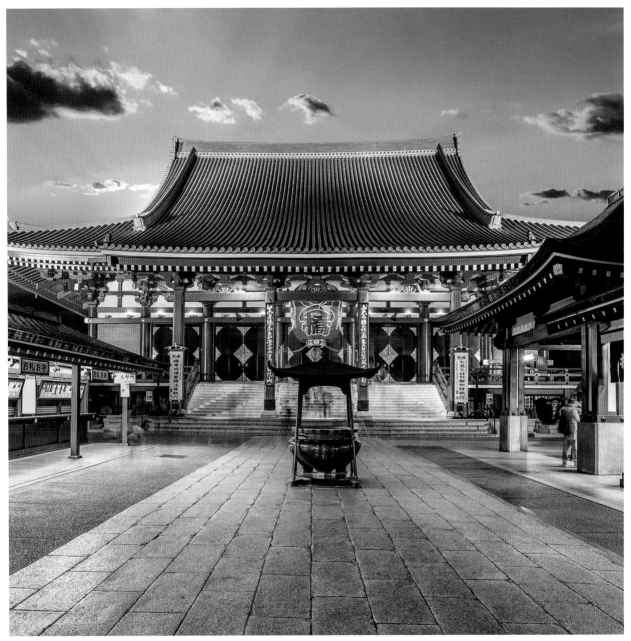

Tokyo › Sensō-ji, the city's oldest and most-visited temple

Kantō

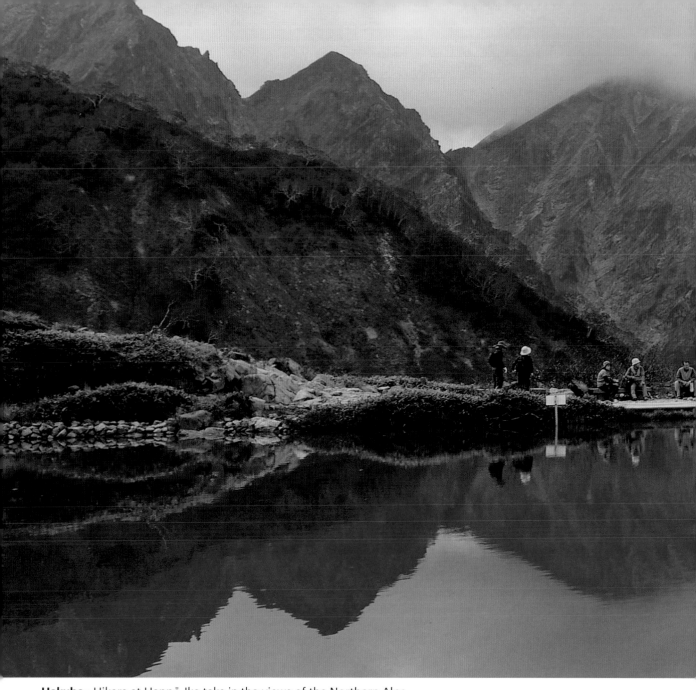

Hakuba › Hikers at Happō-Ike take in the views of the Northern Alps

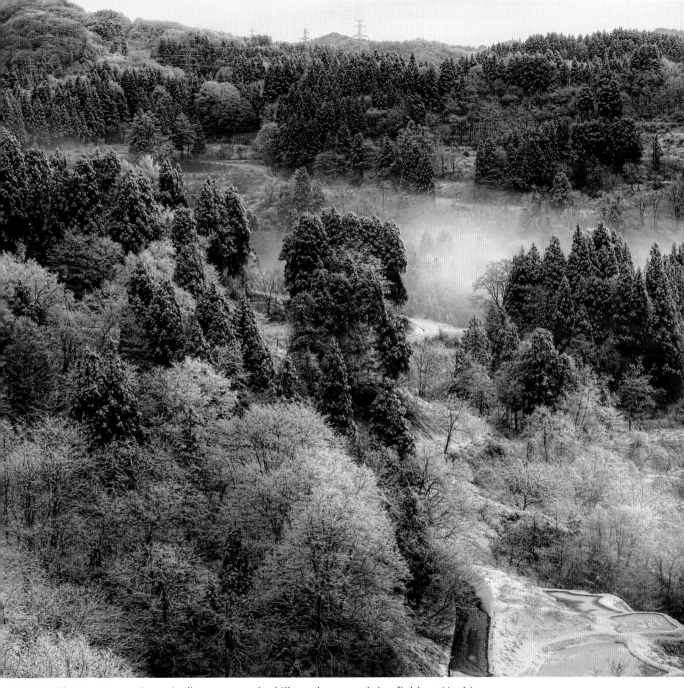

Niigata › A morning mist lingers over the hills and terraced rice fields at Hoshitouge

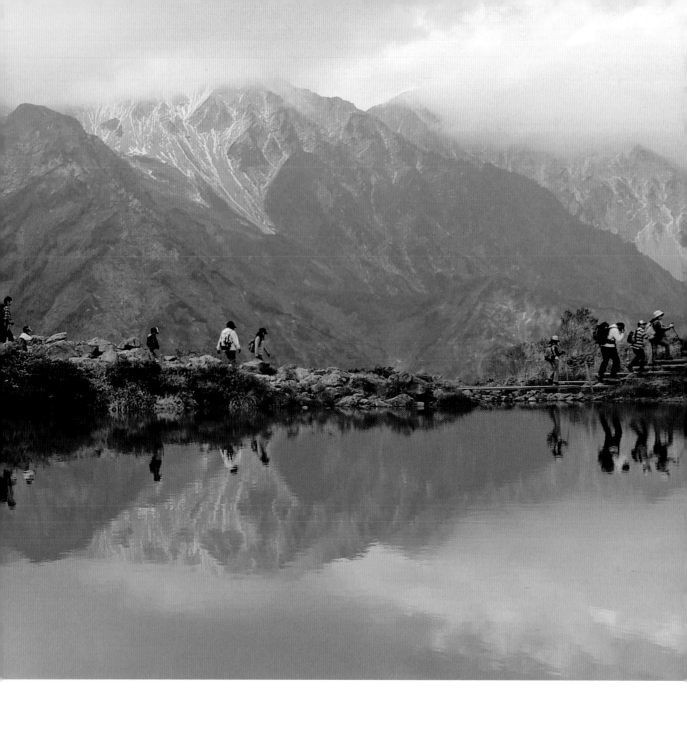

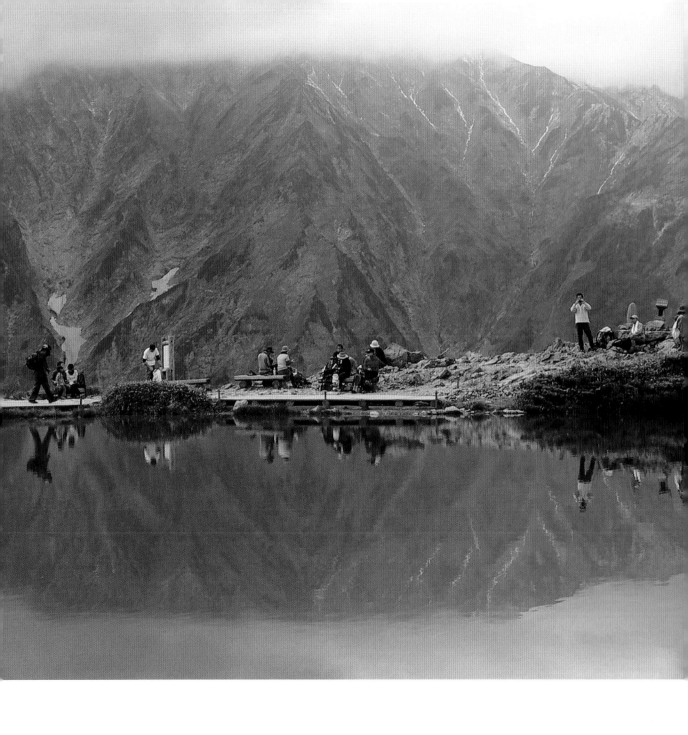

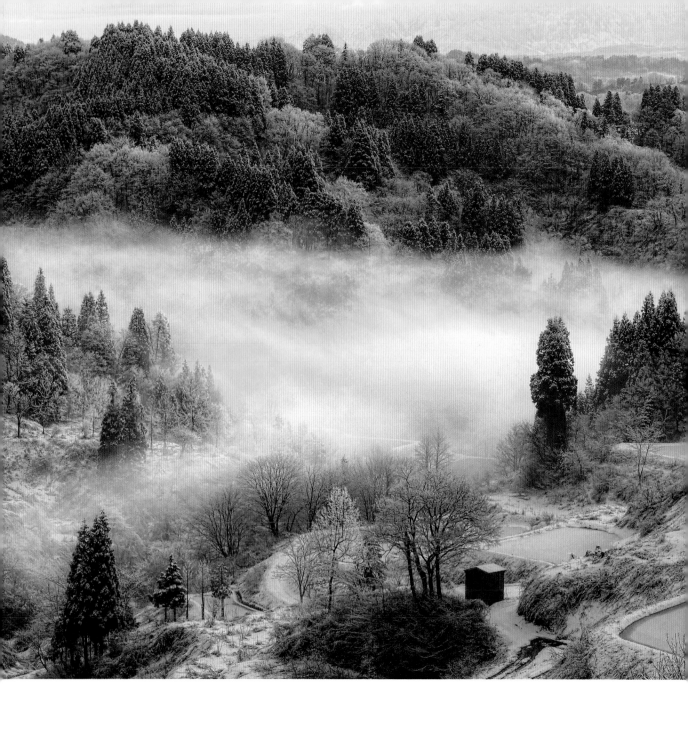

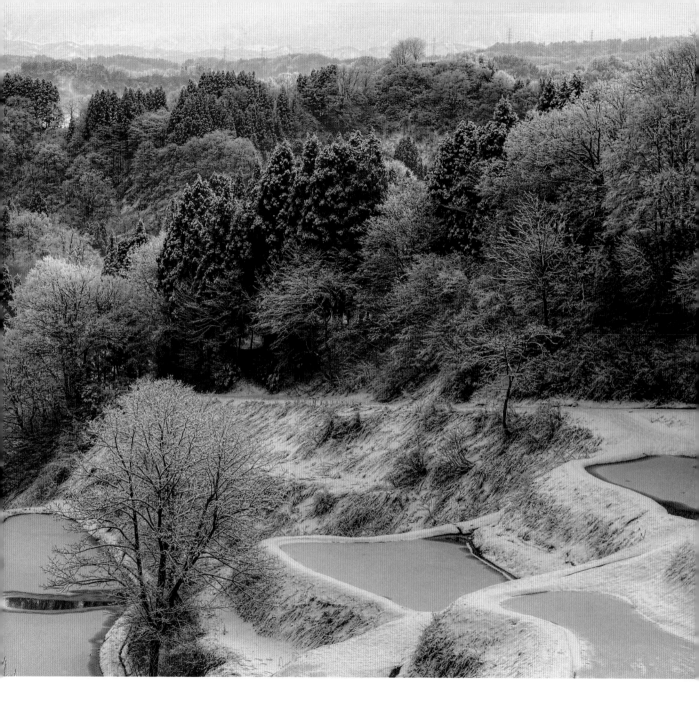

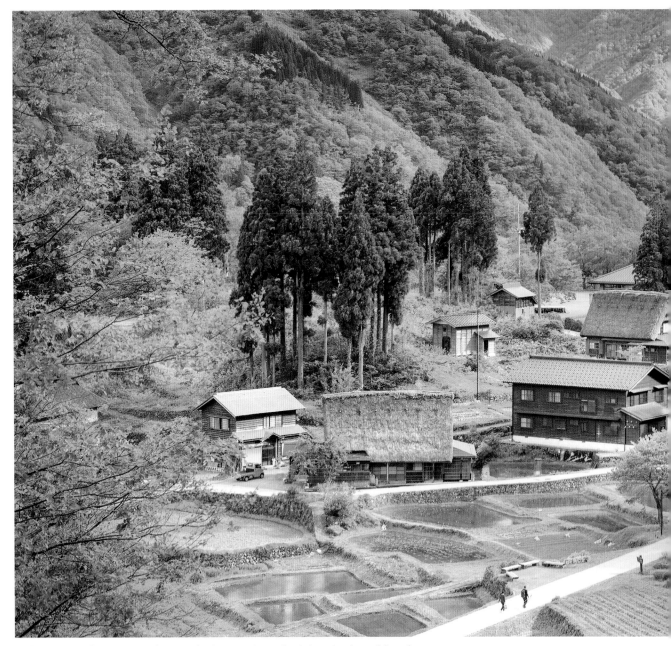

Gokoyama › The region is known for its gasshō-zukuri thatched-roof farmhouses

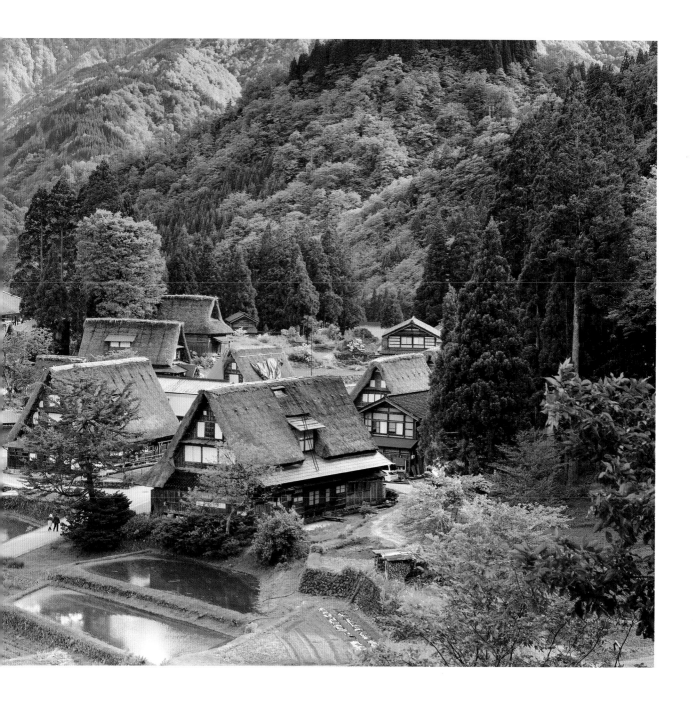

Takayama › Rickshaws cross Nakabashi bridge in the old town

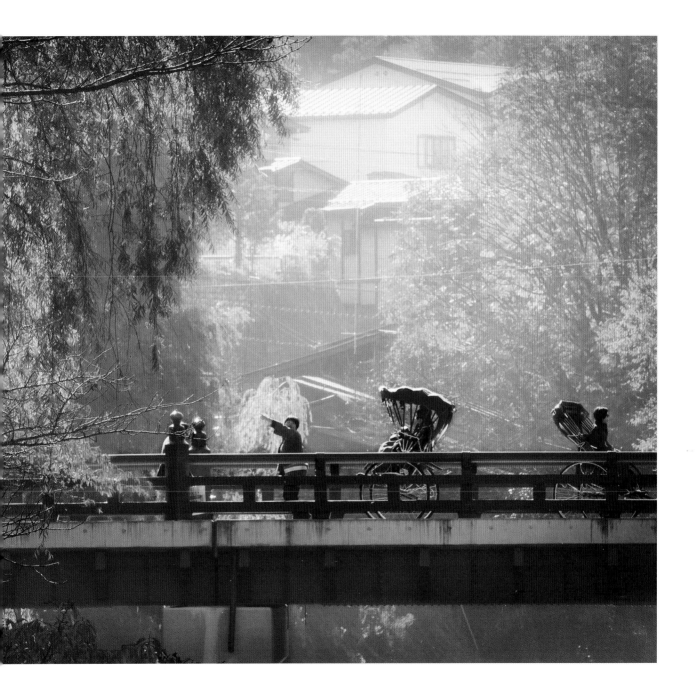

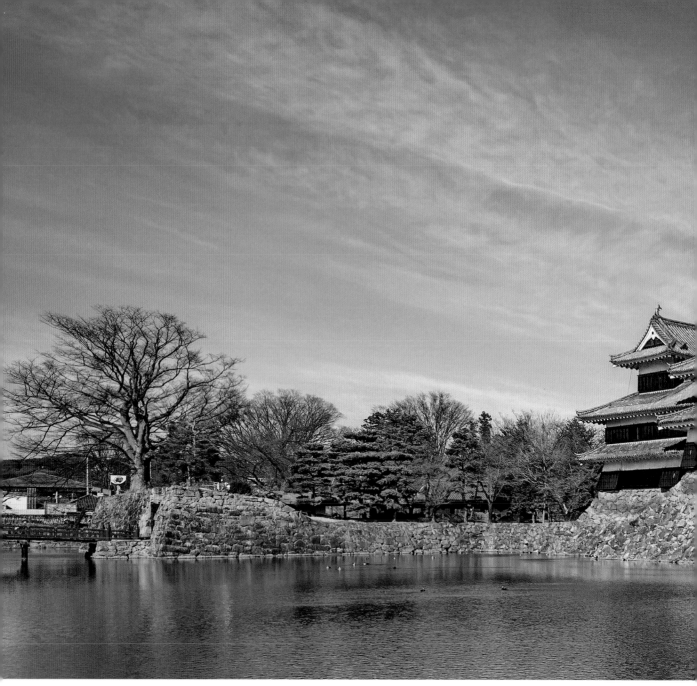

Matsumoto › The country's oldest wooden castle, Matsumoto-jō

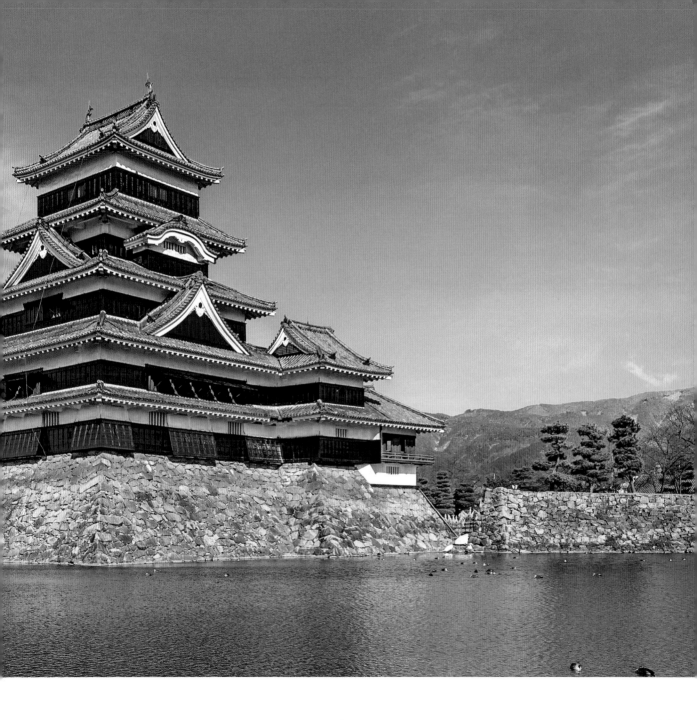

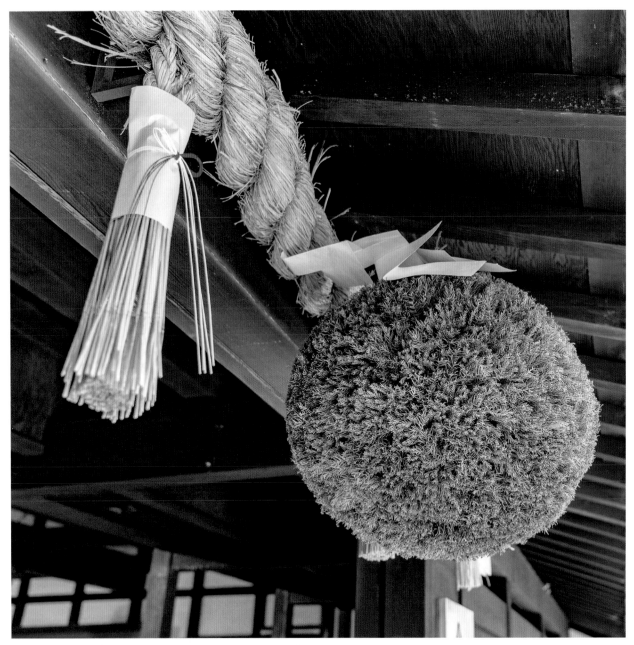

Chūbu › A ball of cedar hangs at the entrance to a sake store

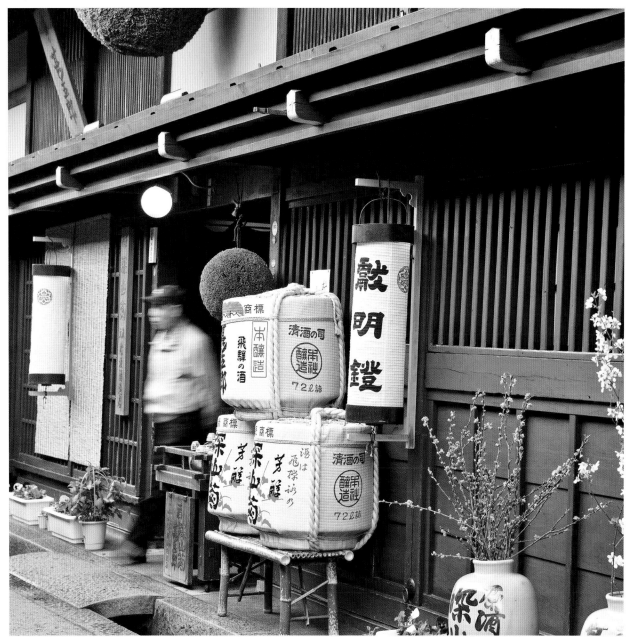

Takayama › Sake barrels outside a brewery

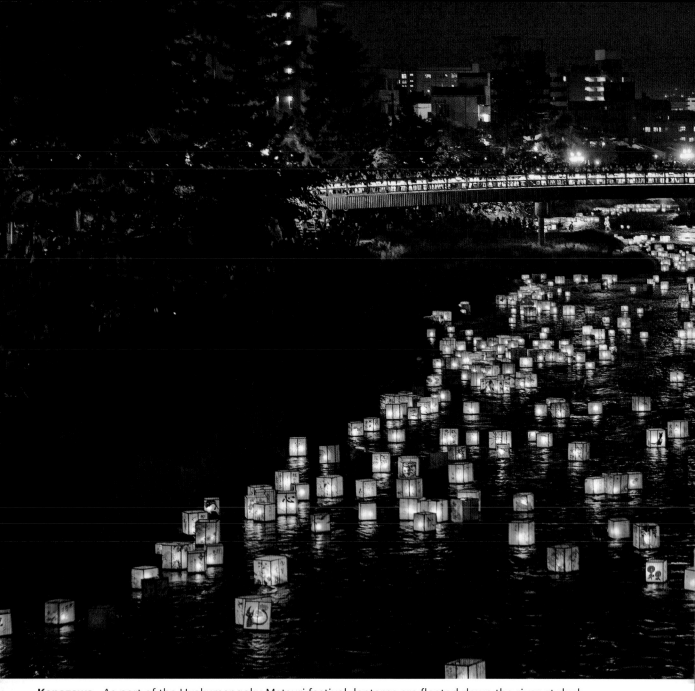

Kanazawa › As part of the Hyakumangoku Matsuri festival, lanterns are floated down the river at dusk

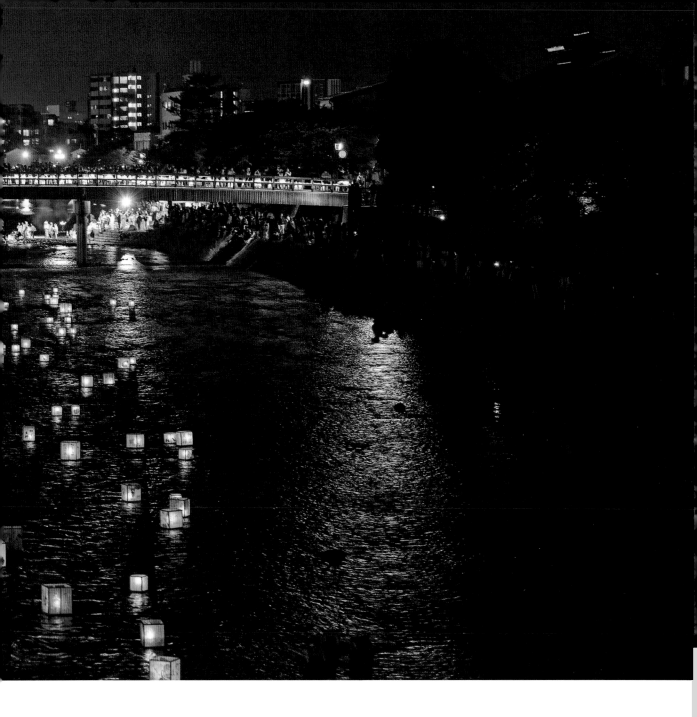

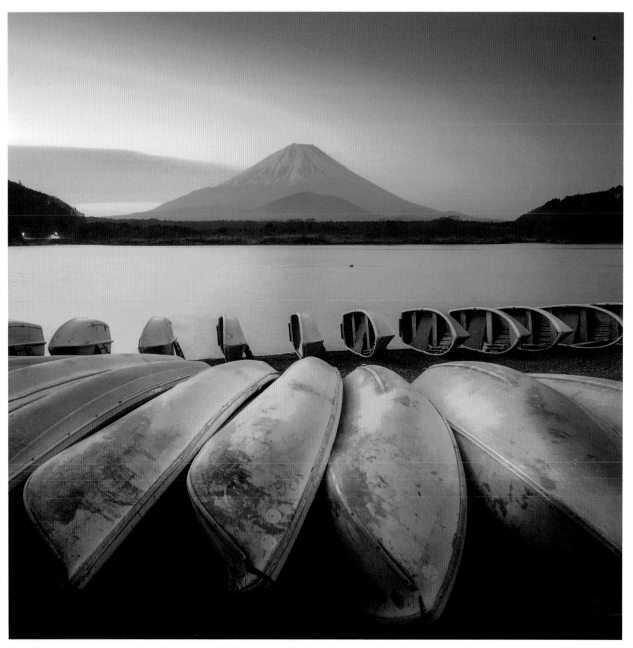

Yamanashi › Mt Fuji looms above Lake Shojiko

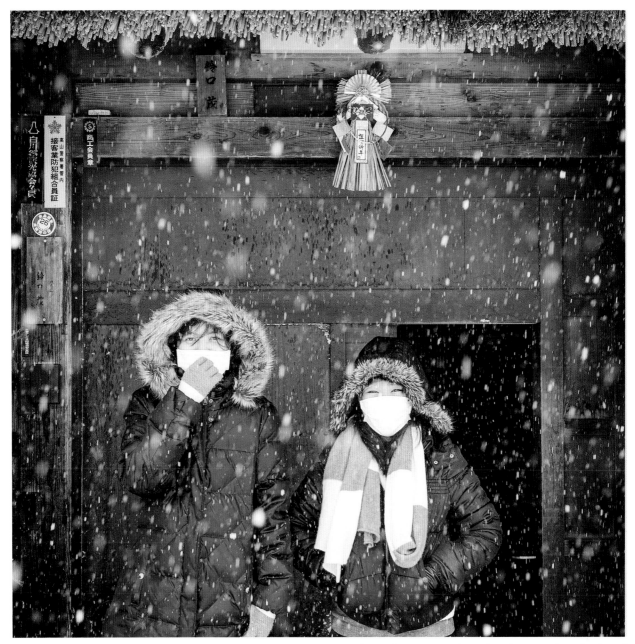

Shirakawa-gō › Sheltering from the snow under a farmhouse's thatched roof

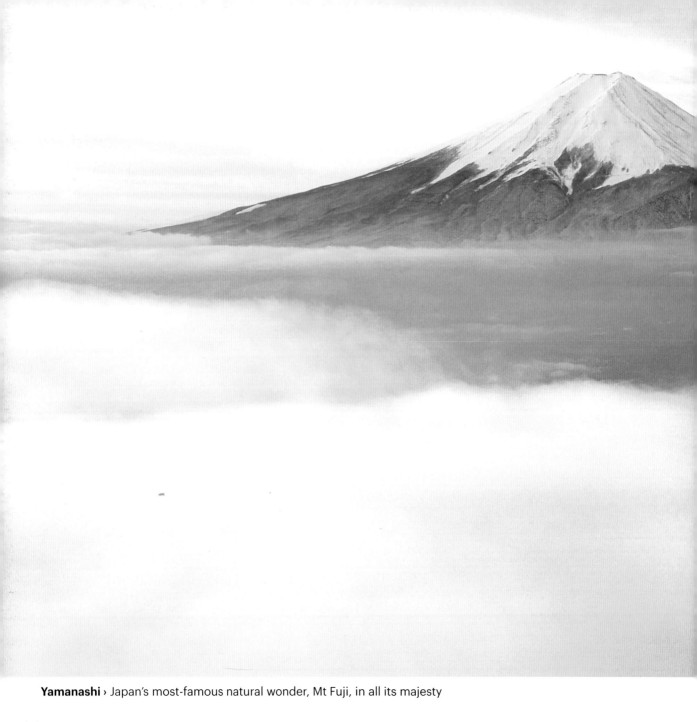

Yamanashi › Japan's most-famous natural wonder, Mt Fuji, in all its majesty

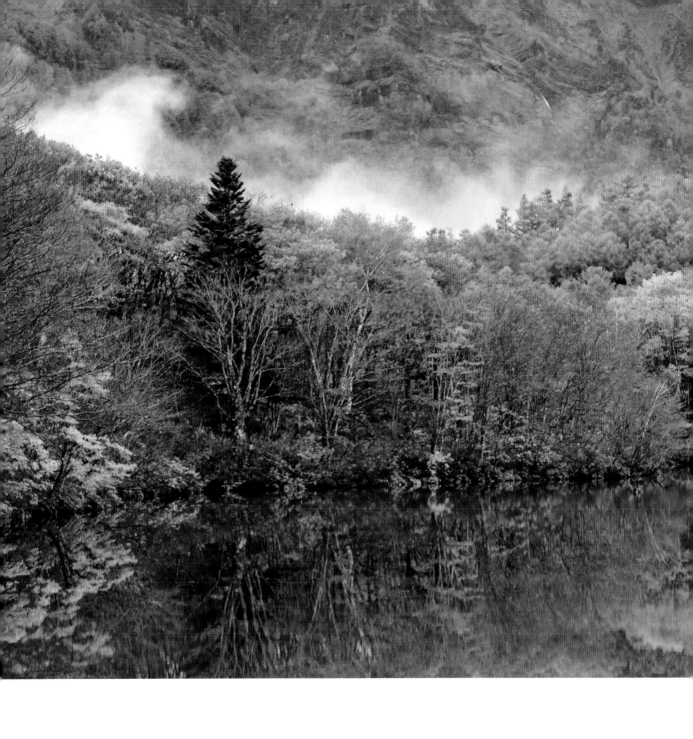

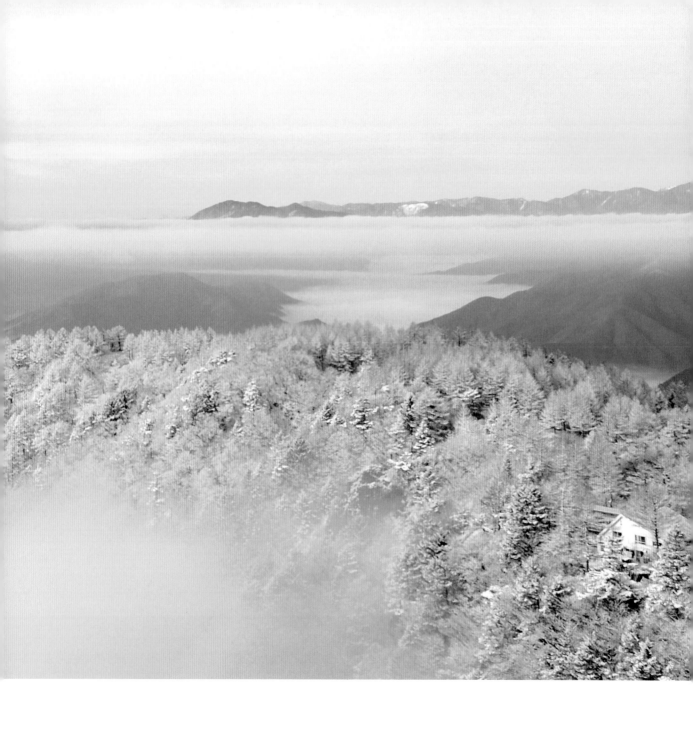

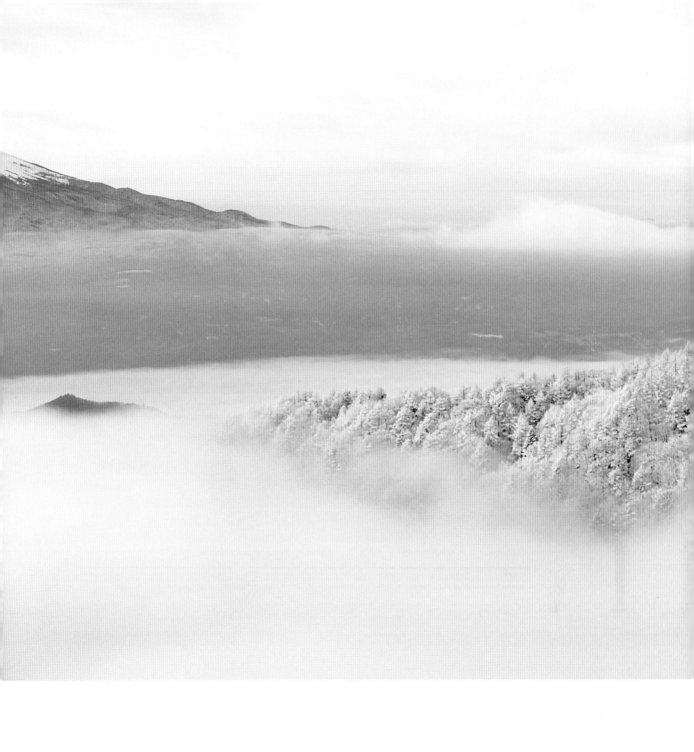

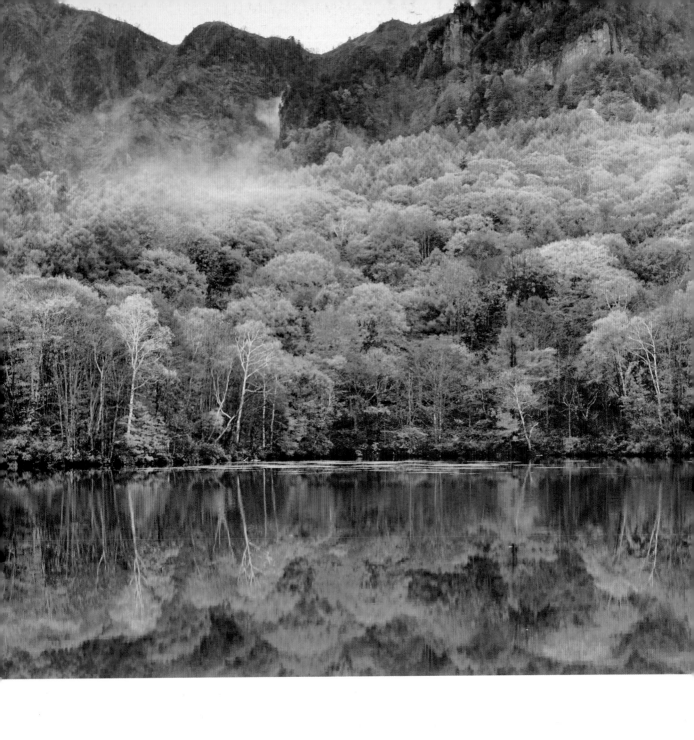

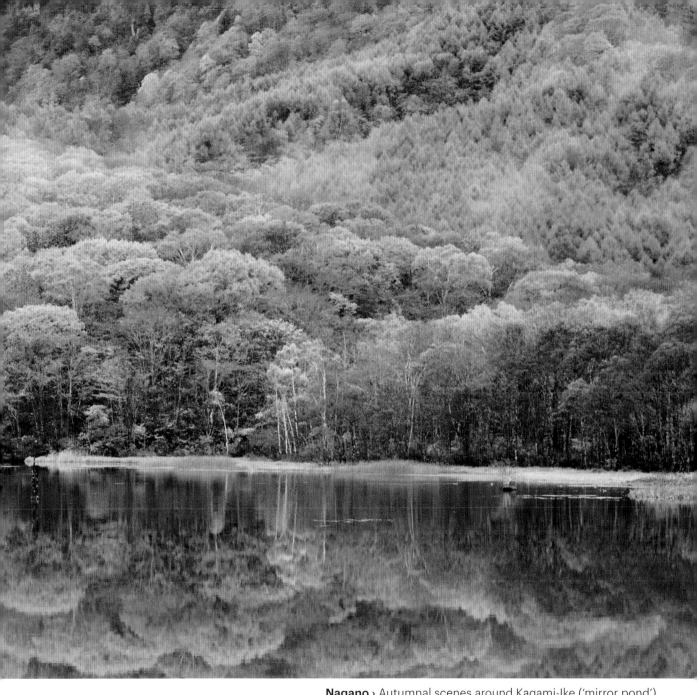

Nagano › Autumnal scenes around Kagami-Ike ('mirror pond')

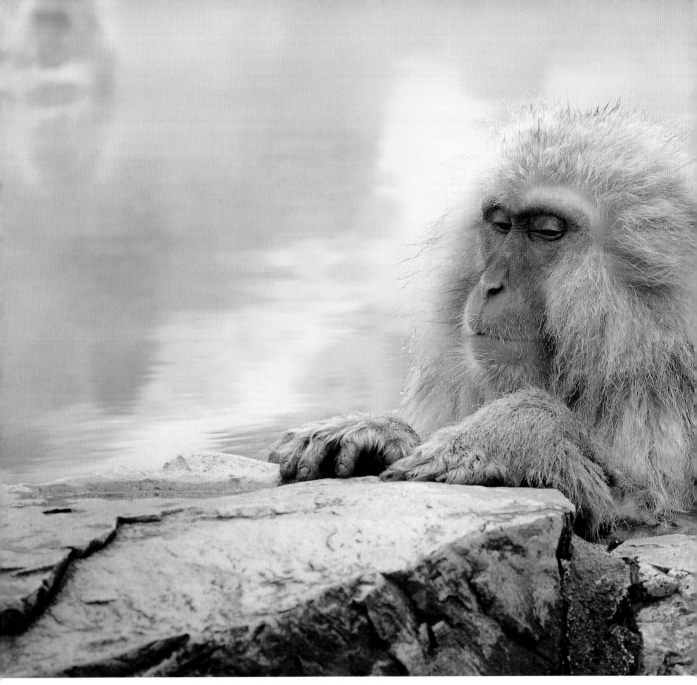

Nagano › Macaques enjoy a hot bath at Jigokudani Monkey Park

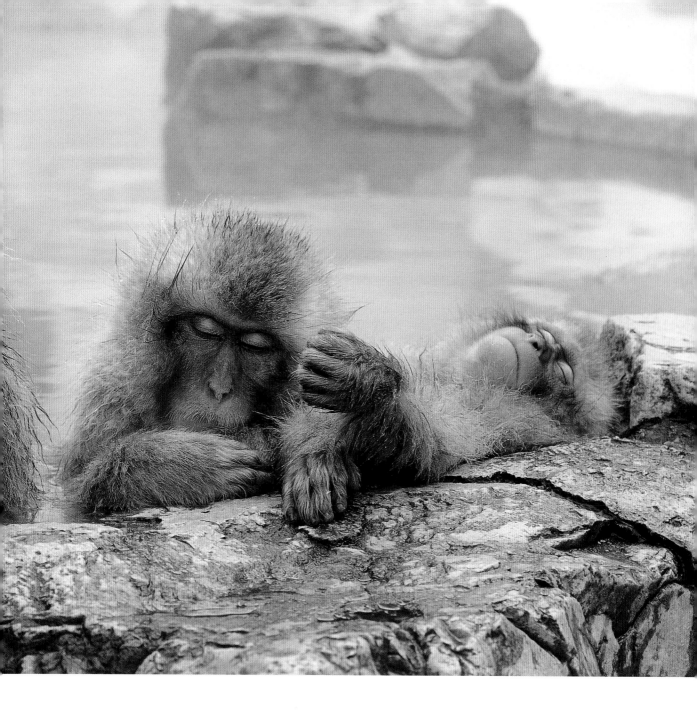

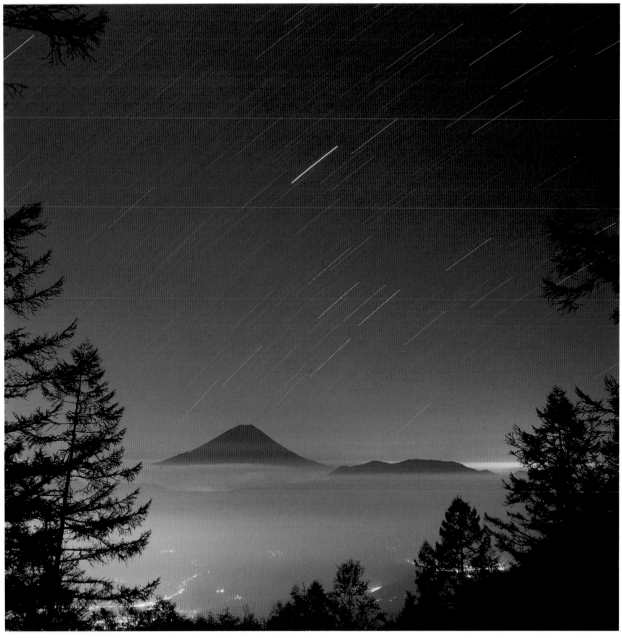

Yamanashi › Night falls on Mt Fuji's sacred 3776m summit

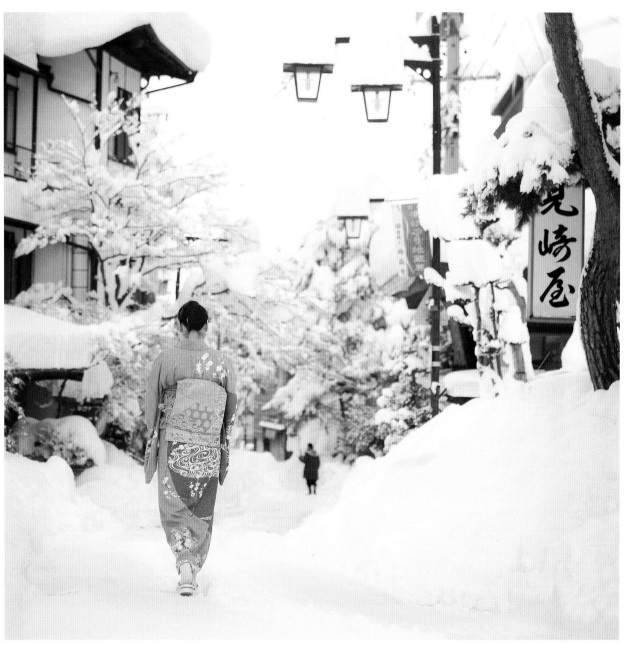

Yudanaka › A woman walks through the snow in the hot-spring resort town

Takayama › Rooms and gardens at Takayama-jinya, an Edo-period administrative complex

Toyama › Firefly squid illuminate the shoreline of Toyama Bay

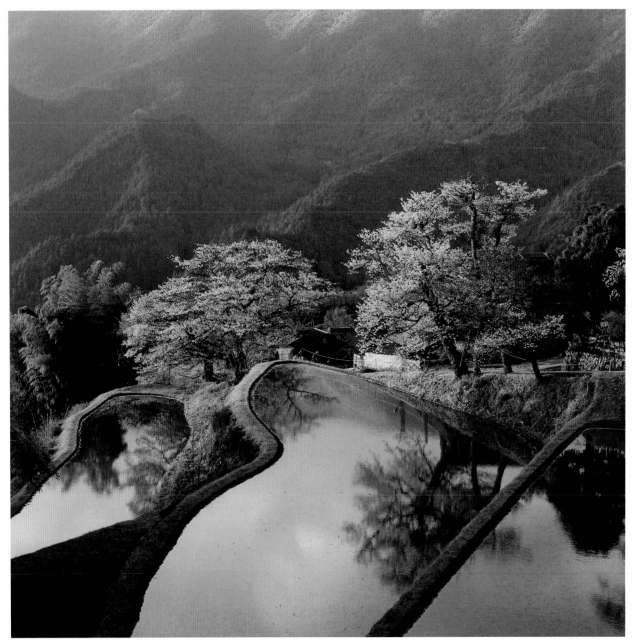

Mie › Autumnal shades aside the Maruyama Senmaida rice terraces

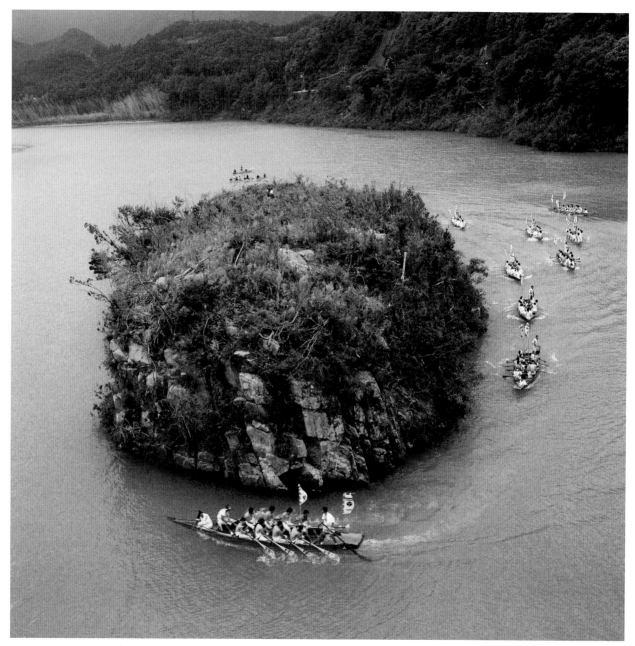

Wakayama › Ceremonial boats compete in the Mifune-matsuri festival on the Kumano-gawa river

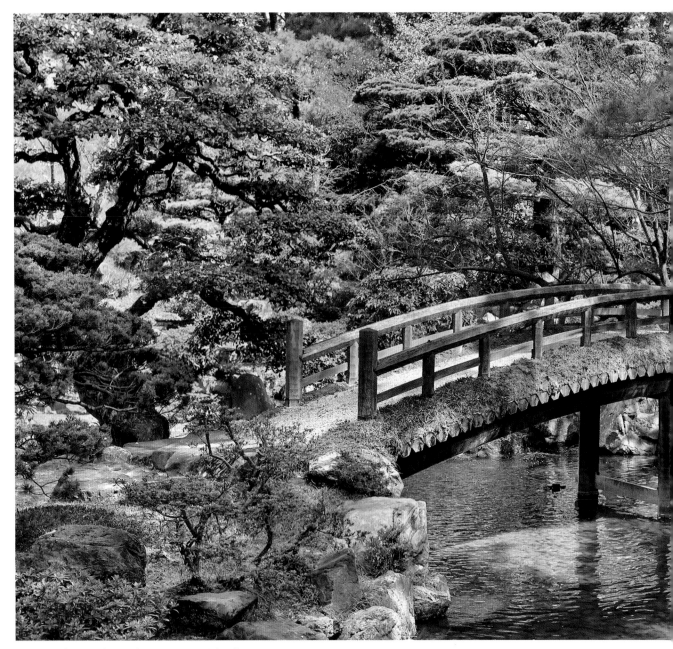

Kyoto › The gardens of Kyoto Imperial Palace

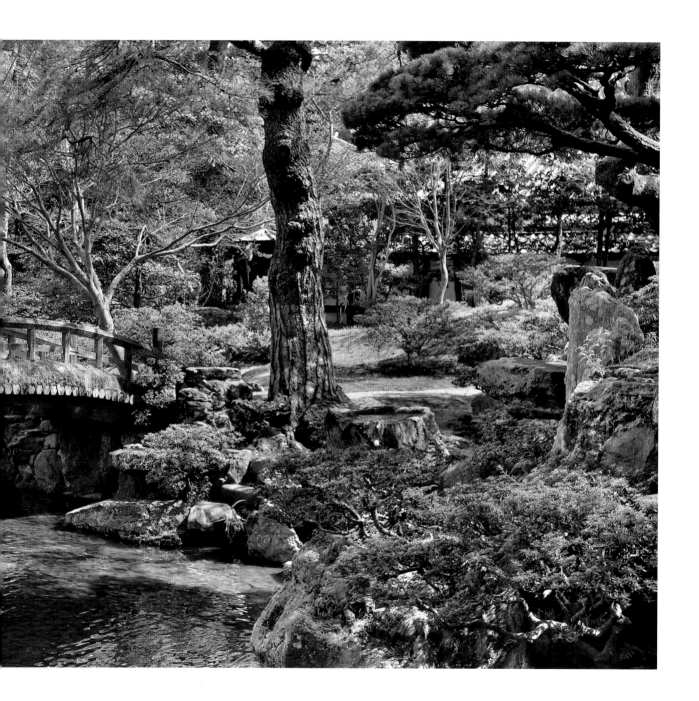

Kyoto › The 8th-century Kiyomizu-dera temple, a Unesco World Heritage Site

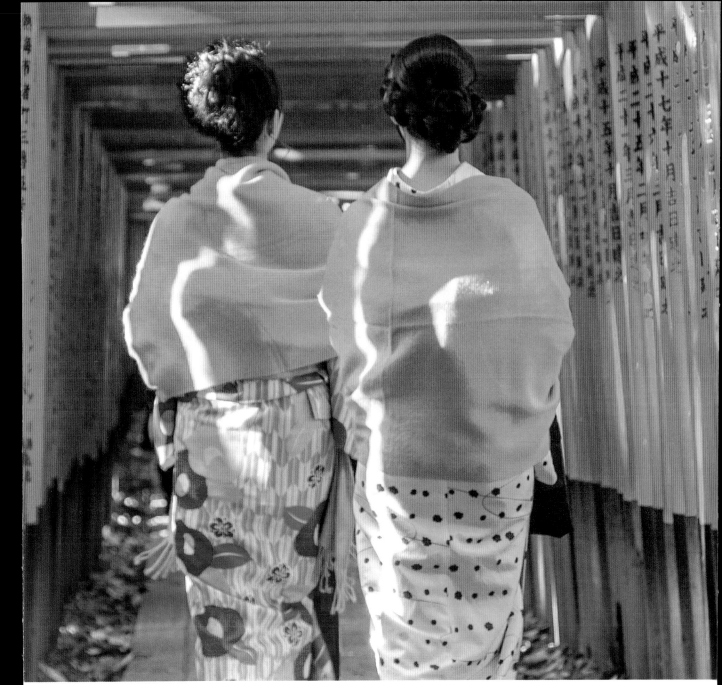

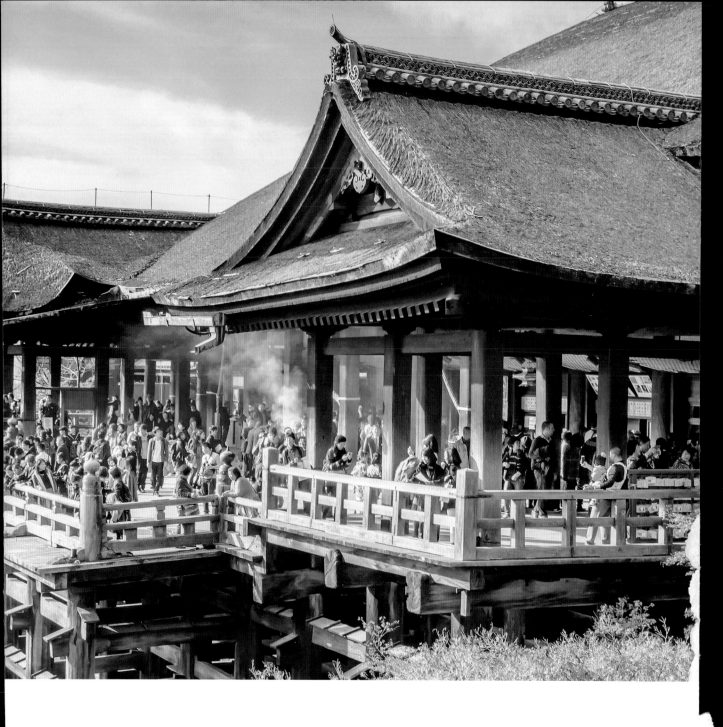

Kyoto › Two geishas walk among the numerous red torii at Fushimi Inari-Taisha

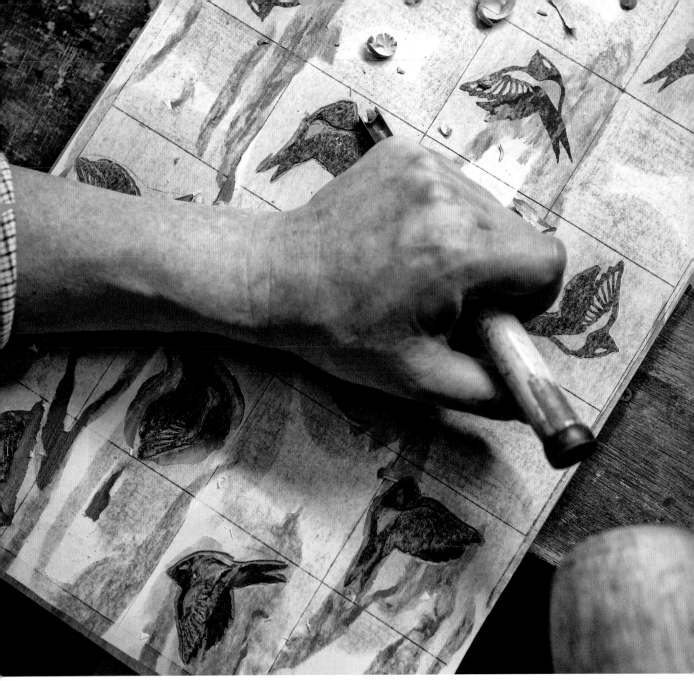

Kyoto › Chiselling a bird design into woodblock at Takezasa-do workshop; the print is then peeled off (right)

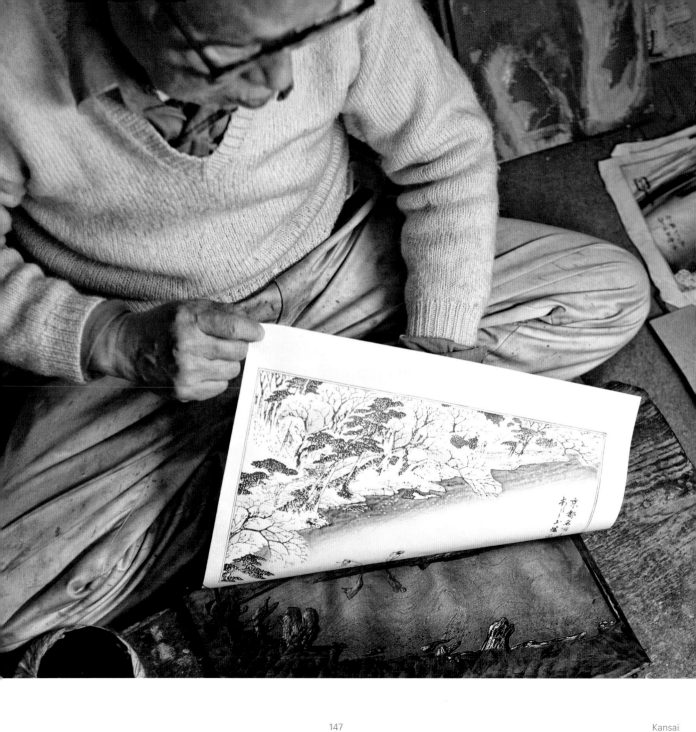

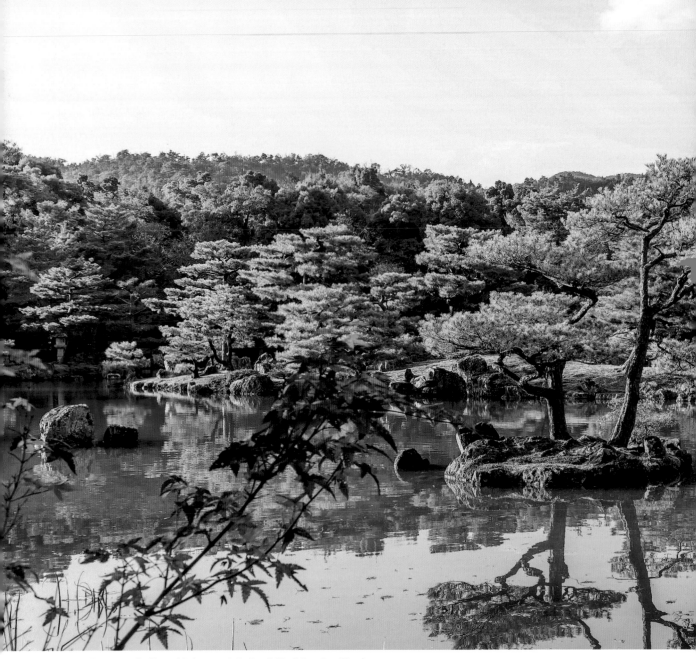

Kyoto › The main hall and lake at Kinkaku-ji (Golden Pavilion)

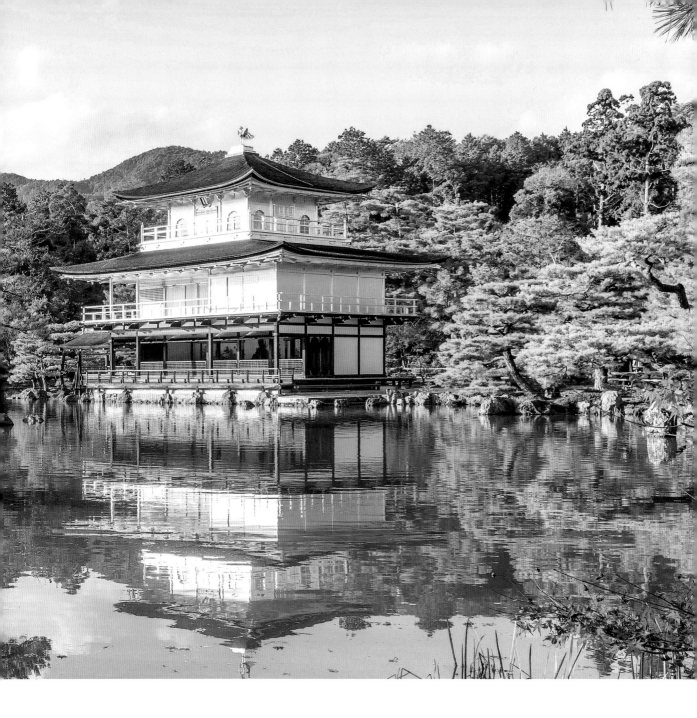

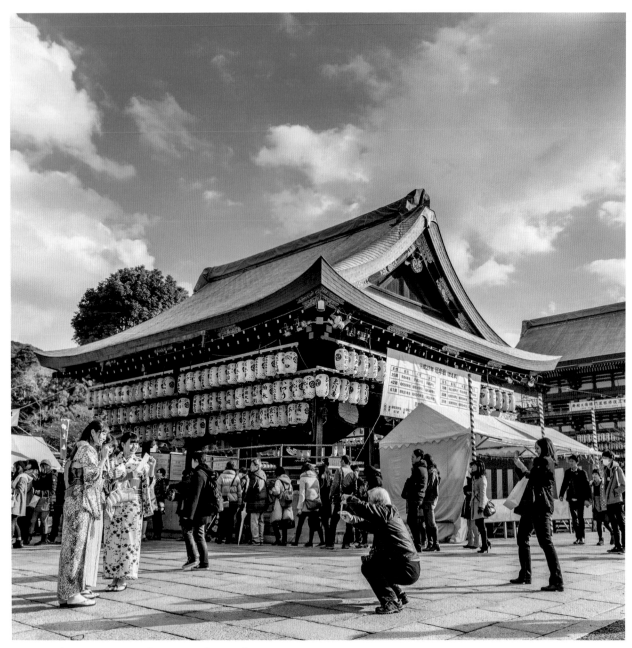

Kyoto › Photo-ops at Yasaka-jinja in the geisha quarter, Gion

Kyoto › Torii at the entrance of Kamigamo-jinja, also a Unesco-listed shrine

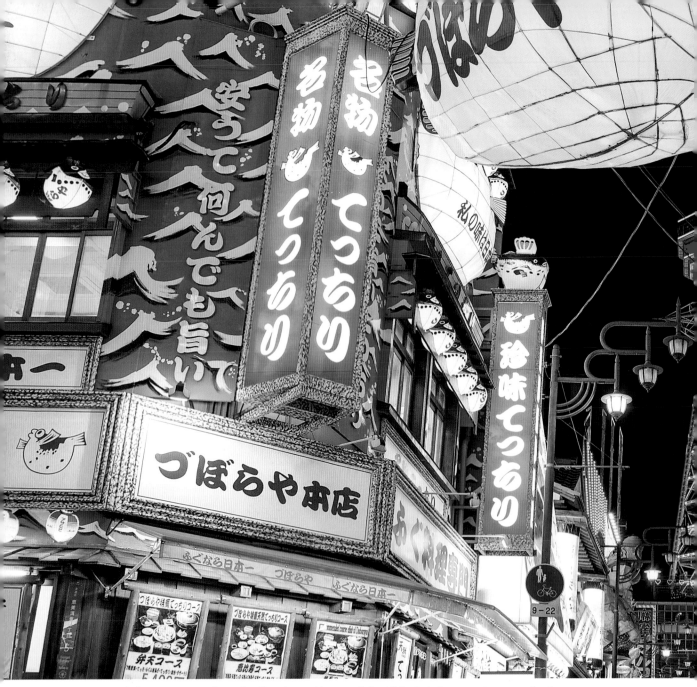

Osaka › Tsūten-kaku tower stands at the illuminated heart of the Shin-Sekai entertainment district

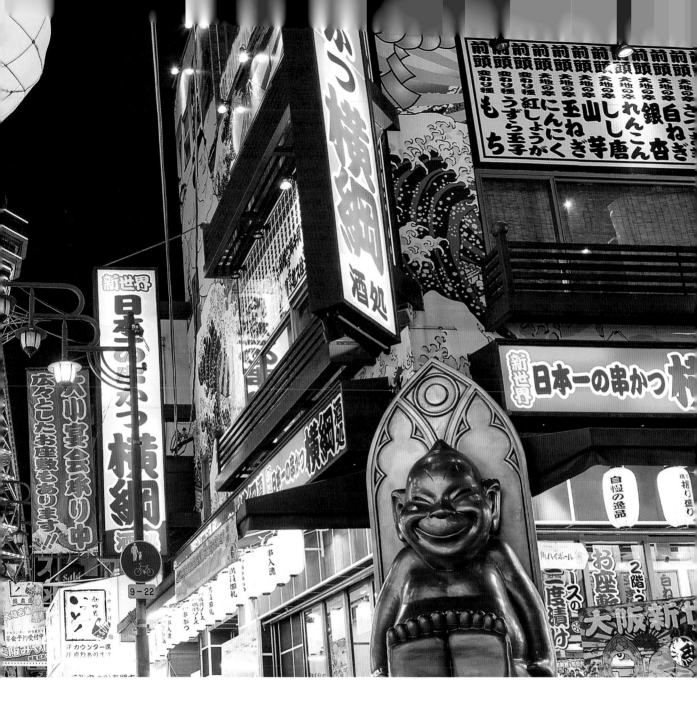

Kyoto › Wooden teahouses line Hanami-kōji, the main avenue in the Gion geisha district

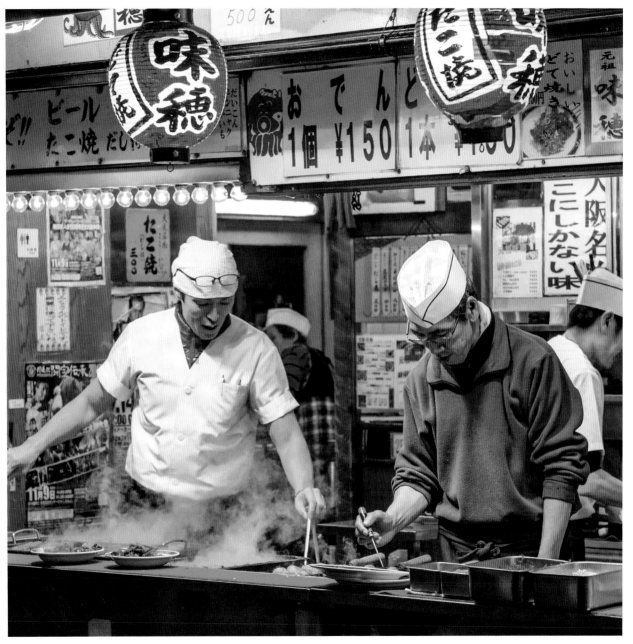

Osaka › Dishing up one of the city's many sizzling street-food specialities

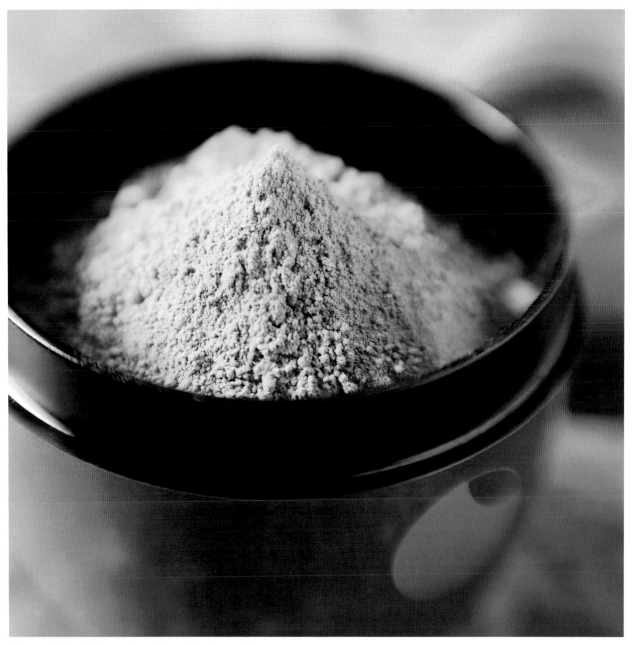

Kyoto › A bowl of powdered matcha for use in a tea ceremony

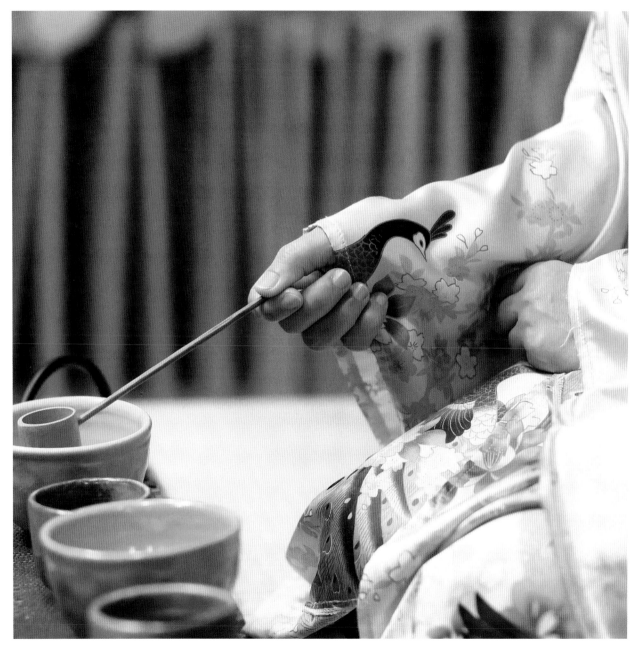

Kyoto › The city's tea ceremonies require strict adherence to ritual

Kansai

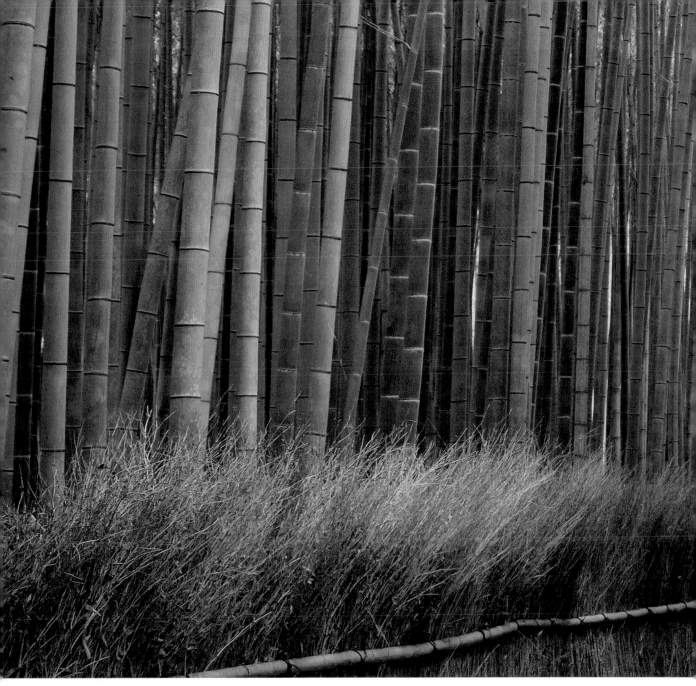

Kyoto › Arashiyama bamboo grove

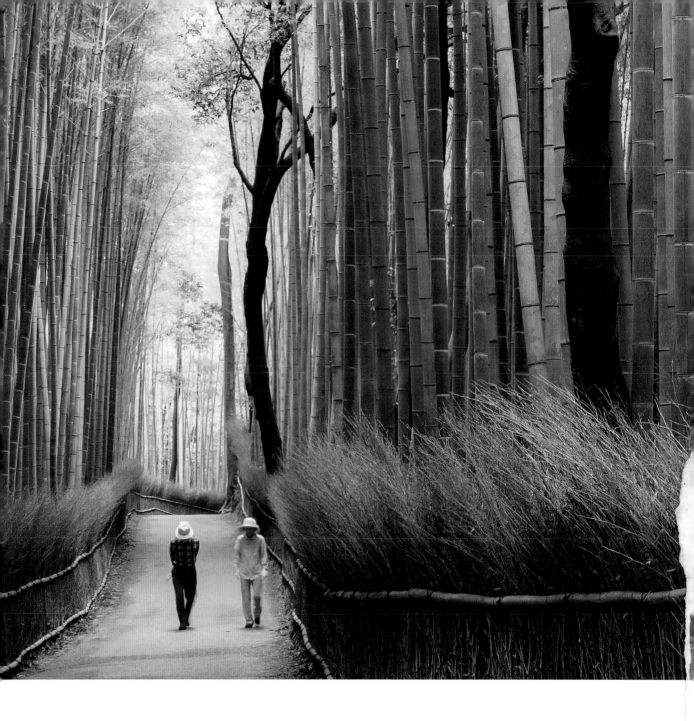

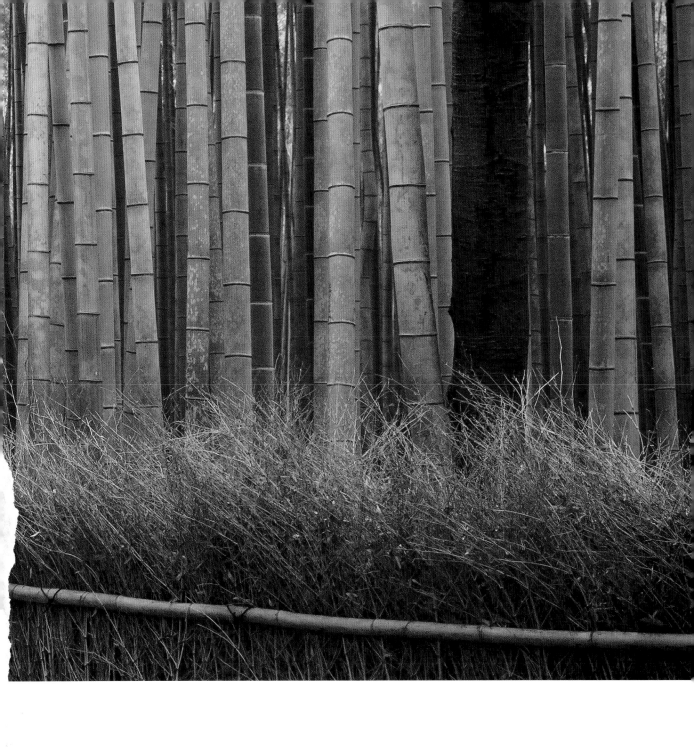

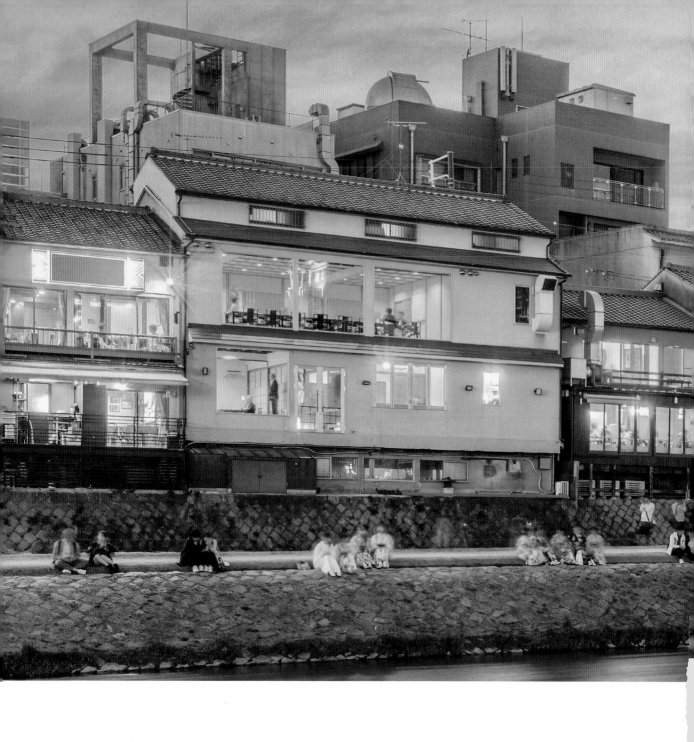

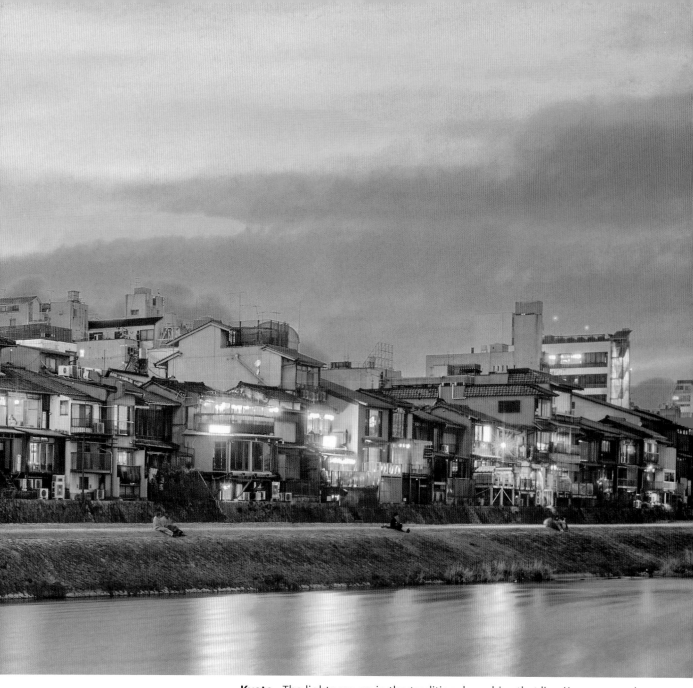

Kyoto › The lights are on in the traditional machiya that line Kamo-gawa river

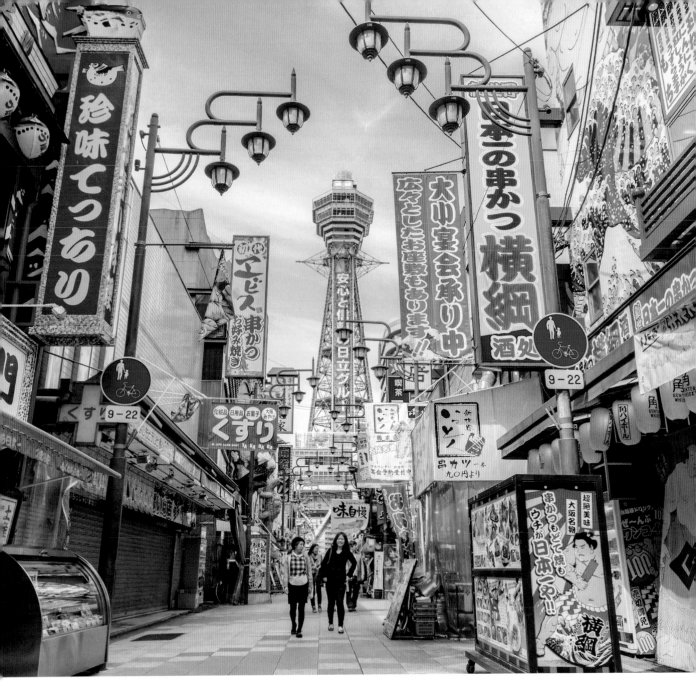

Osaka › Eating and drinking establishments populate the Shin-Sekai district

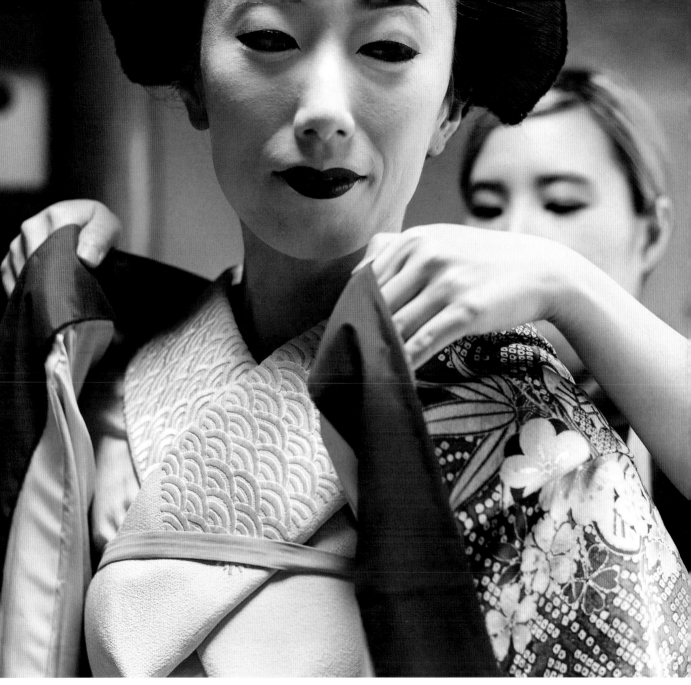

Kyoto › A geisha is dressed in the traditional style

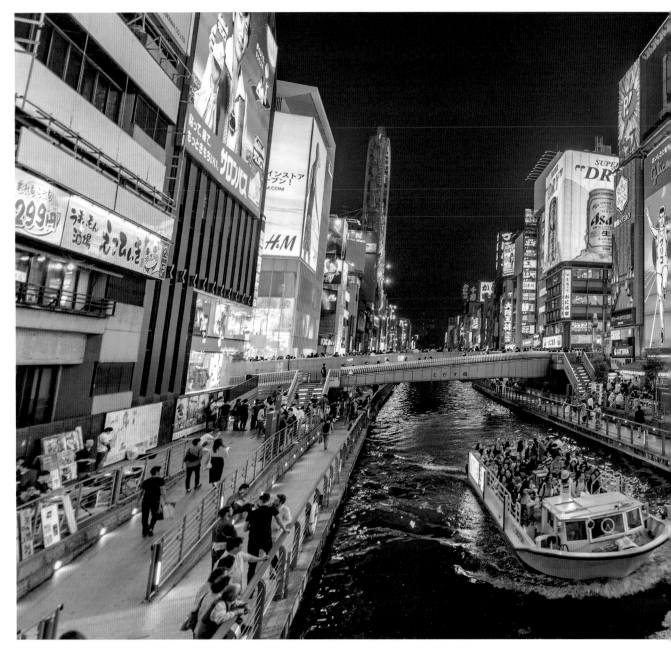

Osaka › Visitors enjoy the Dōtombori canal, which bisects the area's neon-lit nightlife

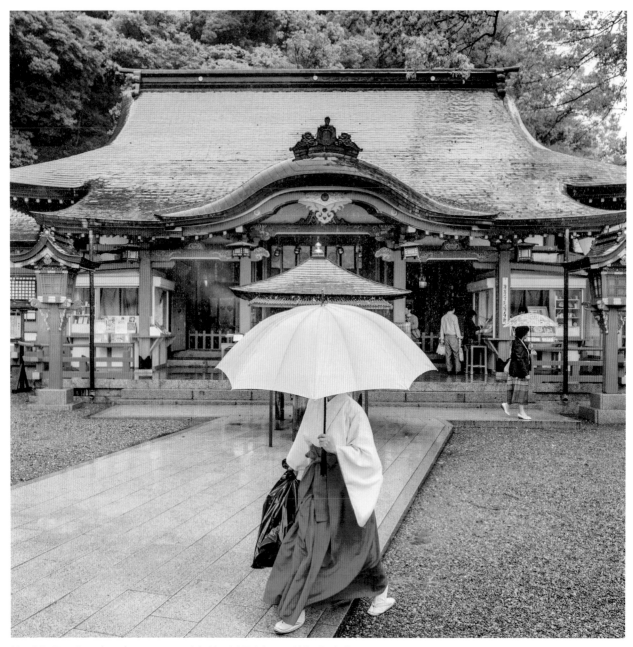

Nachi › Braving the elements to visit Nachi Taisha, a Shintō shrine

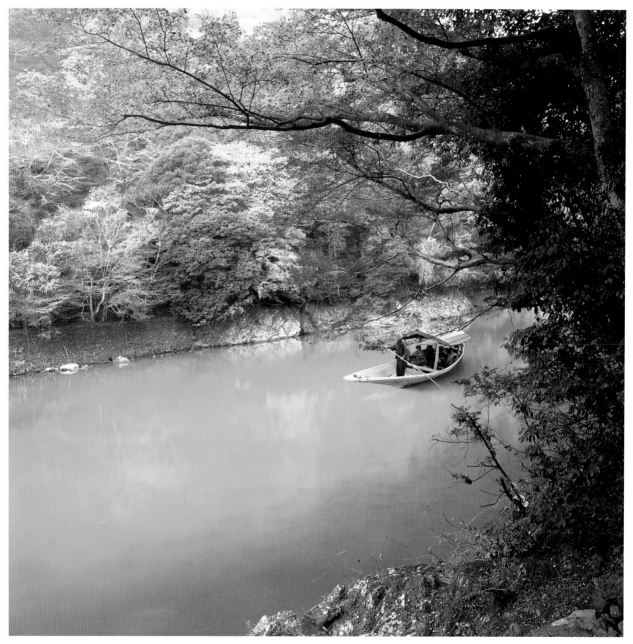

Kyoto › A boatman uses a bamboo pole to punt along the Katsura river through Arashiyama

Kansai

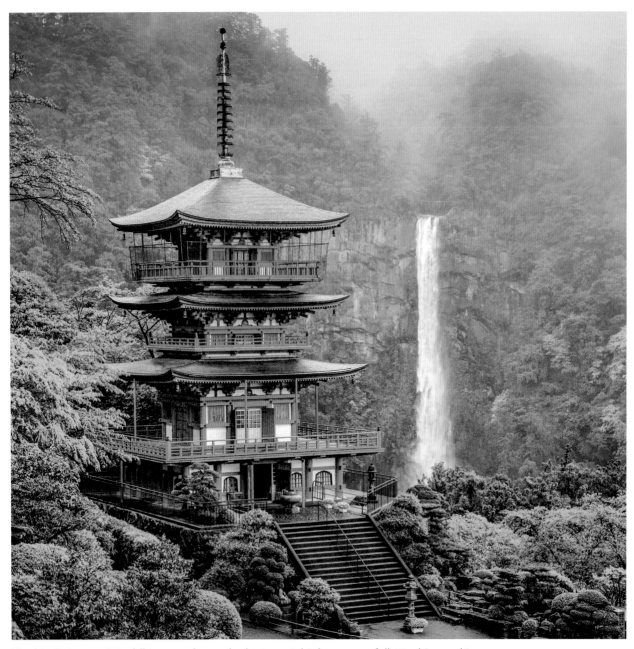

Nachi › Seiganto-ji Buddhist temple overlooks Japan's highest waterfall, Nachi-no-taki

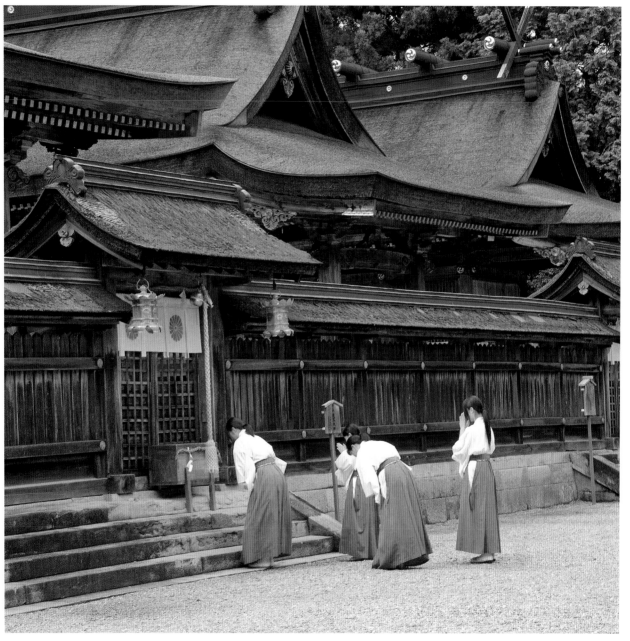

Hongū › Shrine keepers offer prayers at Kumano Hongū Taisha, one of the area's famed Shintō sites

Kansai

Kyoto › Cherry-blossom season in a city park

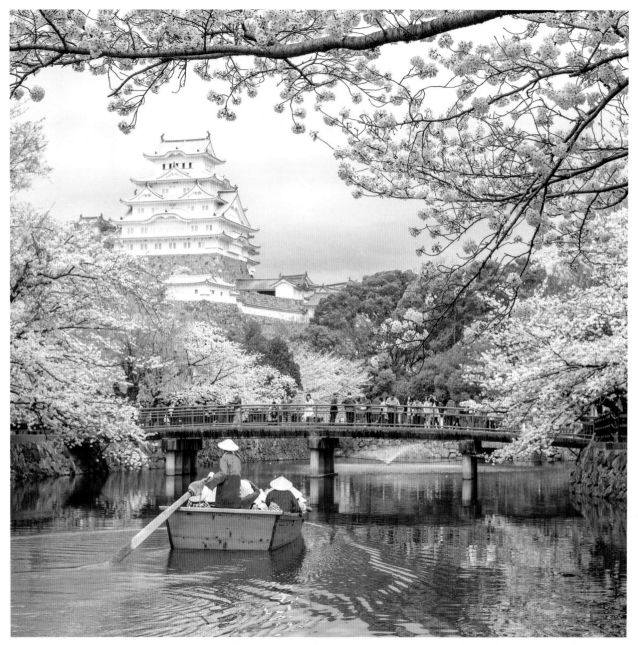

Himeji › Dubbed the 'White Heron' castle, Himeji-jō is encircled by a moat

Kyoto › Maruyama park is a popular spot to gather for parties during sakura season

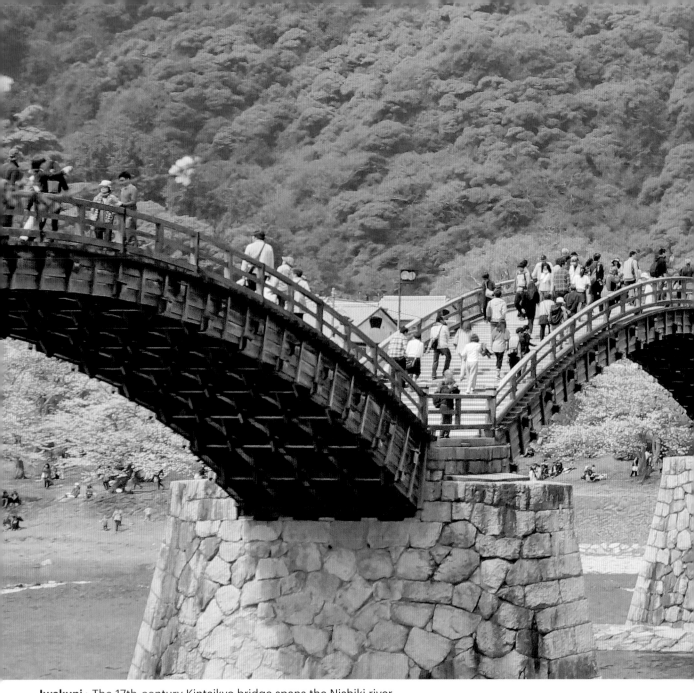

Iwakuni › The 17th-century Kintaikyo bridge spans the Nishiki river

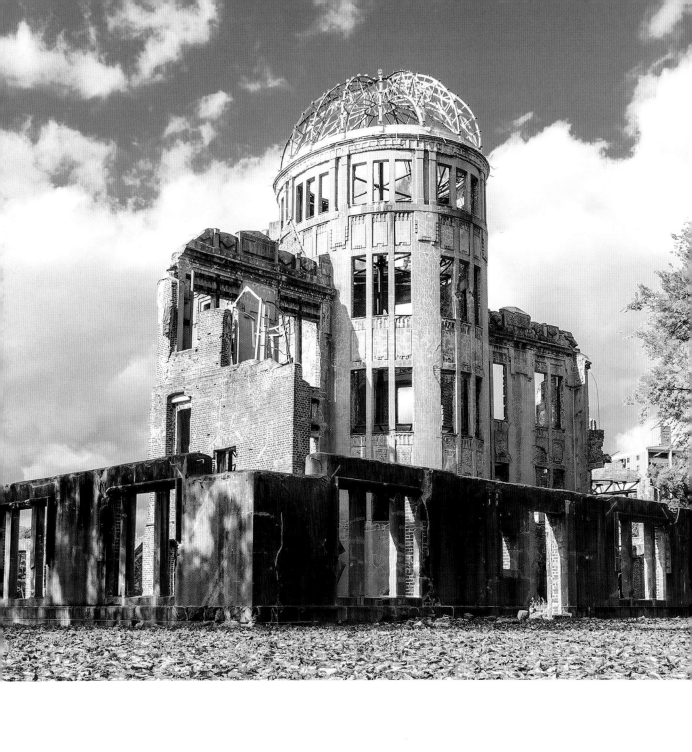

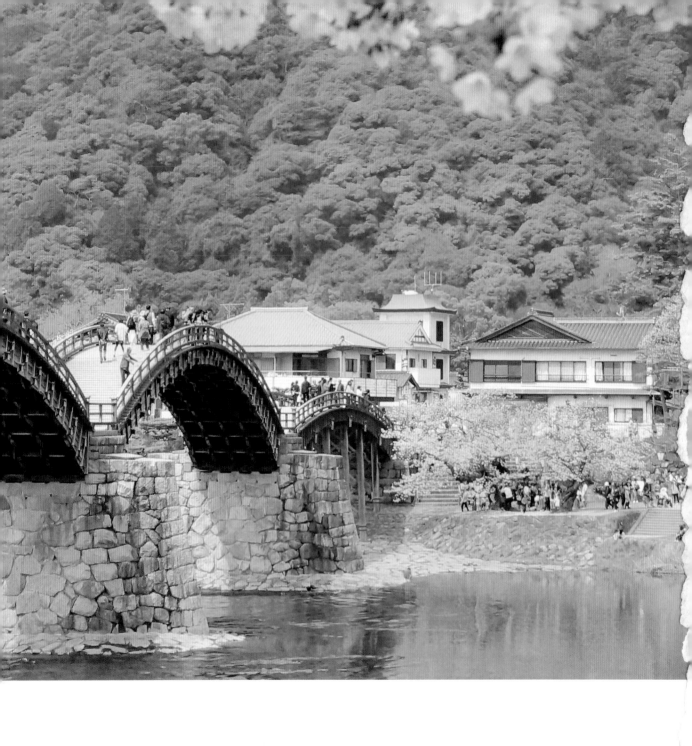

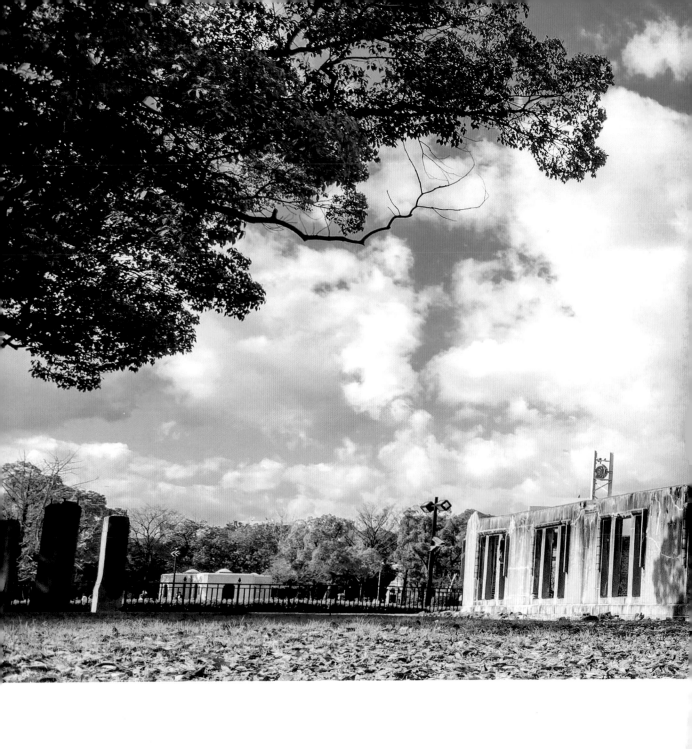

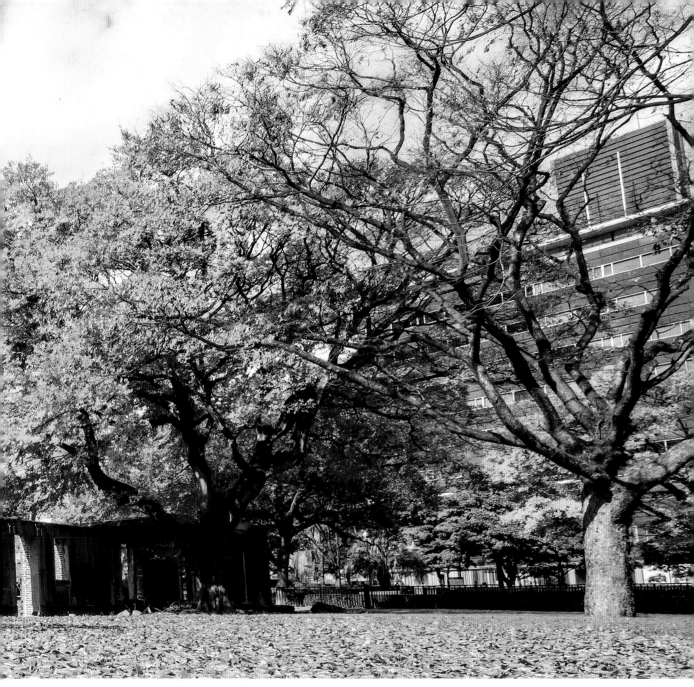

Hiroshima › The Atomic Bomb Dome stands as a memorial to the horror of 6 August 1945

Chūgoku

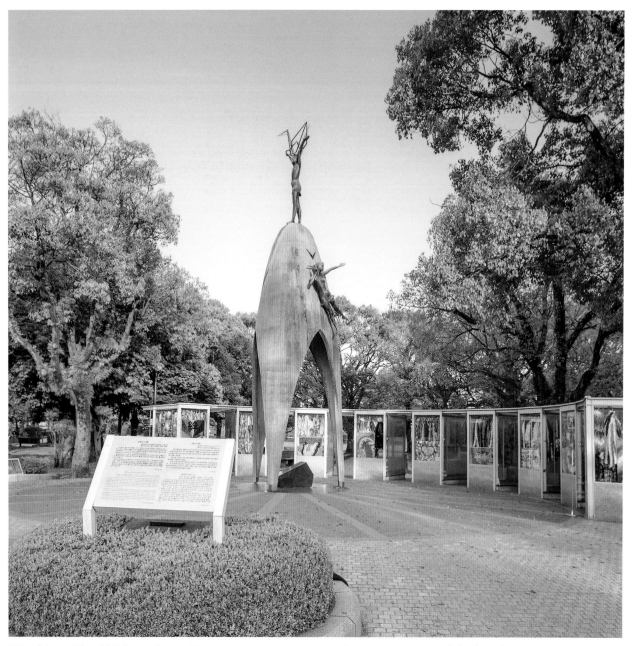

Hiroshima › The Children's Peace Monument commemorates the young victims of the bomb

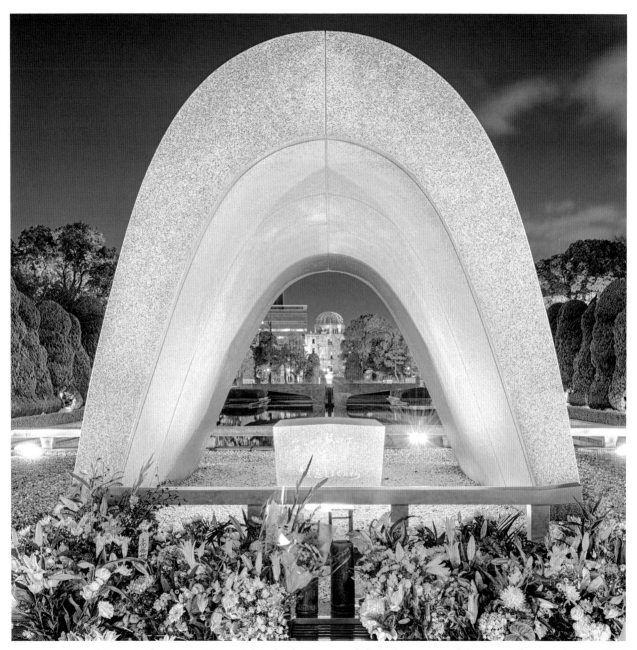

Hiroshima › In the Peace Memorial Park, the Cenotaph lists the names of the many thousands who died

Chūgoku

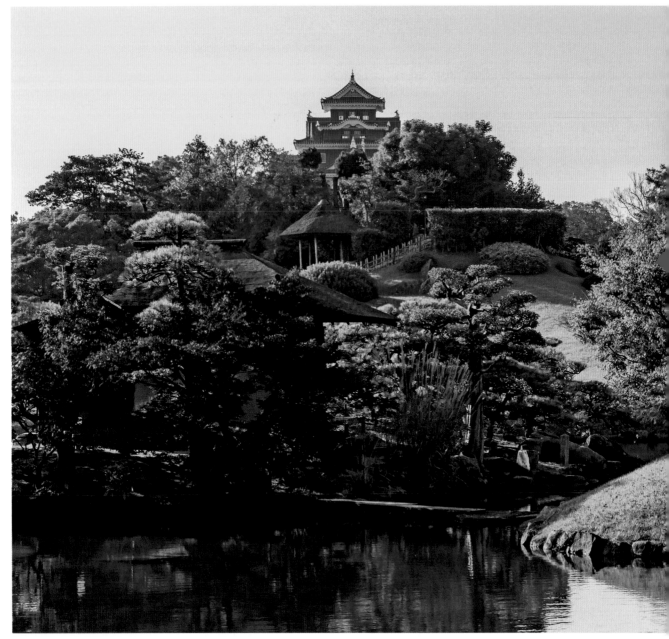

Okayama › Kōraku-en gardens in autumn

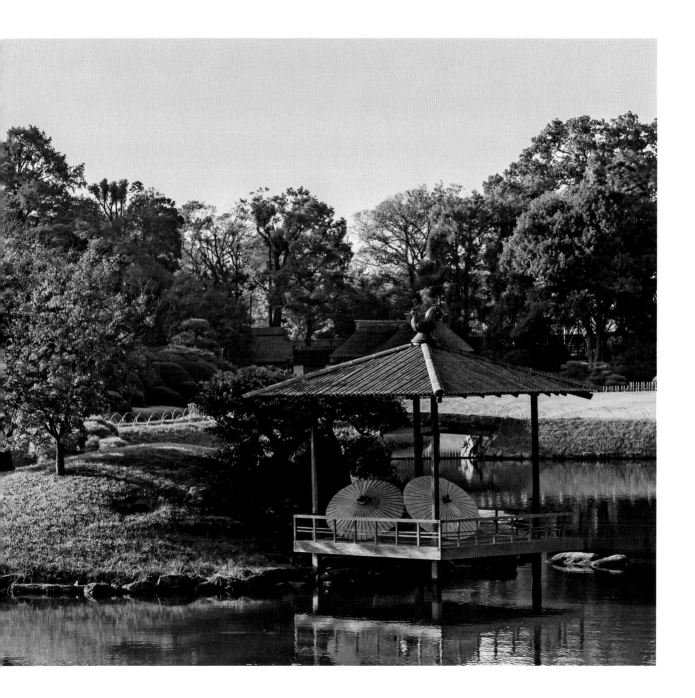

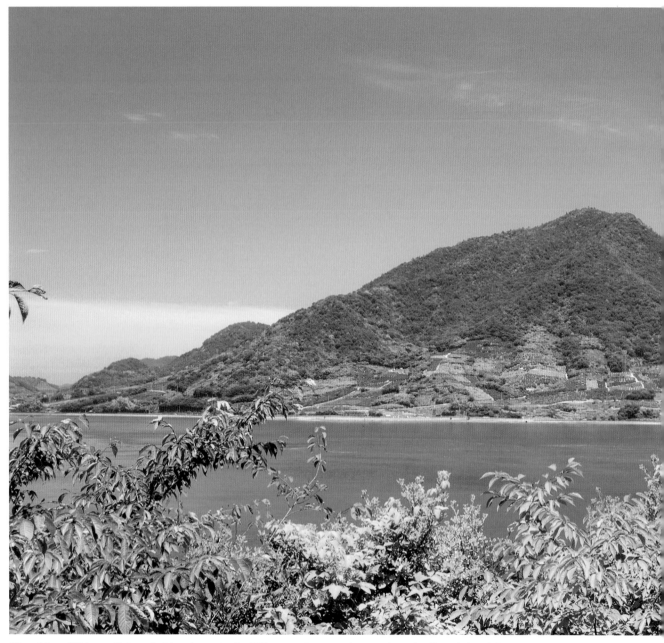

Hiroshima/Ehime › Tatara bridge is part of a 60km road network crossing the Seto Inland Sea

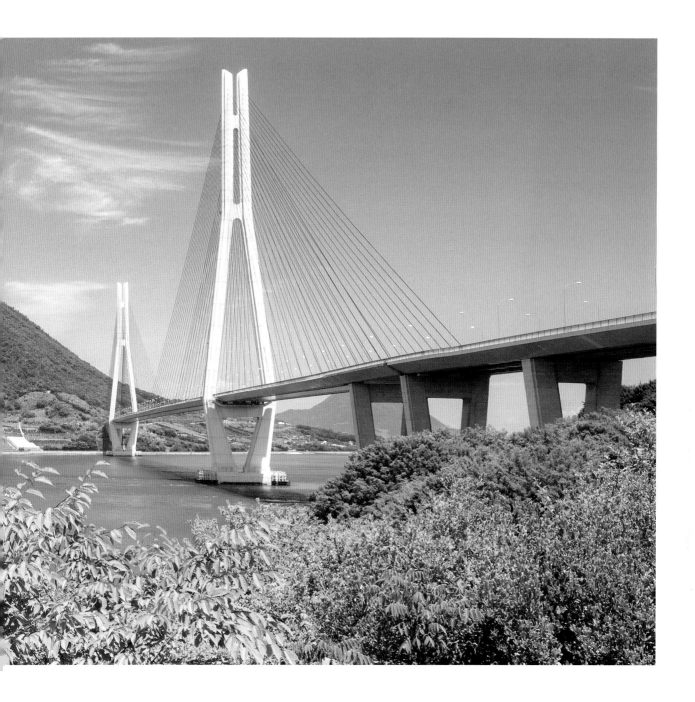

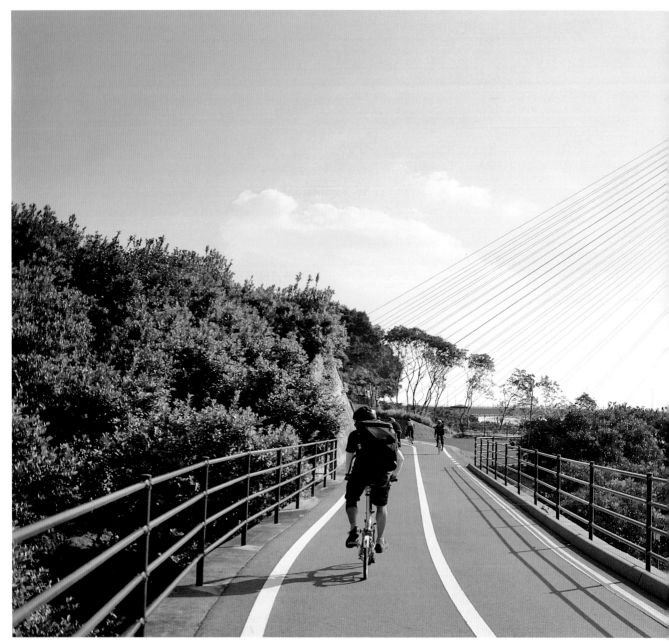

Hiroshima › Approaching Tatari bridge on one of Shimanami Kaidō's cycling trails

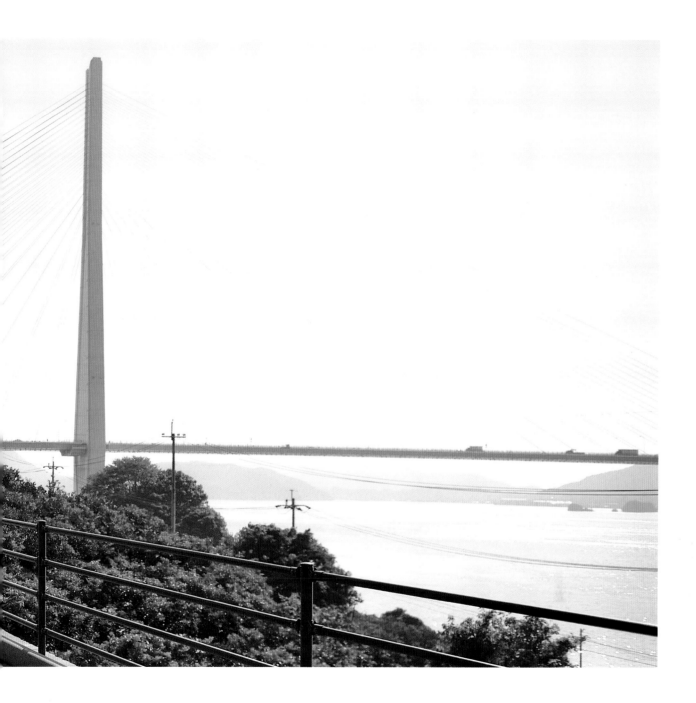

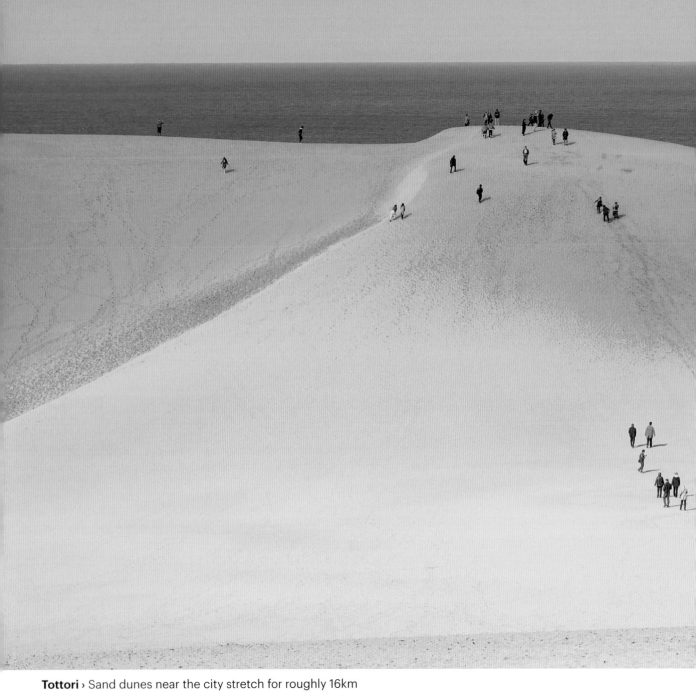

Tottori › Sand dunes near the city stretch for roughly 16km

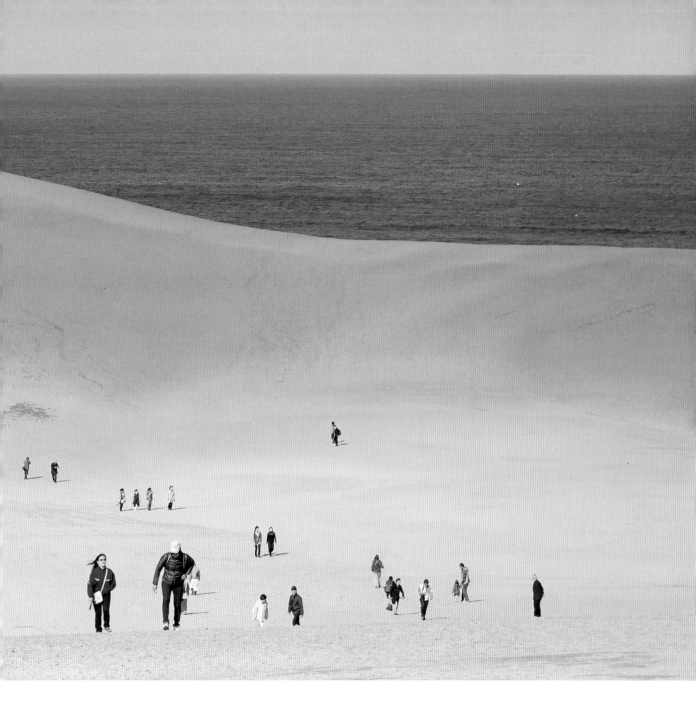

Chūgoku

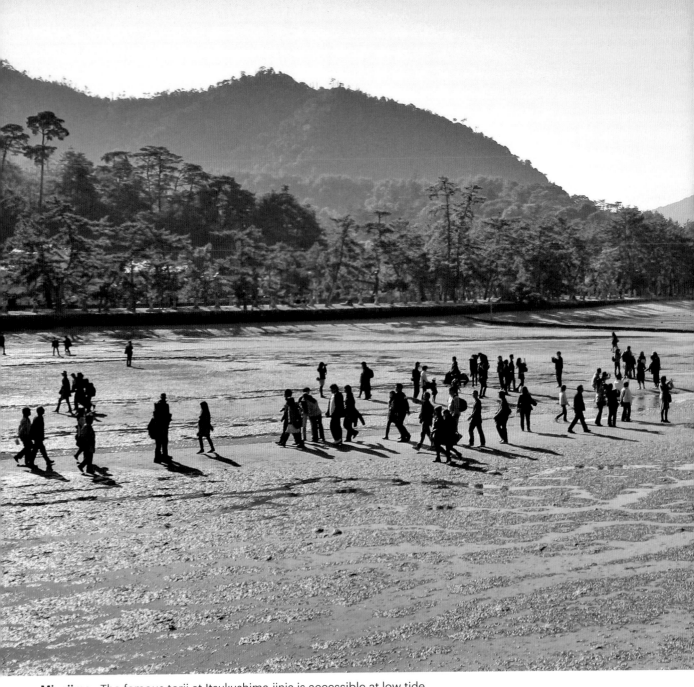

Miyajima › The famous torii at Itsukushima-jinja is accessible at low tide

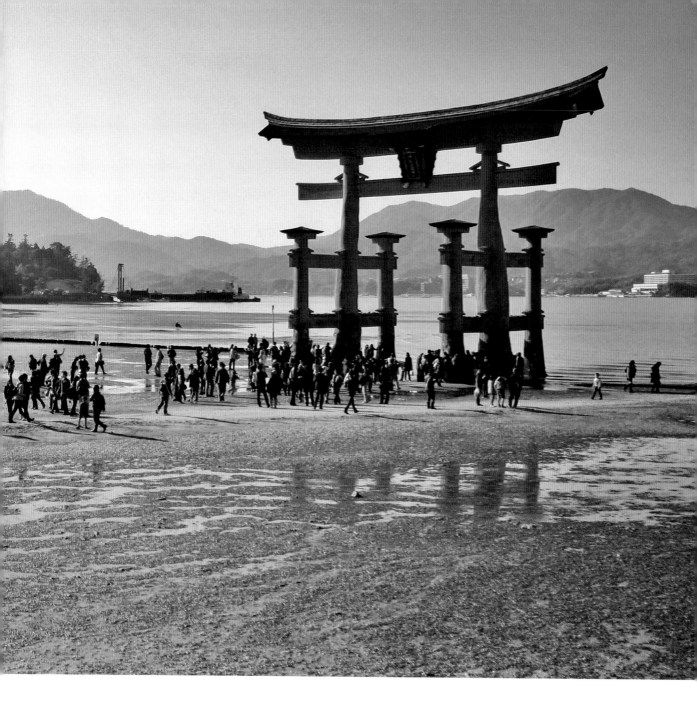

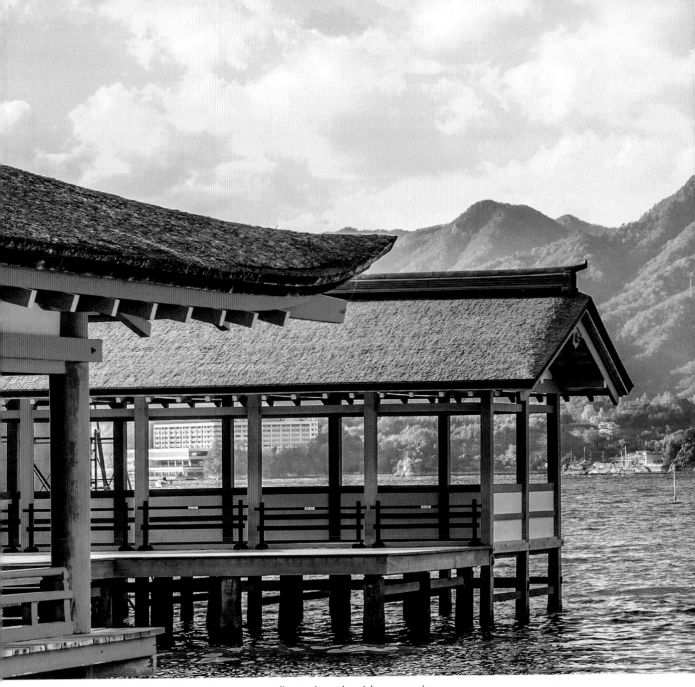

Miyajima › Itsukushima-jinja torii appears to float when the tide comes in

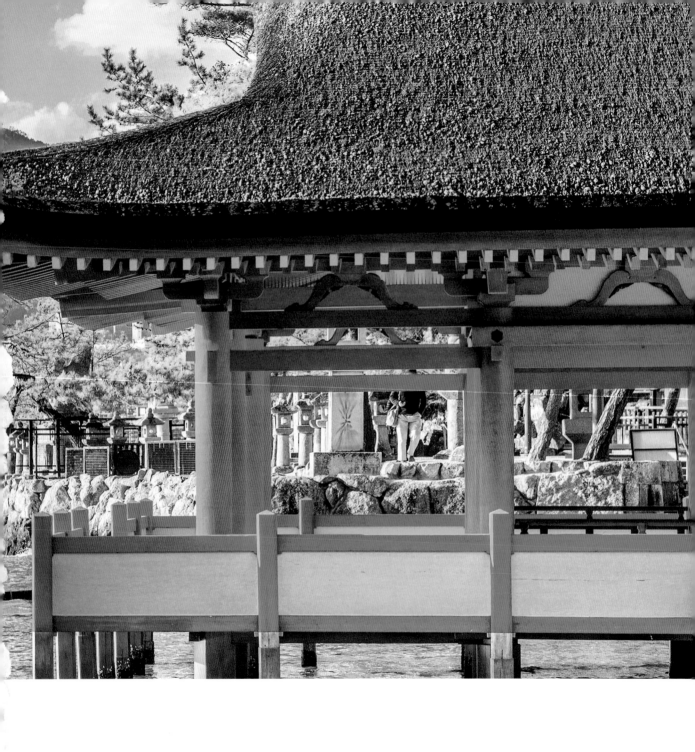

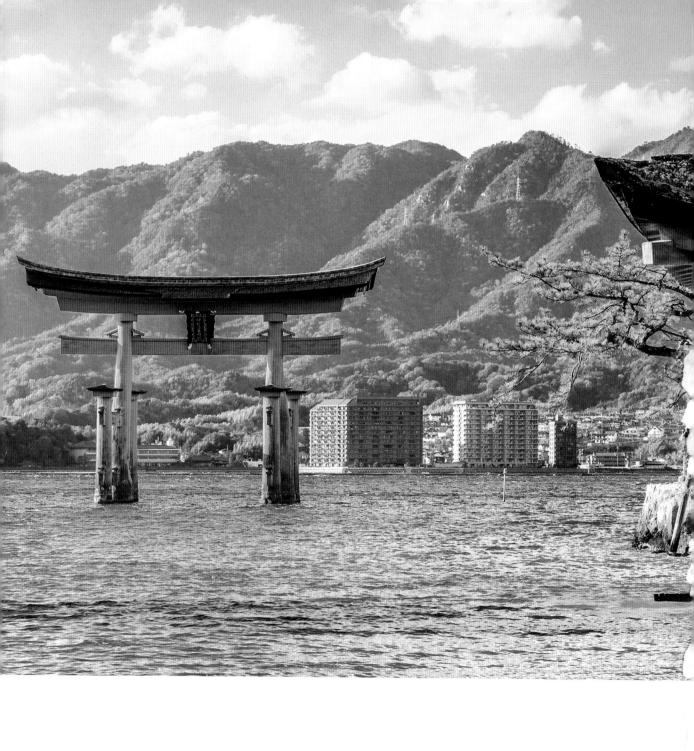

Nagato › Motonosumi Inari shrine has a series of 123 red torii

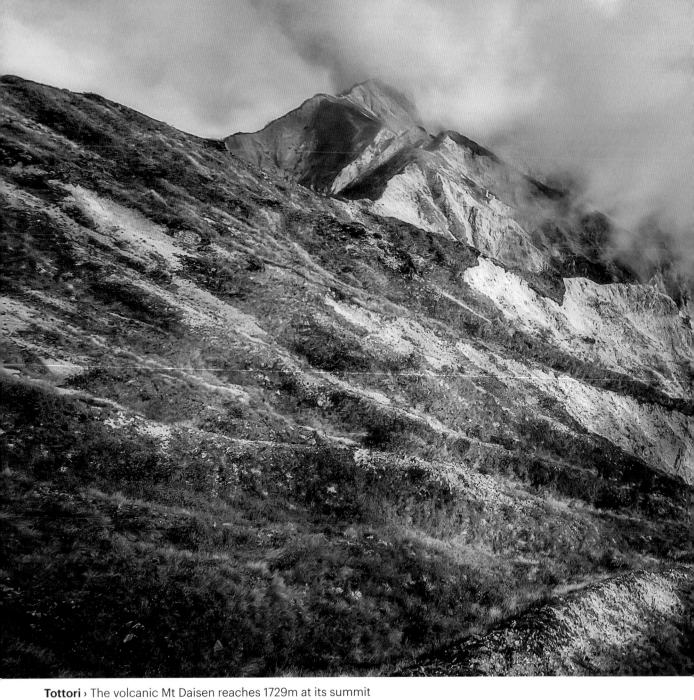

Tottori › The volcanic Mt Daisen reaches 1729m at its summit

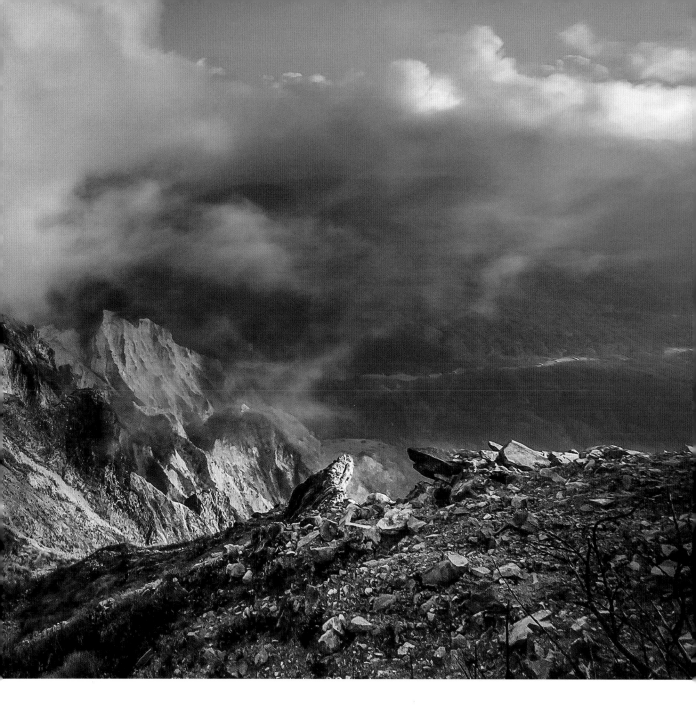

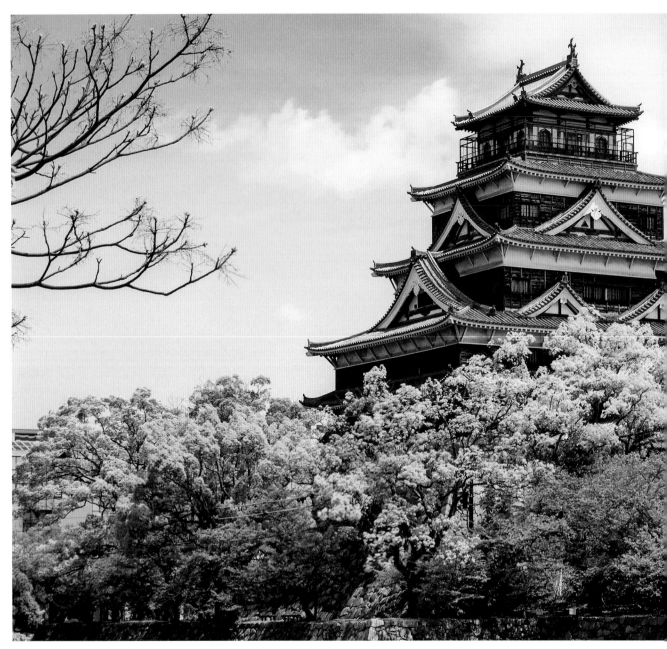

Hiroshima › The city's Carp Castle was rebuilt to its 16th-century specifications in the 1950s

Chūgoku

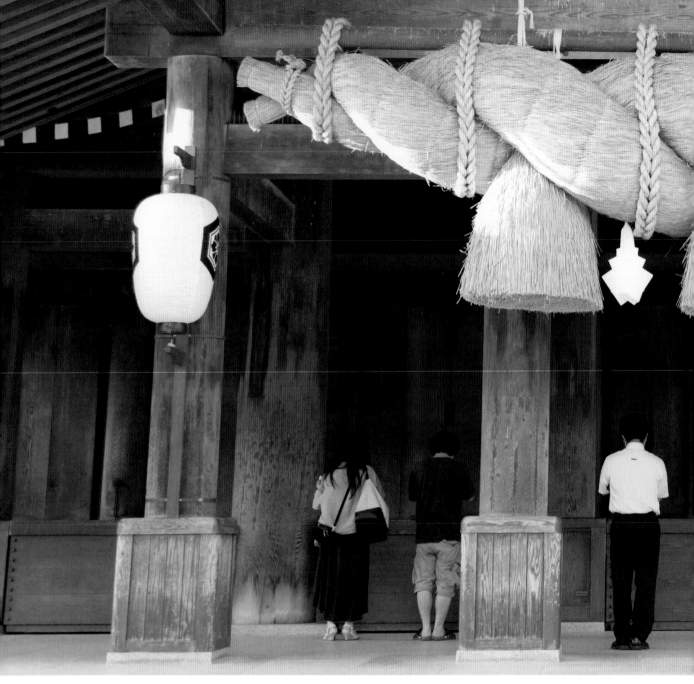

Izumo › Shintō worshippers beneath the huge straw ropes at Izumo Taisha

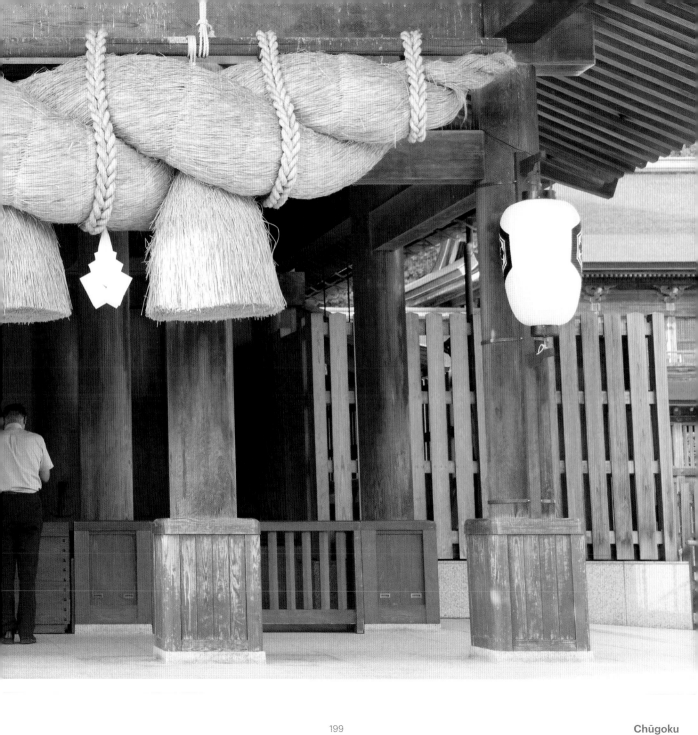

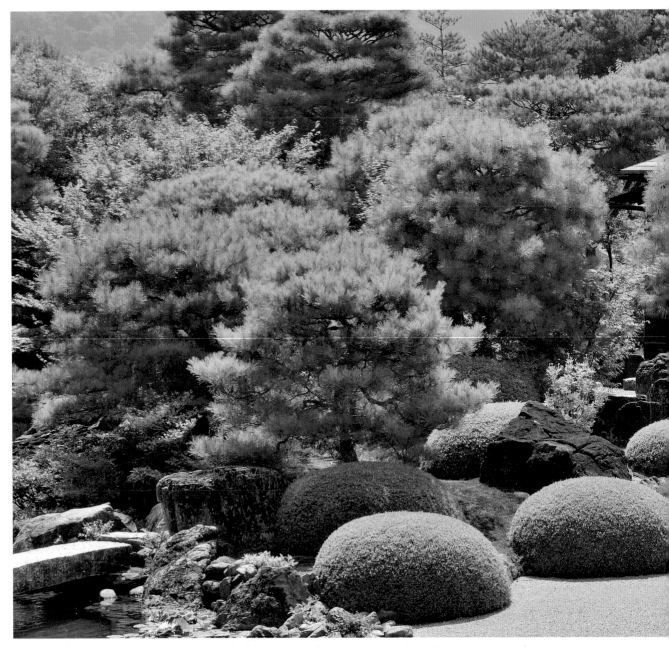

Yasugi › The gardens surrounding the Adachi Museum of Art are among Japan's most treasured

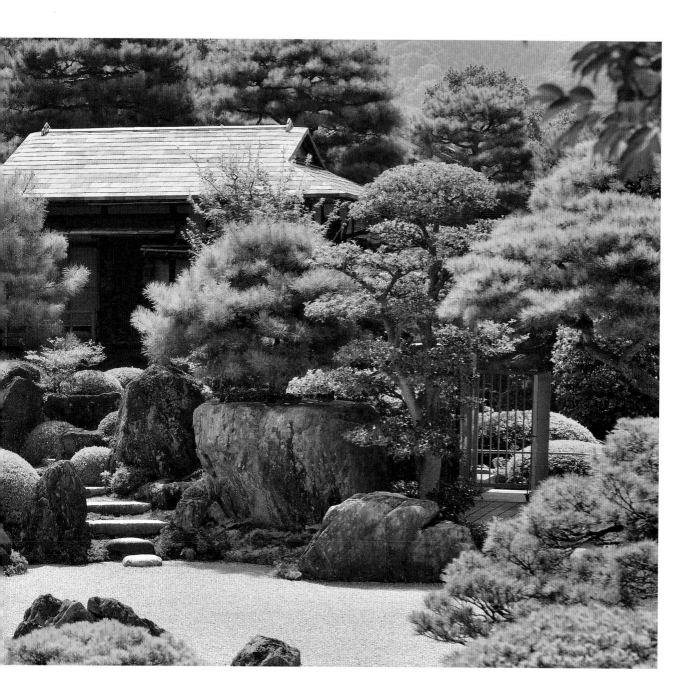

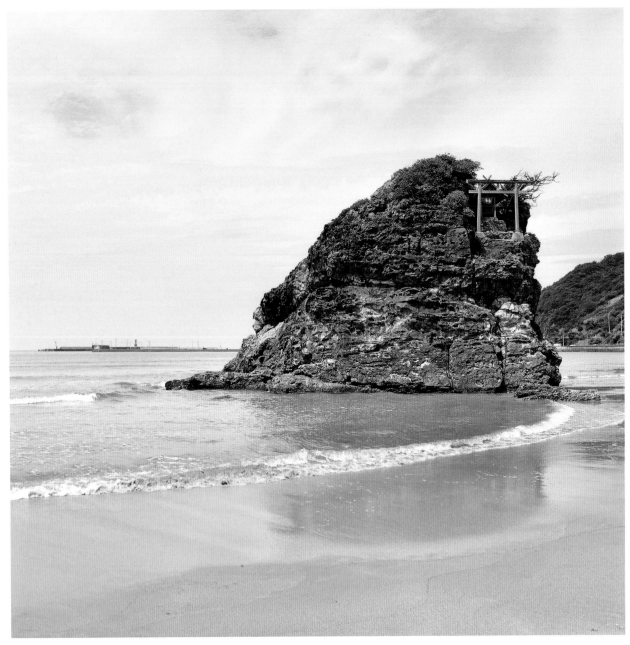

Izumo › Benten-jima shrine is perched on a rock at Inasa beach

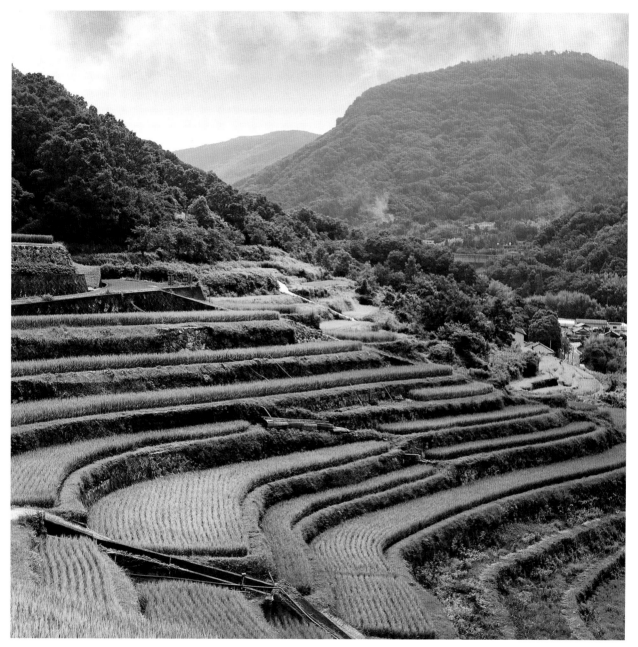

Shōdo-shima › Nakayama terraced rice fields

Shikoku

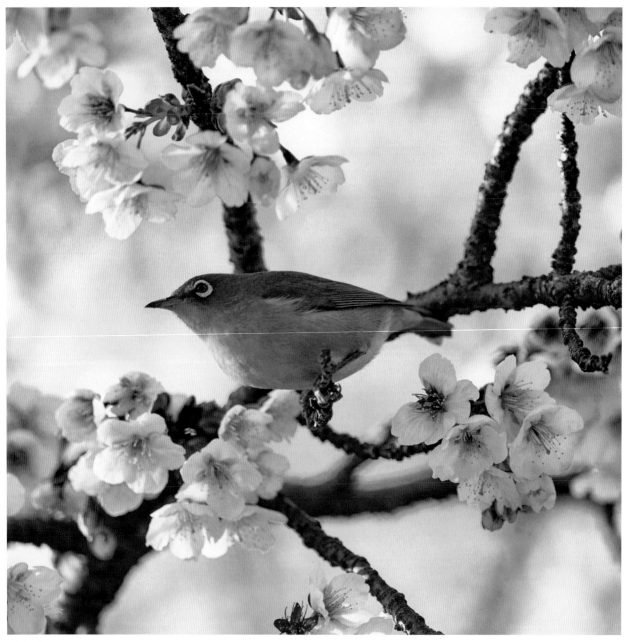

Shikoku › A Japanese white-eye perches on a cherry-blossom branch

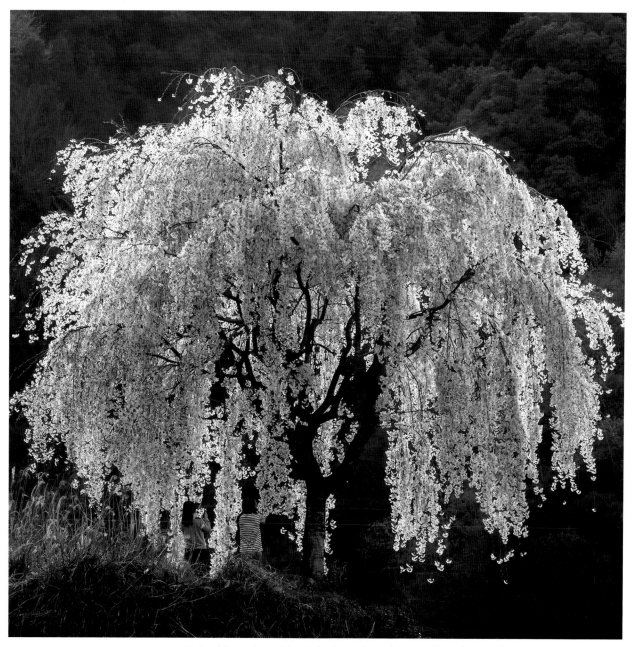

Tokushima › Late March is the prime time to view cherry blossom across Shikoku

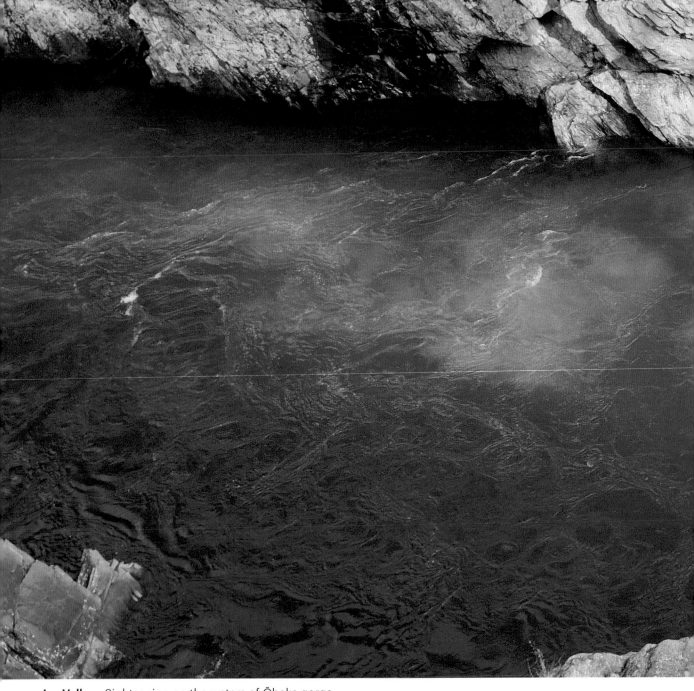

Iya Valley › Sightseeing on the waters of Ōboke gorge

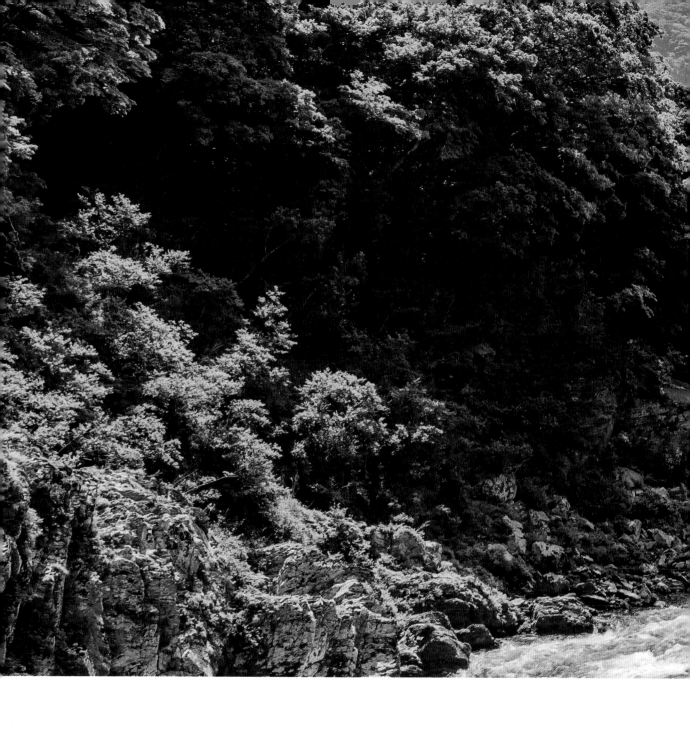

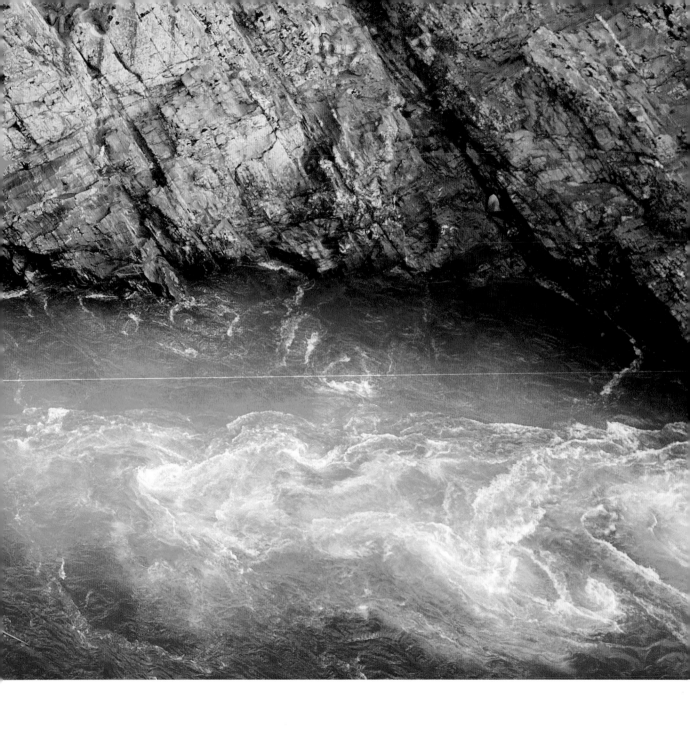

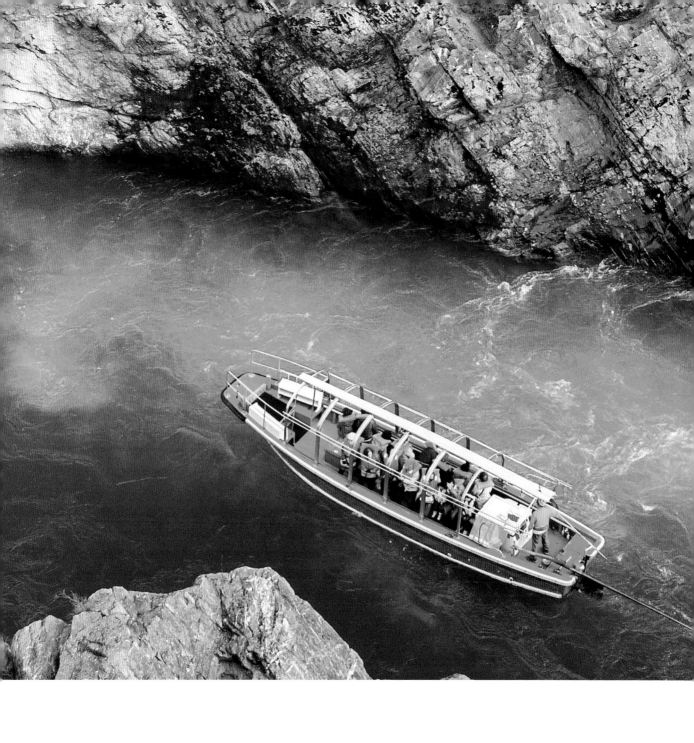

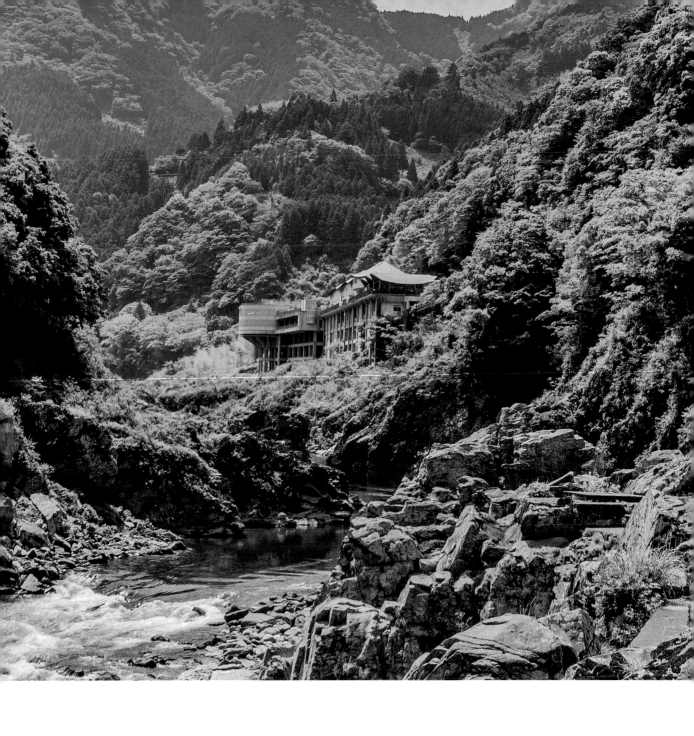

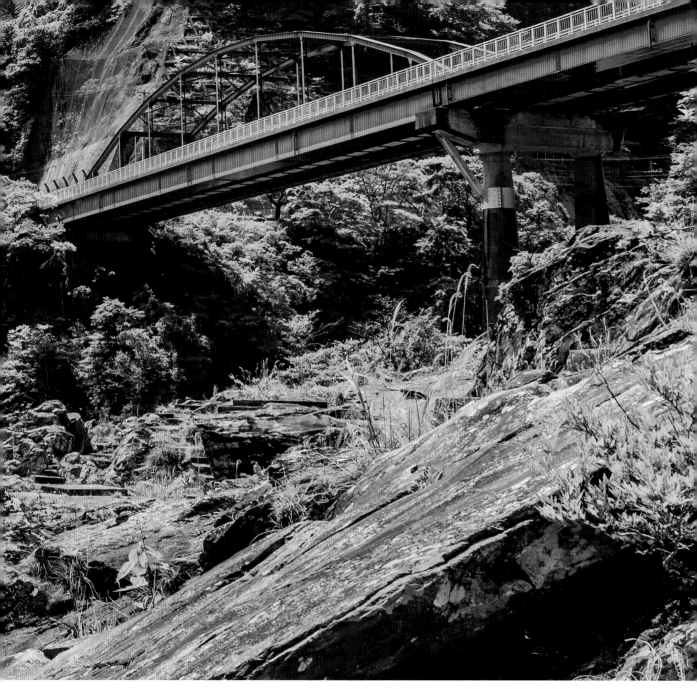

Iya Valley › A stream runs through the lush foothills in spring

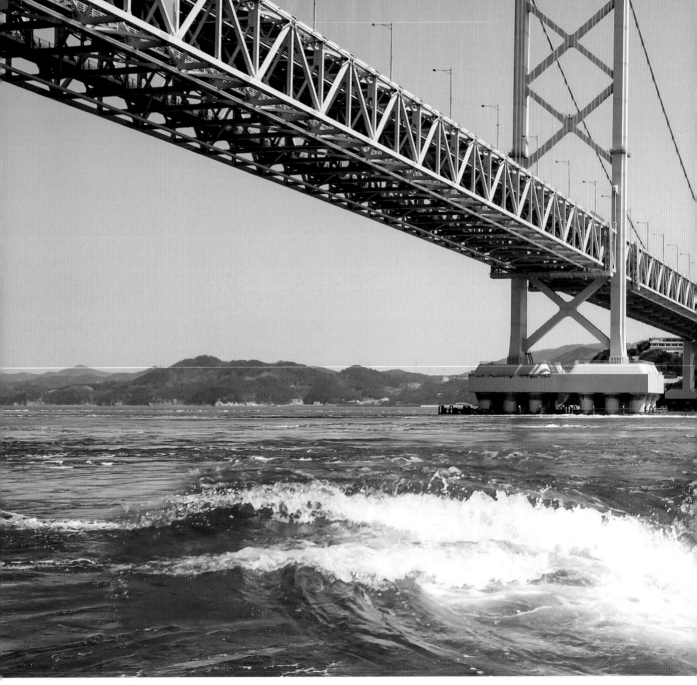

Naruto › Beneath Ōnaruto bridge, the Naruto whirlpools are a natural marvel

Shikoku

Naoshima › Yayoi Kusama's 'Yellow Pumpkin' sculpture is one of many artworks on the island

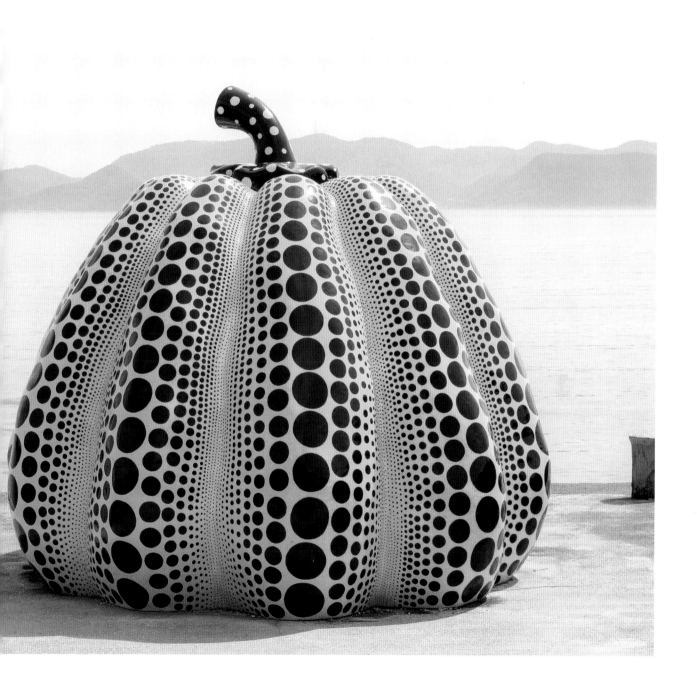

Shikoku

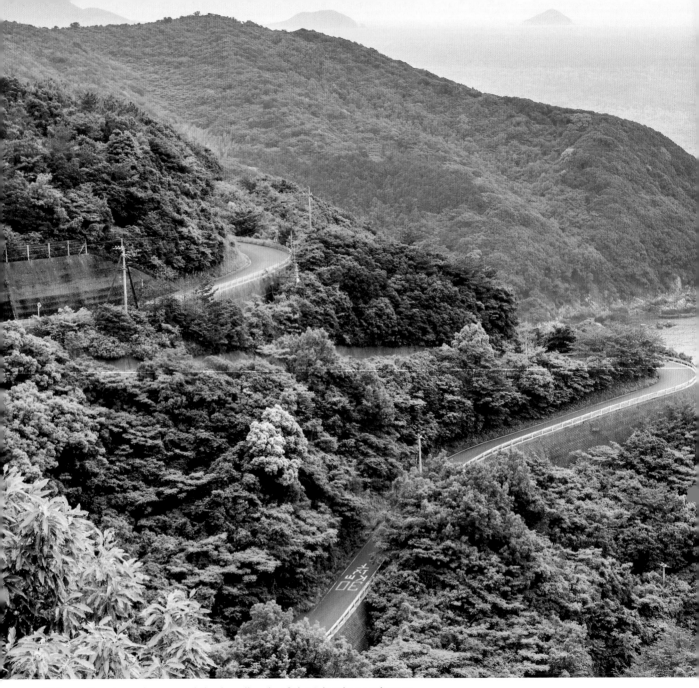

Ehime › Roads snake around the headlands of the island's southwest

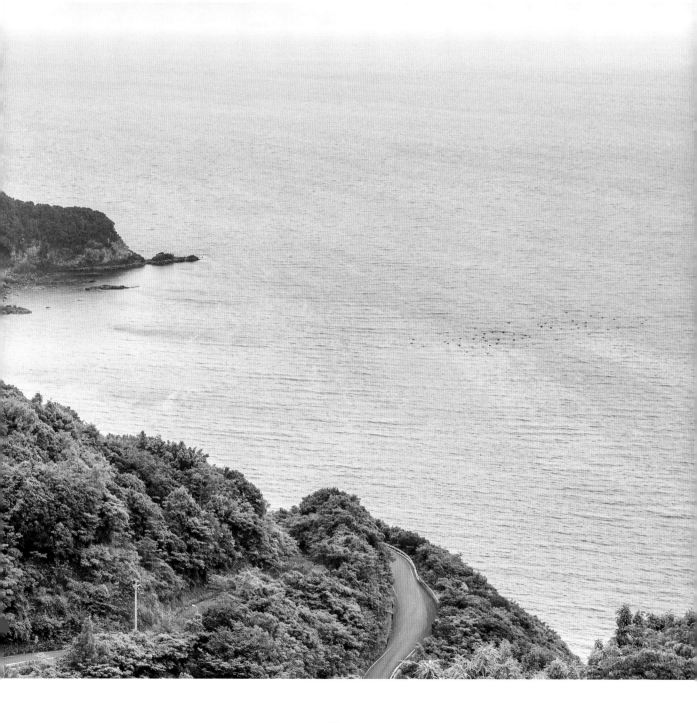

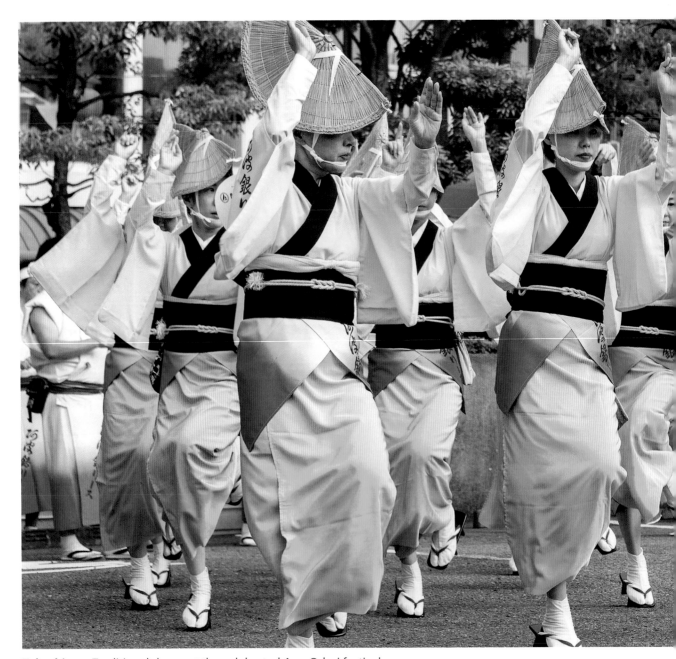

Tokushima › Traditional dance at the celebrated Awa Odori festival

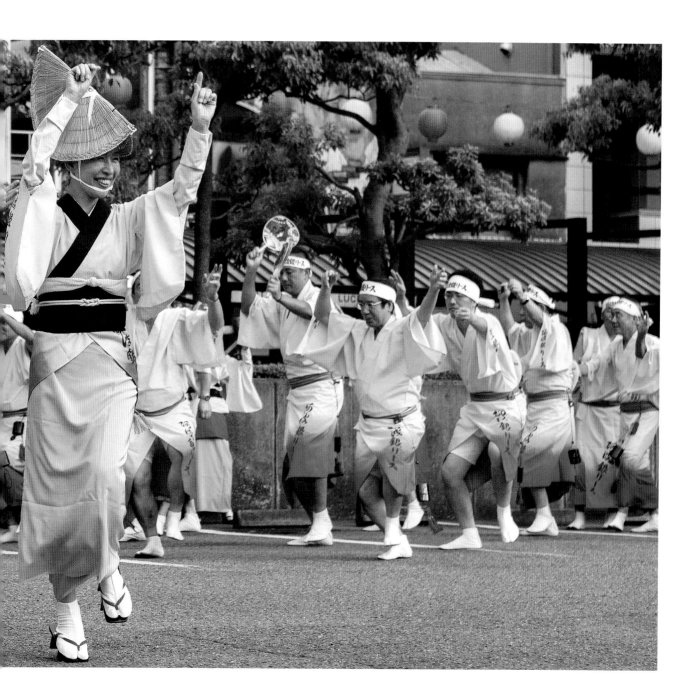

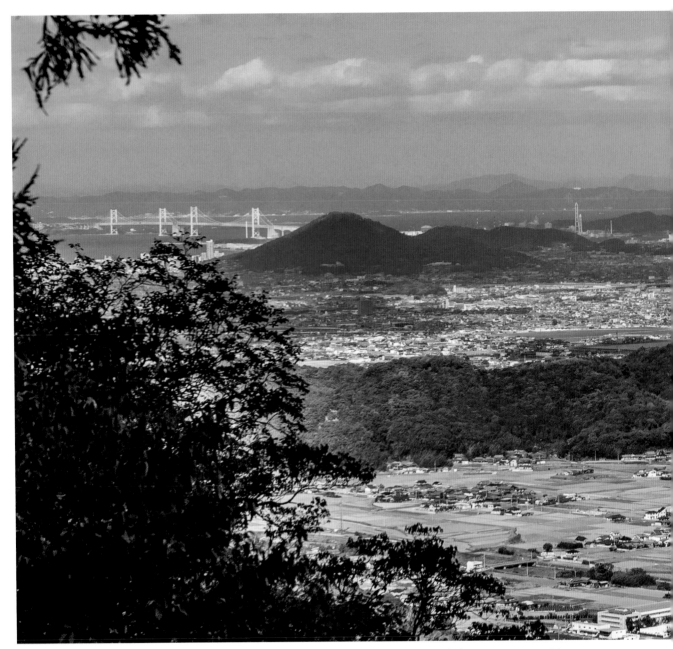

Kotohira › A view from the town across the conurbation beyond and the bridge linking Kagawa to Okayama

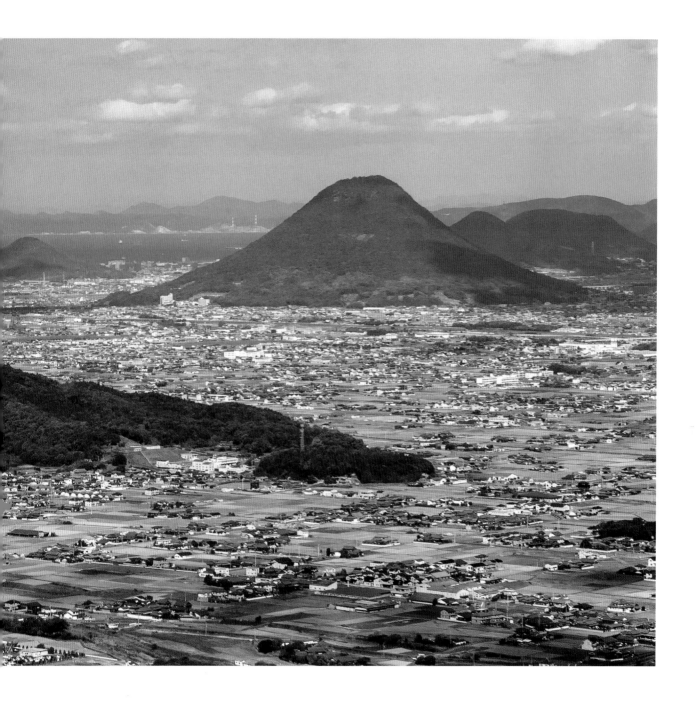

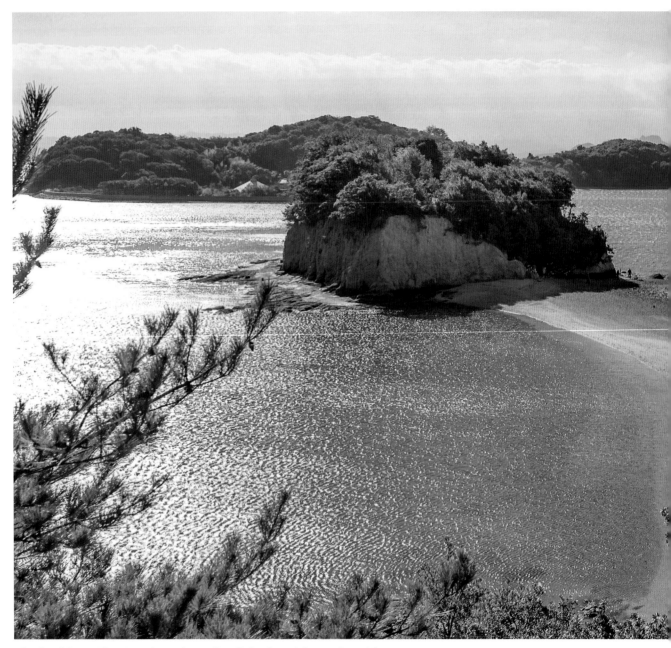

Shōdo-shima › The 'Angel Road' sandbar links three islets at low tide

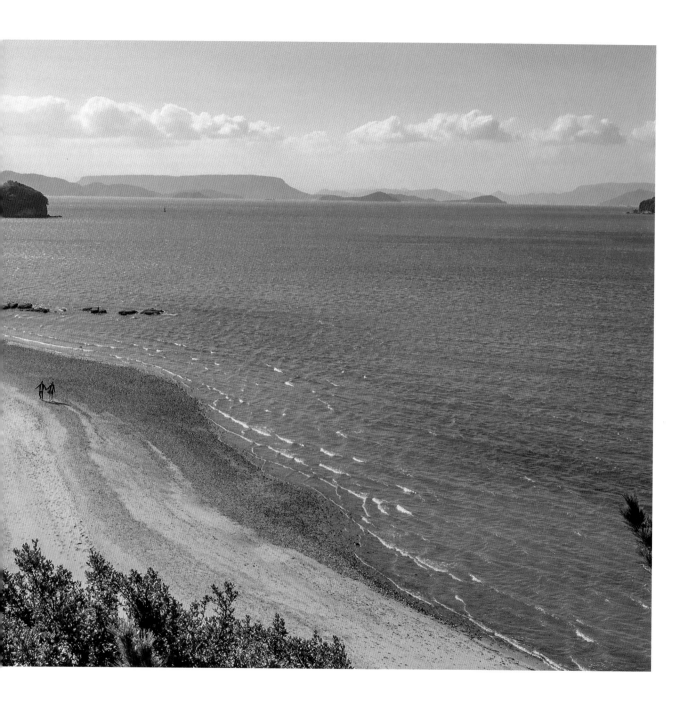

Shikoku

Iya Valley › Crossing the Iya river on the Kazura-bashi, made of mountain vine

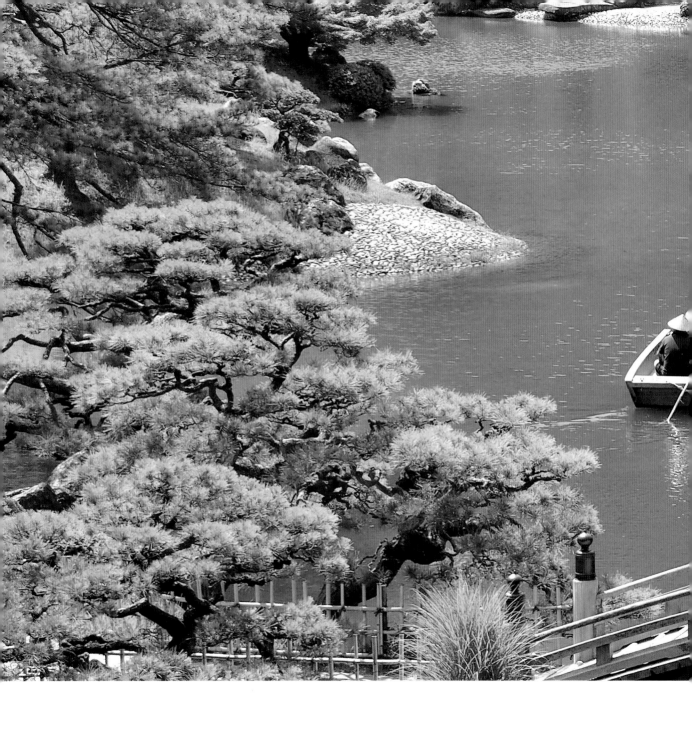

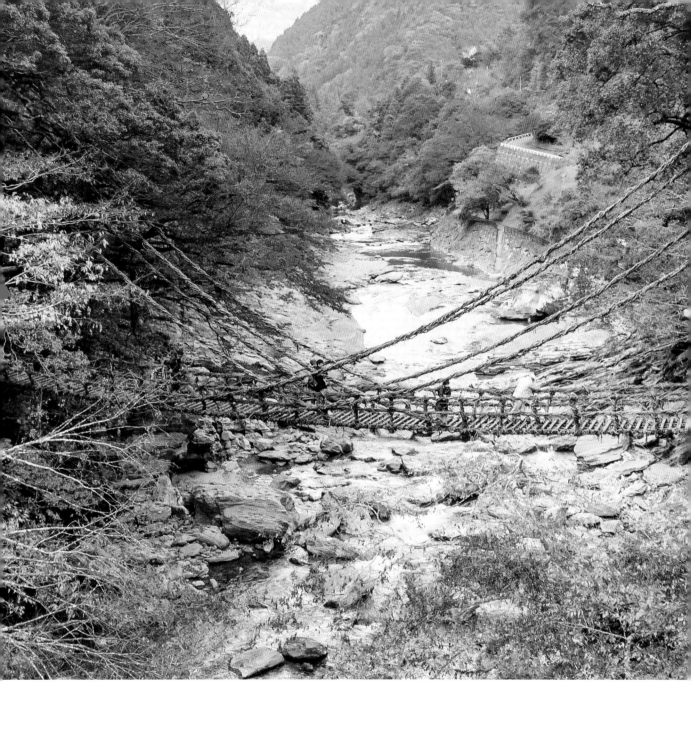

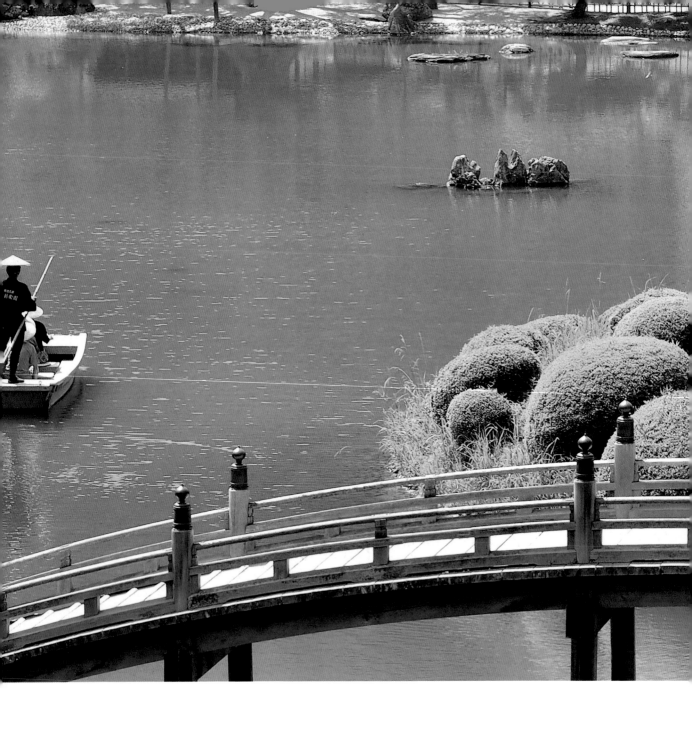

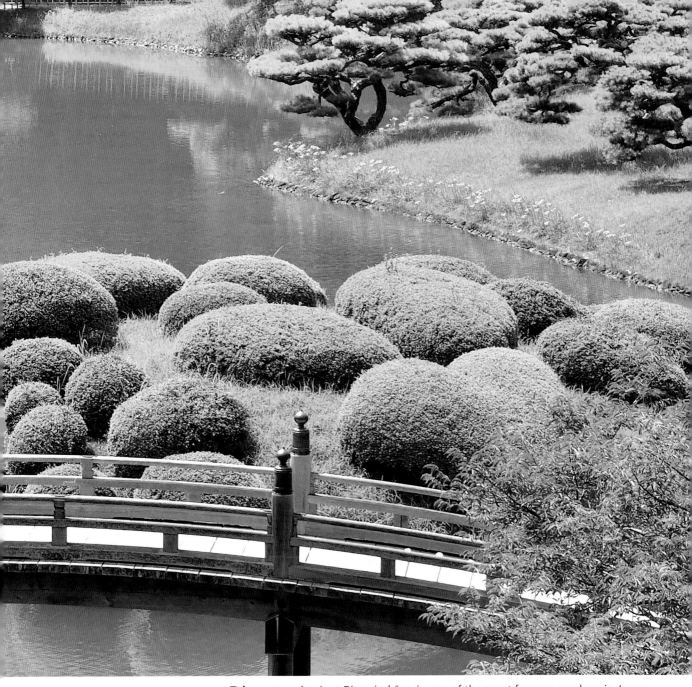

Takamatsu › Ancient Ritsurin-kōen is one of the most famous gardens in Japan

Shikoku

Kōchi › The 17th-century Kōchi-jō stands guard over the city

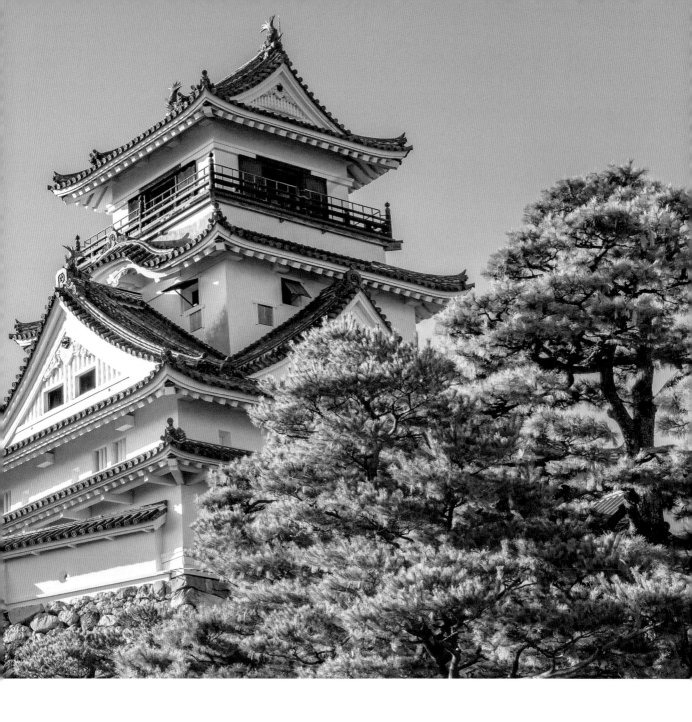

Hirado › Great panoramas are a given for those hiking the island's Kawachi Pass

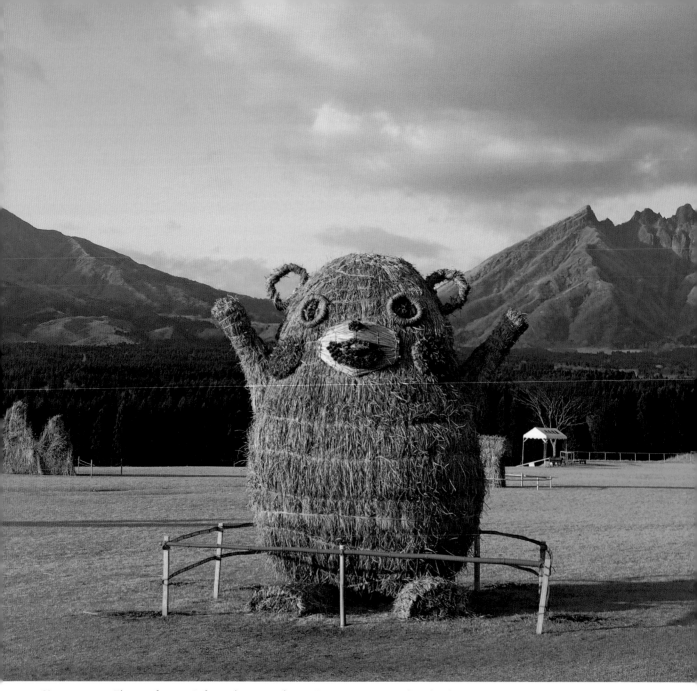

Kumamoto › The prefecture's famed mascot bear, Kumamon, as realised in hay

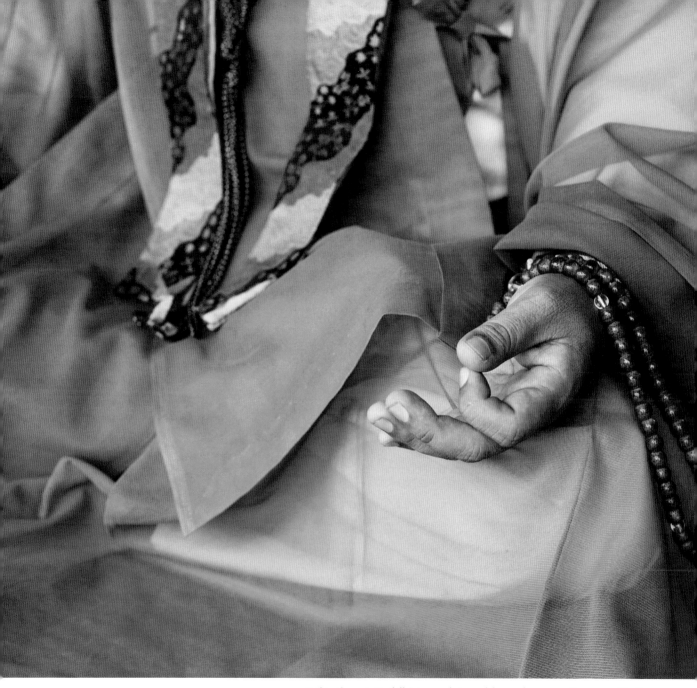

Fukuoka › A Buddhist monk in golden robes practises meditation

Kyūshū & Okinawa

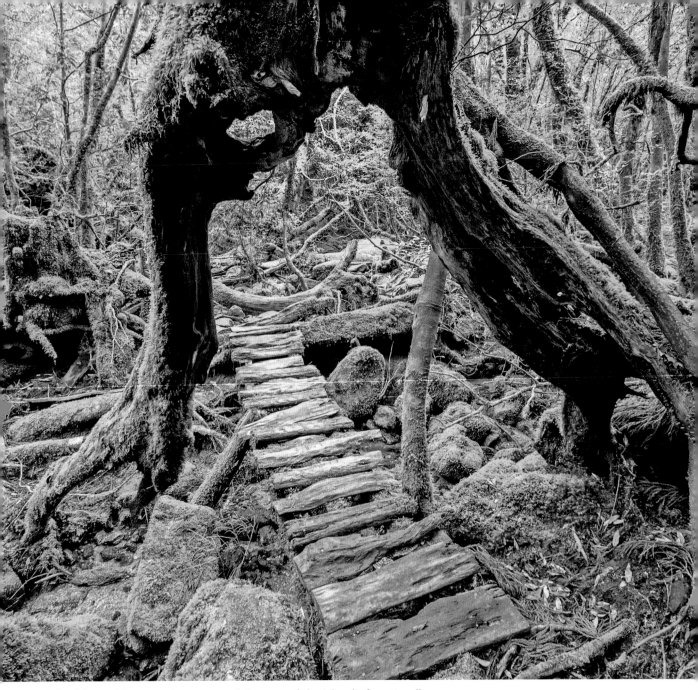

Yakushima › A huge cedar tree straddles one of the island's forest walkways

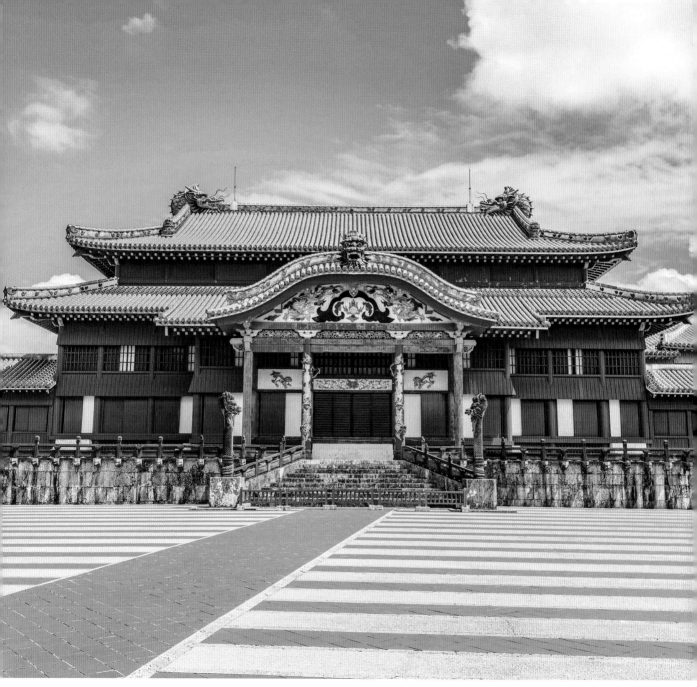

Naha › The 14th-century Shuri-jō was faithfully rebuilt in the 1990s

Kyūshū & Okinawa

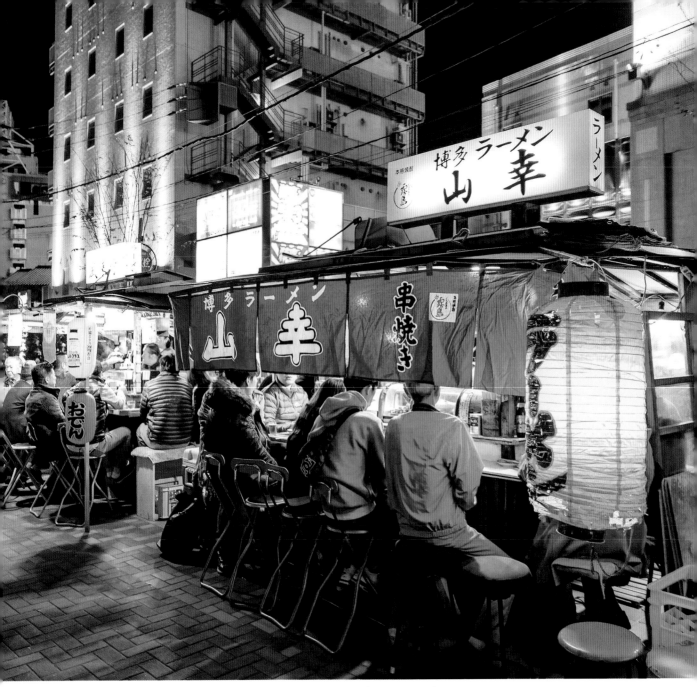

Fukuoka › Yatai (street-food carts) in the Tenjin area, where diners sit at the counter

Fukuoka › Tonkotsu rāmen is served throughout the city

Kyūshū & Okinawa

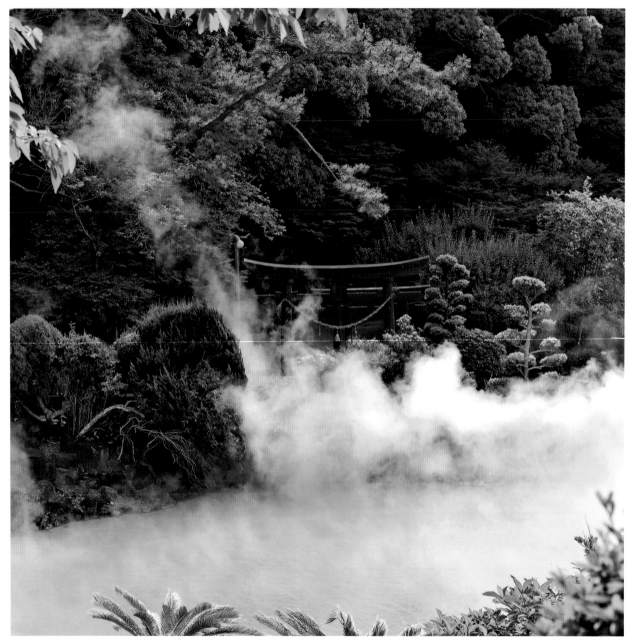

Beppu › Umi jigoku, or 'sea hell', one of Beppu's not-for-bathing hot springs

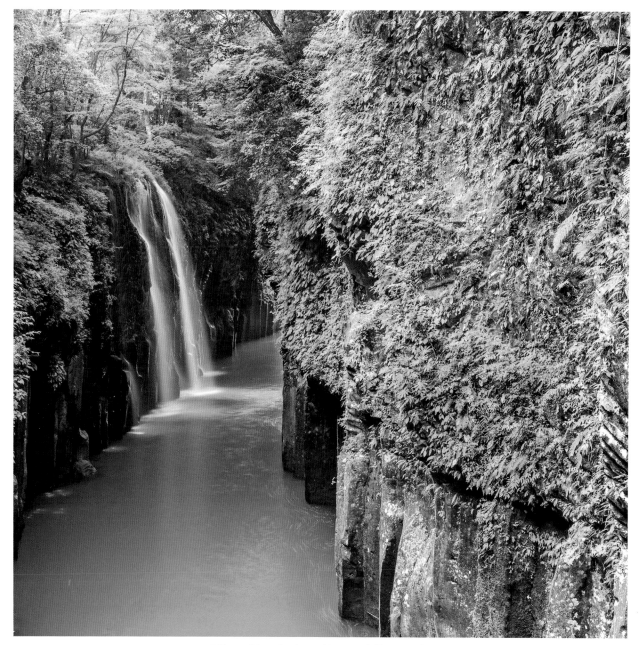

Miyazaki › Minainotaki waterfall cascades into the waters of Takachiho Gorge

Kyūshū & Okinawa

Chiran › The landscaped gardens of one of the town's restored samurai houses

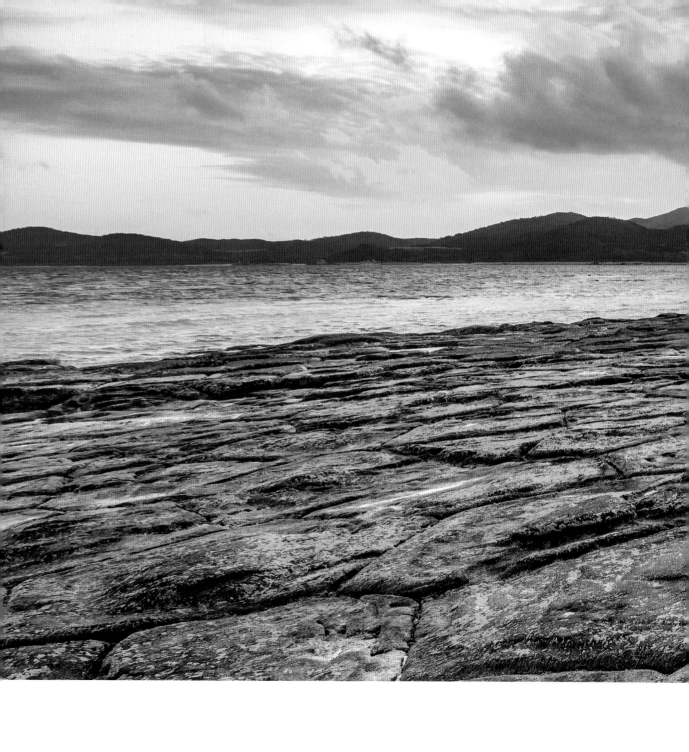

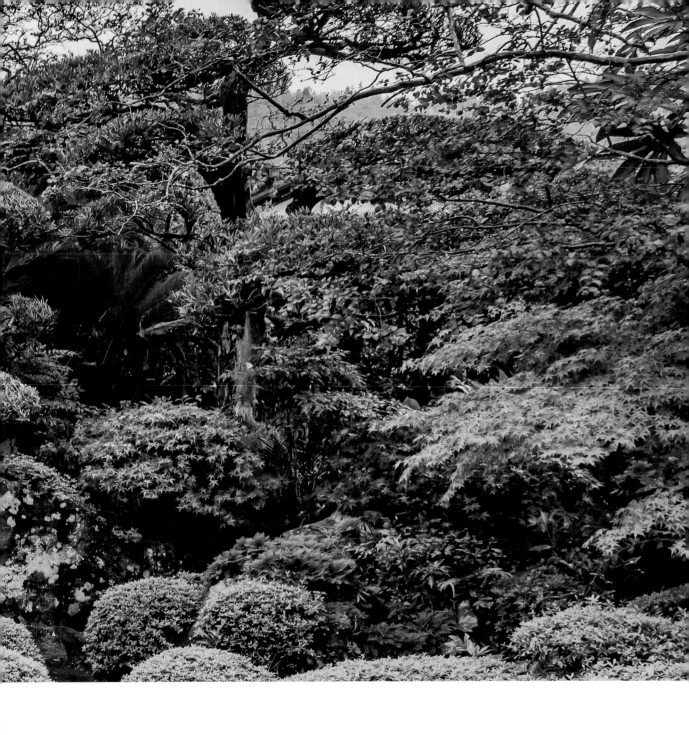

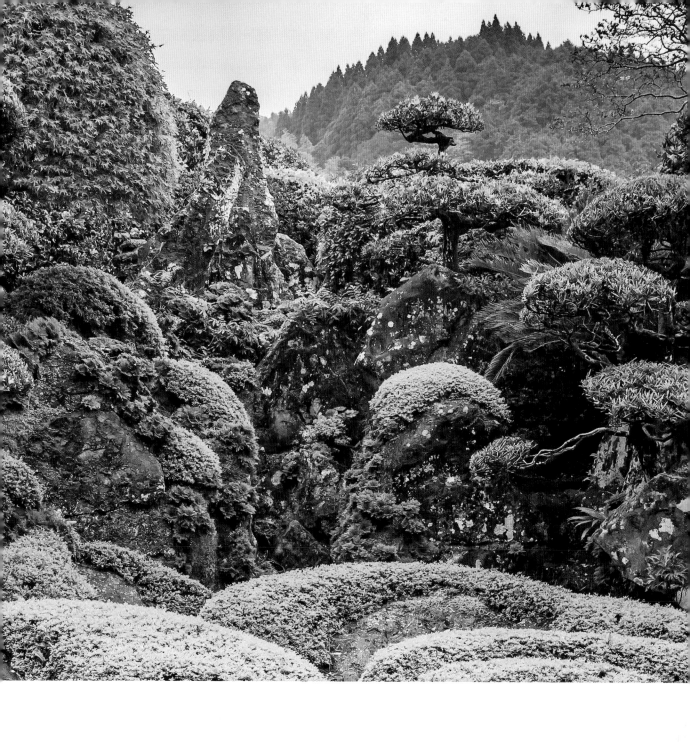

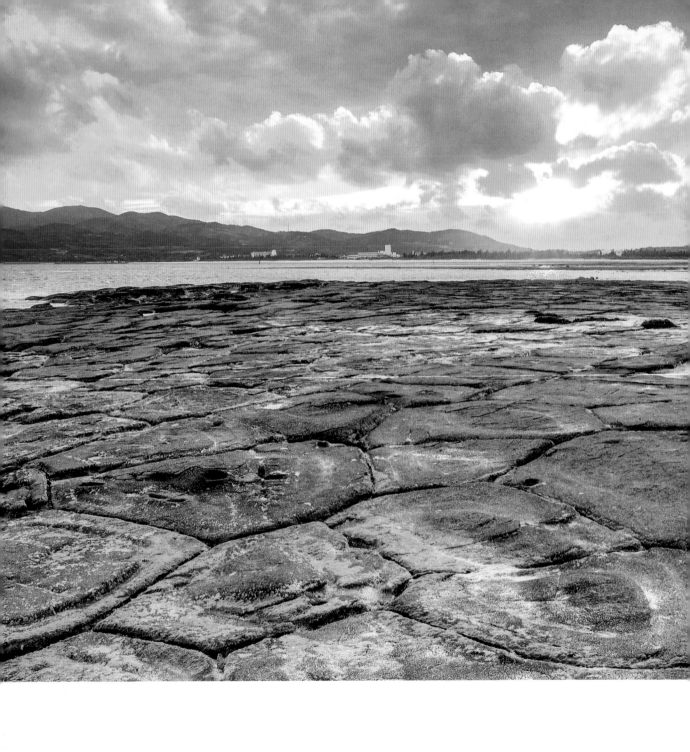

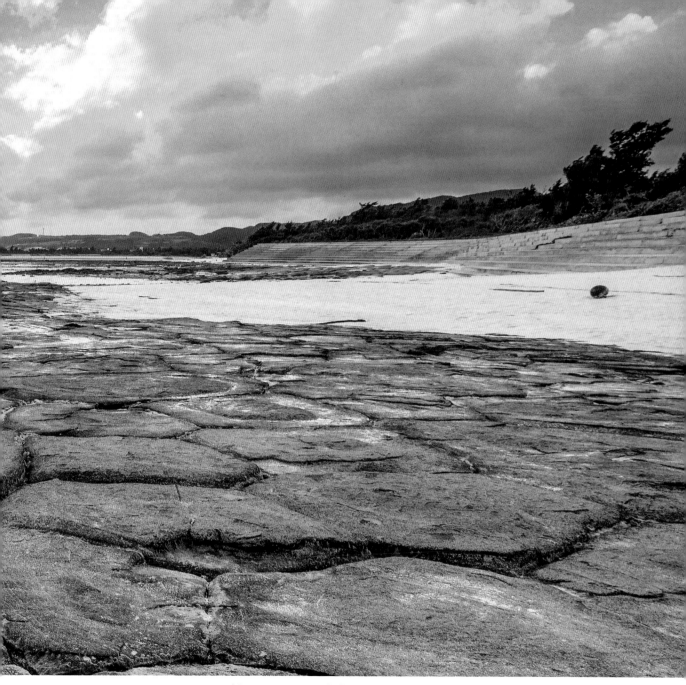

Okinawa › Tatami-ishi beach, connected to the island of Kume-jima, at low tide

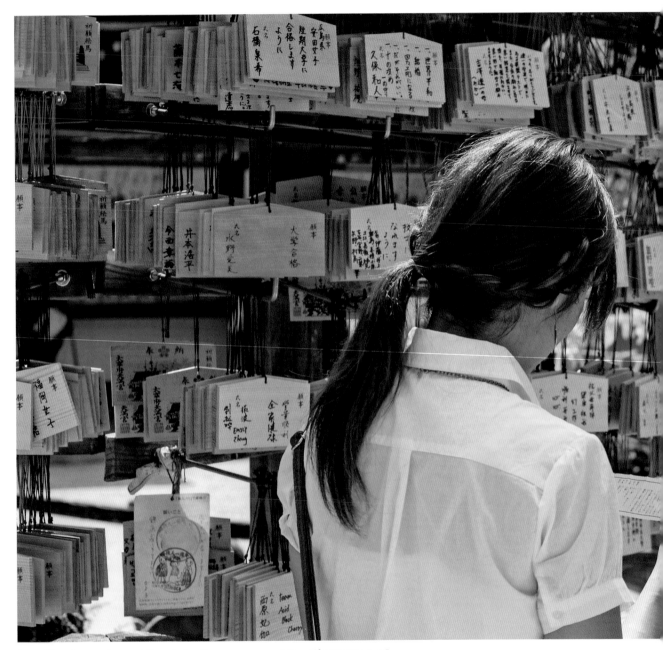

Dazaifu › A couple read the divination message at Dazaifu Tenman-gū

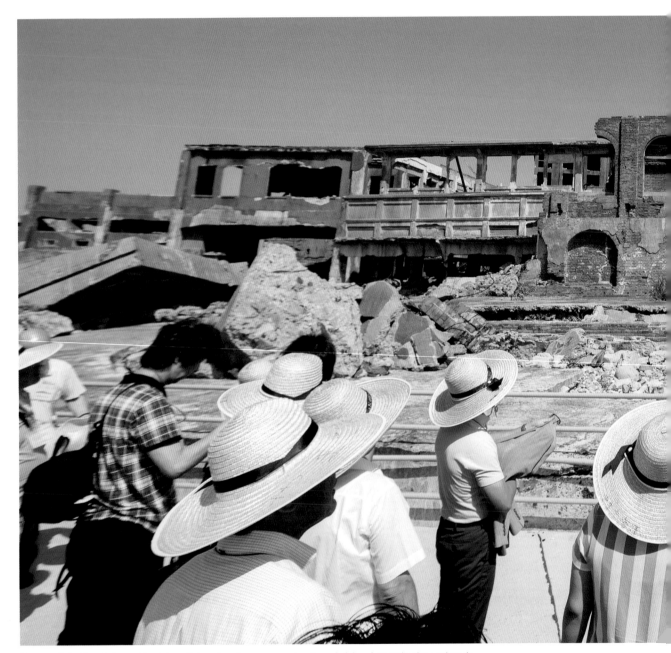

Nagasaki › Tourists at Hashima island, a former coal mine dubbed 'Battleship Island'

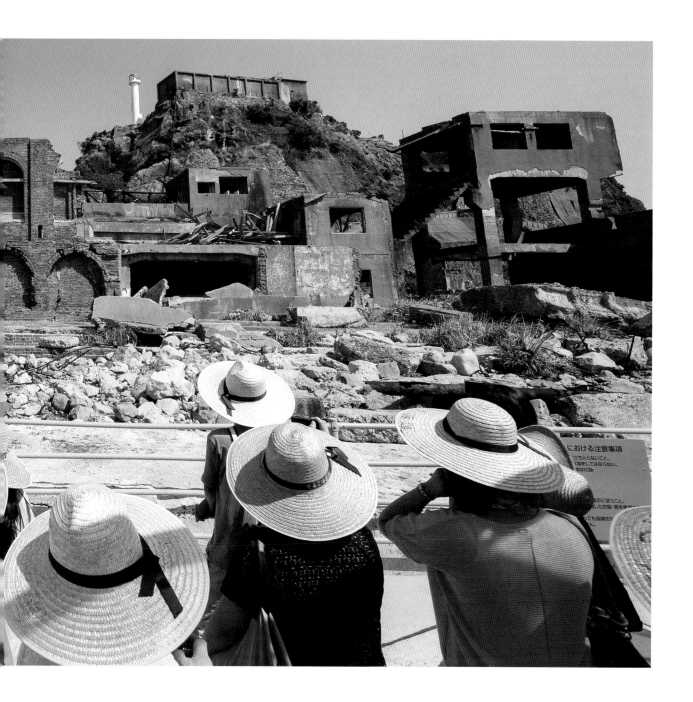

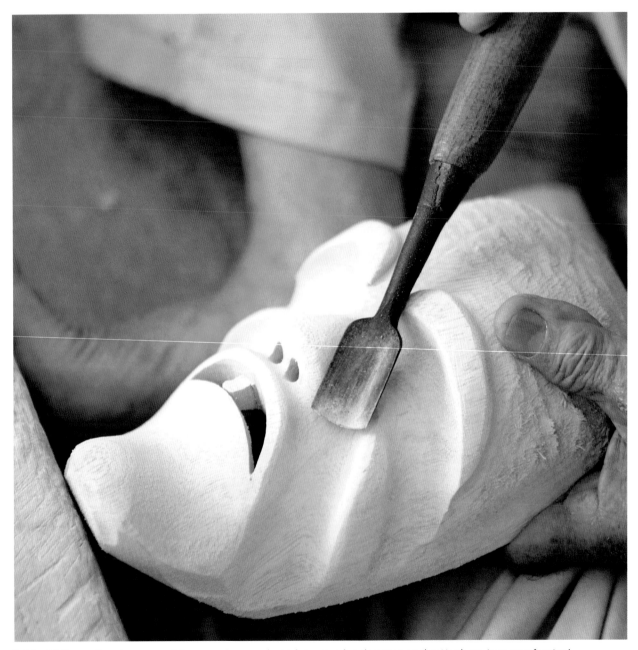

Ishigaki-jima › Carving one of the wooden masks to be worn by dancers at the Kyubon Angama festival

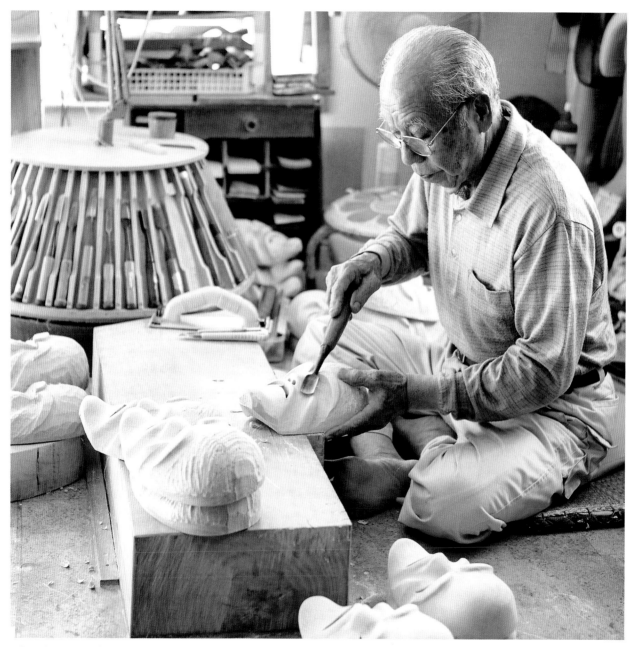

Ishigaki-jima › The masks are worn by Grandfather and Grandmother spirits at the festival on the Yaeyama Islands

Kyūshū & Okinawa

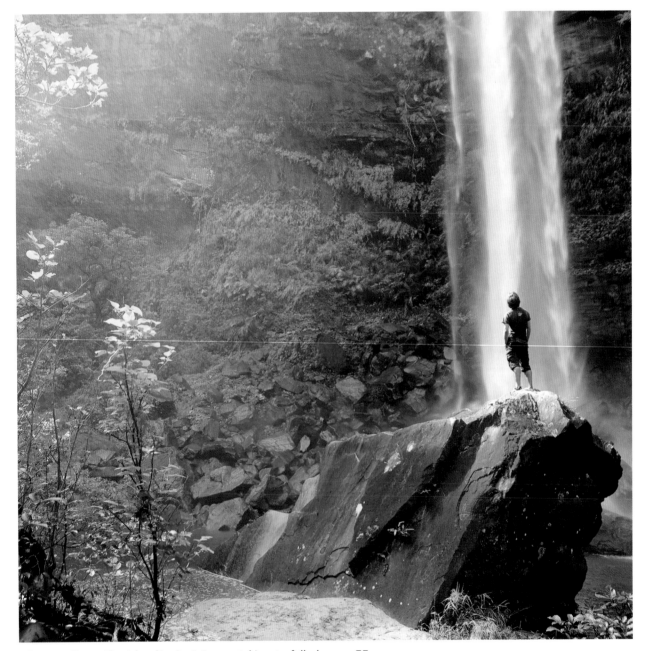

Iriomote-jima › The island's pinaisāra-no-taki waterfall plunges 55m

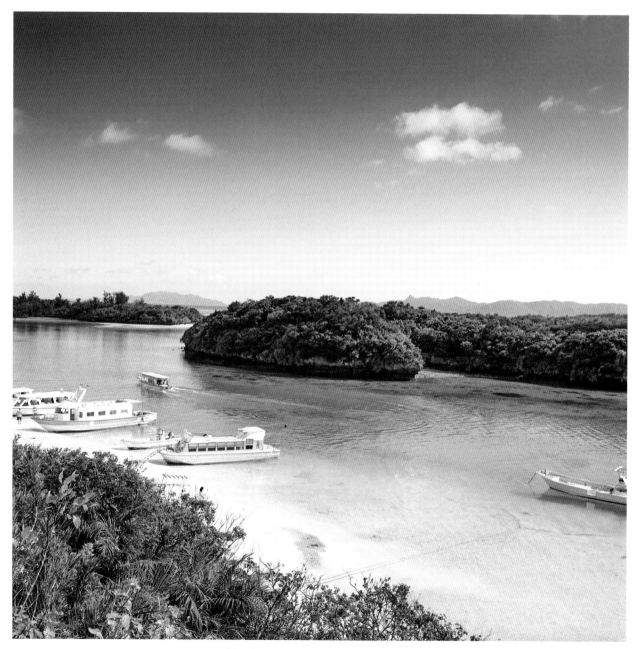

Ishigaki-jima › Boats set off for sightseeing cruises around idyllic Kabira Bay

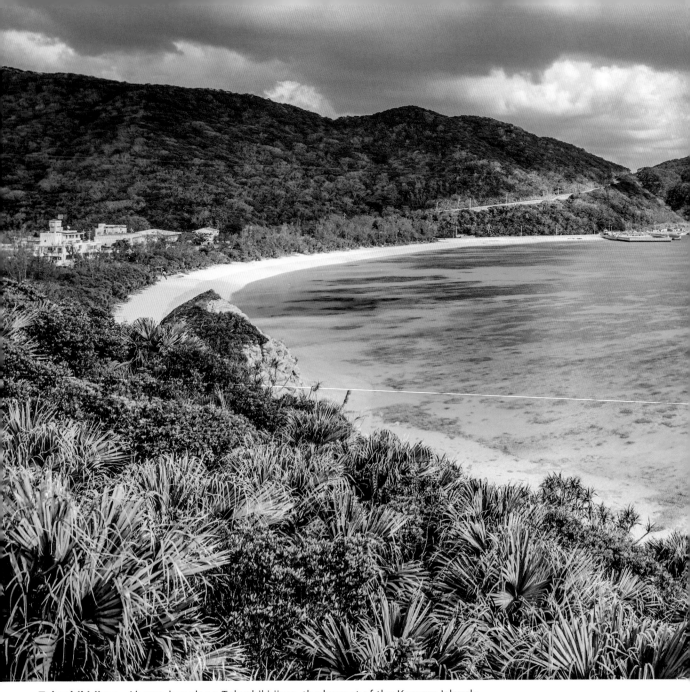

Tokashiki-jima › Aharen beach on Tokashiki-jima, the largest of the Kerama Islands

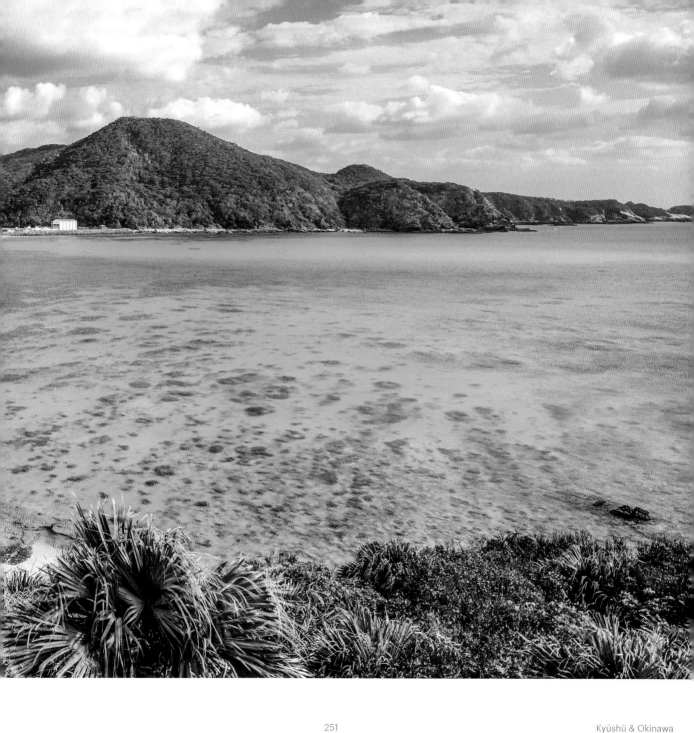

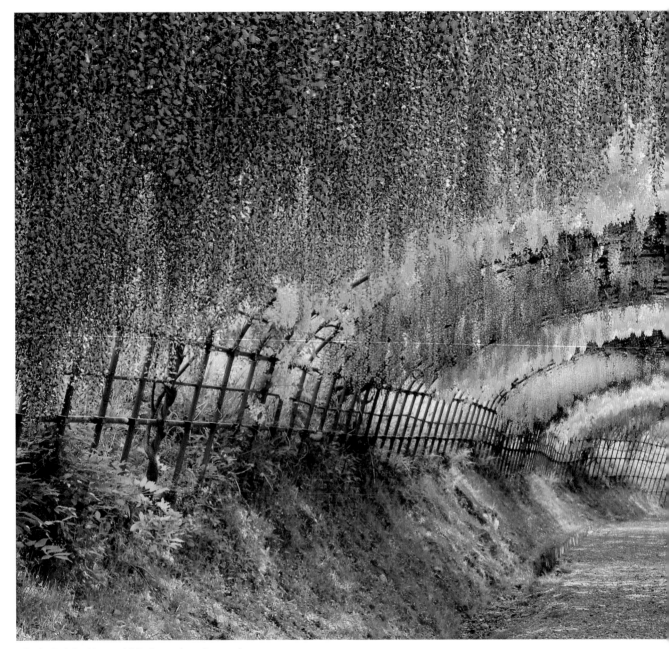

Kitakyūshū › Kawachi Fujien wisteria garden

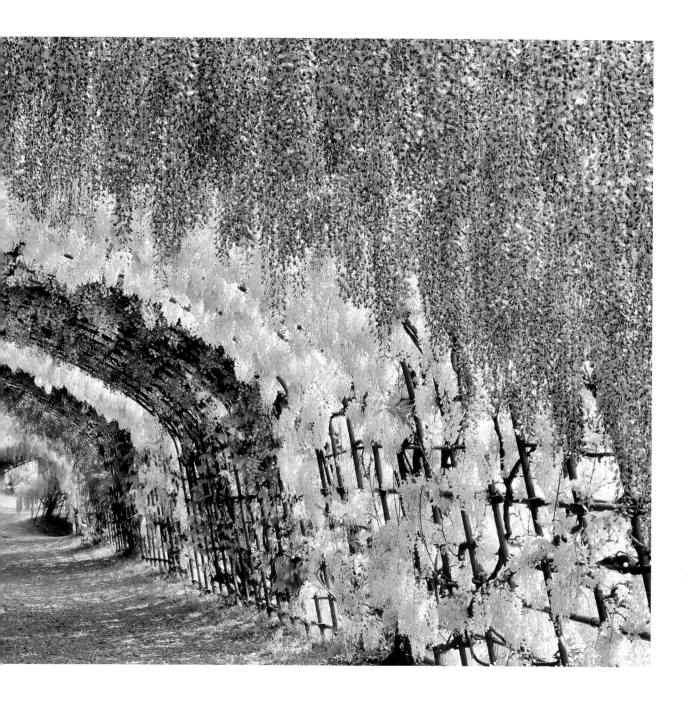

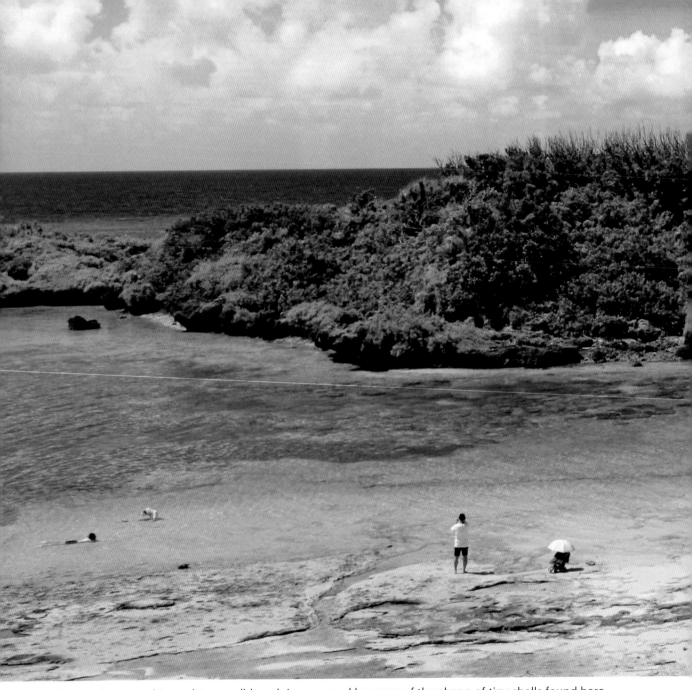

Taketomi-jima › Hoshizuna (star sand) beach is so named because of the shape of tiny shells found here

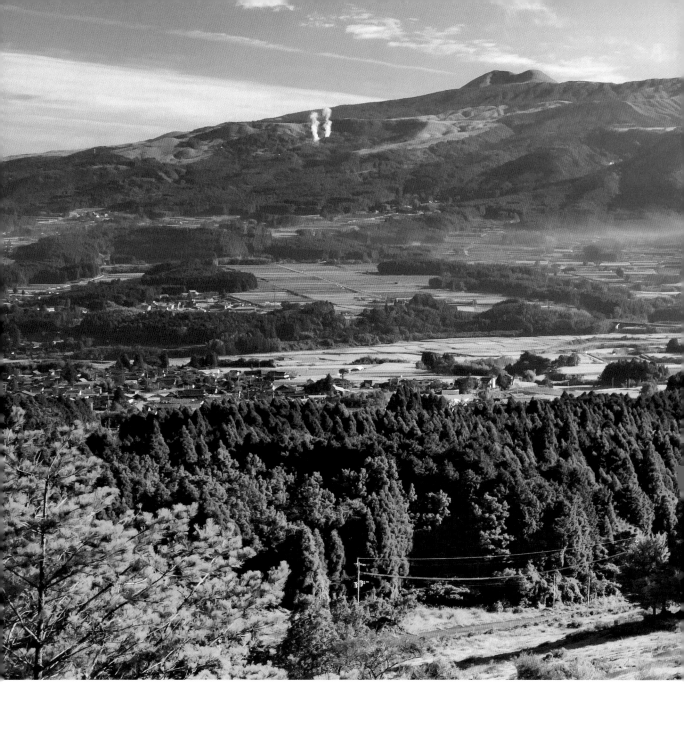

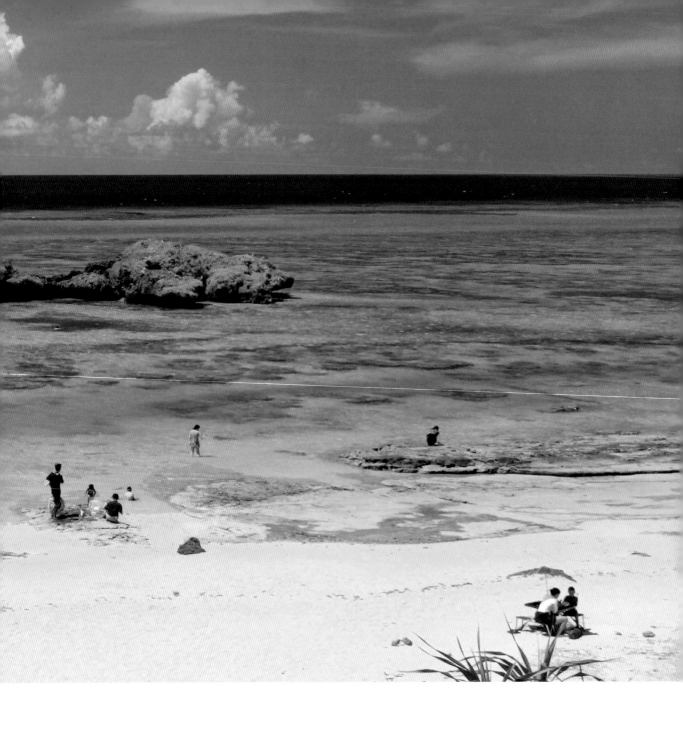

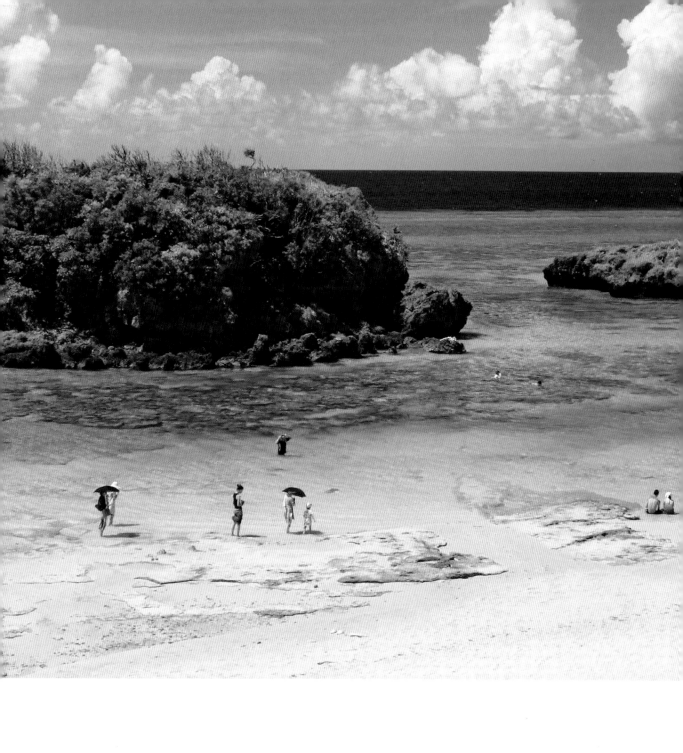

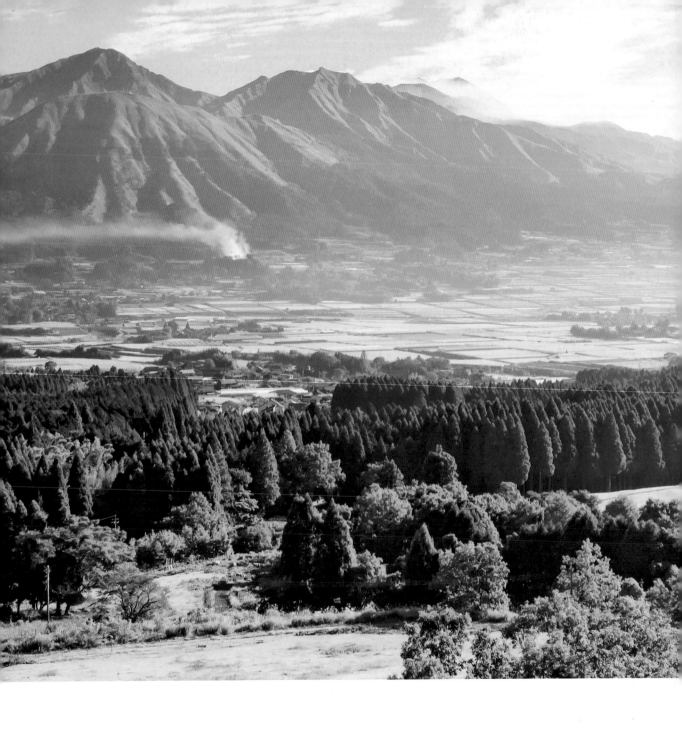

Kumamoto › The landscape of Minami Aso takes in the world's third-largest volcanic caldera

Photo
Captions

Kamikawa › The northernmost of Japan's islands, Hokkaidō is a scenic wilderness of hot springs, volcanoes, forests and shimmering blue caldera lakes. Winter brings Siberian cold fronts and monumental snowfall, turning the region into a skiing and snowboarding wonderland.

7

Masami Goto | Getty Images ©
Marco Wong | Getty Images ©

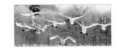

Hokkaidō › Thermal springs and caldera lakes dot Hokkaidō, drawing whooper swans (Cygnus cygnus) to them for warmth. During winter, the swans migrate from their breeding grounds in the Siberian Arctic. Lake Kussharo is a good place to spot them.

8-9

Mint Images | Aurora Photos ©

Niseko › Niseko is king of Hokkaidō's numerous ski resorts, thanks to its soft and powdery light snow. There are four interconnected resorts at Niseko and it's popular with Japanese powderhounds and international visitors alike.

10

Brandon Huttenlocher | Aurora Photos ©

Daisetsuzan National Park › Japan's largest national park, Daisetsuzan is located in northern Hokkaidō and covers more than 2300 sq km. In winter it offers great skiing, which is no surprise considering that Daisetsuzan means 'Big Snow Mountain'.

11

Philip Lee Harvey | Image Source | Aurora Photos ©

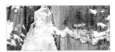

Daisetsuzan National Park › At the base of Kuro-dake on the northeast side of Daisetsuzan National Park is Sōunkyō, a 15km-long string of gorges formed by the Ishikari river. In winter, the gorges are perfect for ice-climbing.

12-13

Andrew Peacock | Aurora Photos ©

Kamikawa › Near the pretty countryside town of Biei is the man-made Blue Pond (Aoiike), named for its shining turquoise waters. The pond was formed by the construction of a dam to control volcanic sand erosion after a 1988 eruption of nearby Tokachidake.

14-15

Okimo | Shutterstock ©

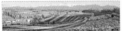

Kamikawa › Shikisai-no-oka is a panoramic flower garden in the countryside of Biei in northern Hokkaidō. The patchwork of flowers stretches over 15 hectares and is made up of about 30 different varieties blooming from spring through autumn in a riot of colour.

16-17

Thanya Jones | Shutterstock ©

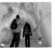

Hokkaidō › During the winter, Hokkaidō plays host to a few ice festivals, the most famous being the Sapporo Snow Festival (Sapporo Yuki Matsuri), which draws more than two million visitors each year. In Sōunkyō, the Ice Fall Festival features illuminated ice sculptures at night.

18 & 19

Supermaw | Shutterstock ©;
Martin Humby | Alamy Stock Photo ©

Sapporo › Sapporo is synonymous with Japanese beer and the city's Sapporo Beer Museum is where visitors can learn all about the brewery on a guided tour through the pretty brick building. It was founded in 1876 and is the country's oldest brewery.

20-21

Martin Brunner | 4Corners ©

Sapporo › The prefectural capital of Hokkaidō, the dynamic city of Sapporo is Japan's fifth-largest city. It's a cosmopolitan place full of great nightlife and good food, and makes a great jumping off point to experience Hokkaidō's wilderness.

22-23

Martin Brunner | 4Corners ©

Kushiro-shitsugen National Park › Designated a national park in 1987 to protect the habitat of numerous species, Japan's largest undeveloped wetland, Kushiro-shitsugen National Park, is home to the red-crowned white crane (tanchō-zuru). In Japan, the crane is a symbol of longevity.

24 & 25

Goh Itoh | Aflo | Getty Images ©;
Mekdet | Getty Images ©

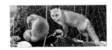

Hokkaidō › The Ezo fox (Ezo comes from an old name for Hokkaidō) is larger than the red fox that lives in other parts of the country. The animal can be found in Kushiro-shitsugen National Park in Eastern Hokkaidō.

26-27

Mint Images | Aurora Photos ©

Shikotsu-Tōya National Park › Hokkaidō's most famous onsen, the Noboribetsu's pungent sulphuric odour can be smelled from miles away. Located in the Shikotsu-Tōya National Park, the onsen's water source is Jigoku-dani, a volcanic pit above town.

28-29

Akkhawin Lertsodsai | 500px ©

Akan National Park › Near the quiet onsen town of Kawayu is the hissing volcano Iō-zan with its yellow patches of stained sulphur. Locals can frequently be heard yelling 'Tamago!' as they try to sell eggs that have been steamed in the volcanic vapours.

30-31

Mint Images | Aurora Photos ©

Hakodate › Hakodate was one of the first ports to open up to international trade under the Kanagawa Treaty of 1854. The gateway to southern Hokkaidō, the city features a lively seafood market and is famous for the night views atop Hakodate-yama.

32-33

Sean Pavone | Shutterstock ©

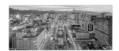

Sapporo › Stretching 1.5km and 13 blocks through the heart of Sapporo is the park Ōdōri-kōen, splitting the city into north and south. At the eastern end of the park is the TV Tower, which has an observation deck providing great city views.

34-35
Prasit photo | Getty Images ©

Aomori › *Iga-menchi*, squid croquettes, are served at the Tsugaru Akatsuki Club in Aomori. A local speciality in Hirosaki city, these tasty croquettes are mixed with vegetables then deep-fried and served with a dipping sauce. They make the perfect snack to accompany sake.

36
Junichi Miyazaki | Lonely Planet ©

Aomori › Flatfish sashimi on rice is a culinary speciality of Aomori prefecture. Aomori's Port of Hachinohe is one of the largest in Japan and its nearby morning market serves extra-fresh sashimi.

37
Daisuke Kawai | 500px ©

Akita › Wooden huts are hidden among the autumn foliage in Nyūtō Onsen village. One of the oldest onsen (hot-spring baths) here is the splendid Tsuru-no-yu with its milky-white waters – its outdoor baths are perfect for a steamy evening soak.

38-39
Piith Hant | Shutterstock ©

Aomori › Dramatic autumnal views can be seen on the daring Hakkōda ropeway ride up to the summit of Tamoyachi-dake in the Hakkōda mountain range. In winter, its deep snow and off-piste trails attract extreme powderhounds.

40-41
Narongsak Nagadhana | Shutterstock ©

Matsuo-kyo › Fireflies have certain spiritual connotations in Japan and some festivals specialise in their emergence. One of these is at Hotaru Doyo Koen, or Tatsuno Firefly Park, in the Matsuo valley, where 10,000 of the radiant beetles appear during peak nights in June.

42-43
Yoshiteru Takahashi | AFLO | 4Corners ©

Towada-Hachimantai National Park › Lake Towada, the largest crater lake in Honshū, is fringed by craggy coastlines and dense forests and provides an escape to nature. Hikers along the Oirase Keiryū river path are treated to dramatic gorges and cascading waterfalls.

44
Photos from Japan, Asia and other of the world | Getty Images ©

Miyagi › In autumn, fiery maple trees line the spectacular, 100m-deep Naruko Gorge, a lovely day trip from Sendai. Hiking trails follow in the footsteps of haiku poet Matsuo Bashō, and atmospheric onsen revive aching muscles.

45
Photographer is my life. | Getty Images ©

Aomori › Mt Hakkoda may be justly popular with winter sports enthusiasts but its slopes are emblazoned with such colour during the autumn that the cable cars are requisitioned for the crowds who flock to view the foliage.

46-47
Mamoru Muto | AFLO | 4Corners ©

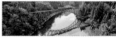

Fukushima › The Tadami railway trundles past a montage of valleys, lakes and dense forest from the city of Aizu Wakamatsu to the countryside of Oku Aizu. Each season brings its own beauty to the journey but the region is well known for its burning autumn maples.

48-49
Yusheng Hsu | 500px ©

Aomori › One of the most beautiful river valleys in Japan, the Oirase Gorge is a 14km-long stretch from Lake Towada to the foot of Mt Hakkōda. Crystal waters gush along, fuzzy moss carpets the gorge and it's a famous autumn-foliage viewing spot.

50-51
Phuong D. Nguyen | Shutterstock ©

Yamagata › A visit to the countryside around the rural capital of Yamagata offers the chance for visitors to stay with local families to experience the daily life of farmers and enjoy some home-cooked mountain cuisine.

52
Junichi Miyazaki | Lonely Planet ©

Iwate › Along with its blooming cherry blossoms, historic Hiraizumi in the Iwate prefecture is a town crammed with cultural treasures including temples, gardens and archaeological sites representing the Buddhist Pure Land.

53
Keiko Iwabuchi | Getty Images ©

Miyagi › The cobalt blue crater lake, Okama, sits atop Mt Zao amid crumbling volcanic rock bordering Miyagi and Yamagata prefectures. The Zaō Sanroku ropeway whisks visitors up the mountain over dense forest to within walking distance of Okama.

54-55
Disorn Lertchairit | 500px ©

Fukushima › Volcanic mineral deposits have left their mark on the lakes around Kita Shiobara where you'll find shimmering turquoise blue and emerald green waters. The brilliant maple trees here glow red and yellow, making this a popular destination in the autumn.

56-57
WADA TETSUO | a.collectionRF | Getty Images ©

Sendai › The biggest event on Sendai's calendar, the Sendai Tanabata Matsuri ('star festival') finds the city coming to life in August in a riot of colourful decorations. The festival honours the Chinese legend of two stars, Altair and Vega, crossing paths.

58
Stephen Shucart | 500px ©

Matsushima › Matsushima's status as one of Japan's Three Great Sights is down to the 260 pine-covered islands that dot the glorious bay. They create such mesmerising views that they are said to have inspired famous haiku poet Matsuo Bashō.

59
dorinser | Shutterstock ©

Fukushima › Dubbed the 'Heavenly Mirror Lake' due to Mt Bandai reflecting in its clear waters, vast Lake Inawashiro sits in the centre of the Fukushima prefecture and is the fourth-largest lake in Japan. Its coast provides beaches and many activities.

60-61
Yanyao Shi | Getty Images ©

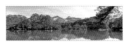

Fukushima › In the middle of Fukushima prefecture, Mt Bandai looms large in the Bandai Plateau, offering spectacular scenery and excellent hiking opportunities. Mineral deposits from an 1888 eruption colour the dozen or so pools, known as the Five Coloured Lakes, shades of blue and green.

62-63
mTaira | Shutterstock ©

Yamadera › In winter, heavy snow blankets the town of Yamadera in the Yamagata prefecture. The place was immortalised in the poem *The Narrow Road to the Deep North* by haiku master Matsuo Bashō and it's home to some magical mountaintop temples.

64-65
Sean Pavone | Getty Images ©

Yamagata › One of the three sacred Dewa mountain shrines, Yudono-san is subject to strict rituals – you must remove your shoes, bow your head and never disclose what you witness here. Needless to say, don't reach for your camera.

66-67
B.S.P.I. | Getty Images ©

Chiba › Beaches line the coast of the Bōsō Peninsula, situated some 15km east of the capital across Tokyo Bay. Exploring the mountainous interior, riding the surf or just basking in the sun is an easy day trip from chaotic Tokyo.

68-69
Ippei Naoi | Getty Images ©

Kanagawa › The futuristic-looking Tōkaidō *shinkansen* shoots through Japan connecting Tokyo with many points across the country. Travelling at speeds of up to 285km/h, it began operating in 1964. On a clear day, Mt Fuji is visible on the journey.

70
Shingo M | 500px ©

Tokyo › Dedicated to Tokugawa Ieyasu, the shogun who reunited Japan, the Tōshō-gū shrine sits within Tokyo's sprawling Ueno park. Built in 1627, its shining gold façade and intricate details are impressive and it features a lovely garden that blooms twice a year.

71
Luciano Mortula | Shutterstock ©

Narita › A popular attraction in the town of Narita, Narita-san Shinshōji has a history that dates back more than 1000 years. Its beautifully landscaped temple grounds are among the largest in Japan and feature a number of walking paths.

72
Thia Konig | Aurora Photos ©

Tokyo › When describing Tokyo, words that come to mind are usually concrete jungle, neon and skyscrapers, but Japan's capital also offers up a number of sprawling leafy parks and landscaped gardens.

73
Keri Oberly | Aurora Photos ©

Tokyo › Tokyo's Imperial Palace is on the site of the original Tokugawa shogunate's castle. The 3.4 sq km complex can be visited on a free tour, though as this is the home of the Emperor, most of it is closed to the public.

74-75
golaizola | Getty Images ©

Tokyo › Cherry blossom, *sakura* in Japanese, is something of a national obsession. Groups gather in parks during blossoming season for *hanami* (cherry-blossom viewing) parties to signal the arrival of spring. Tokyo's season is short, usually from late March to mid-April.

76-77
YP_photographer | Shutterstock ©

Hitachi Seaside Park › Blue flowers outnumber the pink blooms at Hitachi Seaside Park where 4.5 million nemophila flowers carpet Miharashi Hill in April. Elsewhere in the popular park, which overlooks the ocean, yellow daffodils and red tulips add visual variety.

78-79
Teerayut Hiruntaraporn | 500px ©

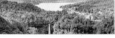

Nikko National Park › High on a plateau above Tokyo, Lake Chuzenji, at an elevation of 1269m, drains in several waterfalls, the most notable being Kegon Falls. In spring, snowmelt creates a torrent, and from October the falls are garlanded by the warm tones of autumnal foliage.

80-81
Akihito Endo | 500px ©

Tokyo › It's no secret that Tokyo is a sprawling megalopolis. The population of the city exceeds 13 million and while growth has been declining in the past decade or so, the population is expected to peak in 2020.

82-83
Tim Martin | Aurora Photos ©

Tokyo › Tokyo Station is the terminus for the *shinkansen* connecting Tokyo to other major cities across Japan. The original brick building on the Marunouchi side was restored in 2014 for the station's centenary.

84-85
Yukinori Hasumi | Getty Images ©

Yokohama › South of central Tokyo, approximately 20 minutes by train, lies Yokohama, Japan's second-largest city. Its bayfront area offers some great dining and microbreweries, and one of the highest big wheels in the world.

86-87
Ratnakorn Piyasirisorost | 500px ©

Tokyo › *Wagashi* is the name of a variety of traditional confectionery found throughout Japan. *Wagashi* makers press the dough into moulds to create delicate designs and shapes. The sweets are often served with matcha (powdered green tea).

88
Mint Images | Aurora Photos ©

Tokyo › *Wagashi* are closely tied to the seasons, coming in designs such as cherry blossoms for spring and maple leaves for autumn. The sweets are enjoyed at celebrations through the year.

89
Mint Images | Aurora Photos ©

Tokyo › It's easy to see why the capital's red-light and nightlife district, Kabukichō, is often referred to as 'Sleepless Town'. This is quintessential sci-fi, skyscraper-filled, neon-plastered Tokyo at its best.

90-91
Luciano Mortula | Shutterstock ©

Tokyo › Amid the skyscrapers and bustle of central Tokyo one can forget this city started as a seaside town. These days, cruise ships come into dock, shipping containers set off to ply the trade routes and sightseeing boats glide across Tokyo Bay.

92-93
Photography by ZhangXun | Getty Images ©

Tokyo › The pedestrian lights pulse and hundreds of people scurry in every direction across Tokyo's Shibuya Crossing, said to be one of the busiest intersections in the world. It's at its most impressive at night when the blazing neon billboards serve as a backdrop.

94-95
Sean Pavone | Shutterstock ©

Tokyo › Tokyo Bay is scattered with a collection of artificial islands, one of which is linked to the mainland by the 798m-long Rainbow Bridge. Photographers head to the waterfront park, Odaiba Kaihin-kōen, to snap shots of Tokyo's skyline and the Rainbow Bridge lit up at night.

96-97
Omjai Chalard | Shutterstock ©

Yokohama › Said to be the world's first 'food-themed amusement park', the Shin-Yokohama Ramen Museum is a replica of a 1958 *shitamachi* (downtown district) with a collection of ramen restaurants specialising in regional variations.

98-99
JKI14 | Shutterstock ©

Chiba › Farming in Japan is increasingly becoming an occupation undertaken by the elderly. Six out of every 10 farmers are over the age of 65 and the industry is declining across the country.

100
Eddie Gianelloni Media | Aurora Photos ©

Chiba › New initiatives are being introduced to tackle Japan's ageing agricultural sector. The government is prepared to accept skilled foreign farm workers, while a new breed of younger tech-savvy farmers offers hope for the future.

101
Mint Images | Aurora Photos ©

Yamato › A woman in *yukata* (light summer kimono) and *amigasa* hat dances up a storm as part of the Kanagawa Yamato Awa Odori dance festival held each summer. It's modelled on the famous Awa Odori festival in Tokushima.

102
DigiPub | Getty Images ©

Tokyo › The kimono is a traditional Japanese garment that can be worn on a variety of special events and occasions. The outer sash that is tied around the kimono is called the *obi*.

103
Jirat Teparaksa | Shutterstock ©

Tokyo › The West Shinjuku neighbourhood in Tokyo is home to one of the city's most talked about bars. At Ben Fiddich, renowned bartender/alchemist Hiroyasu Kayama creates inventive takes on classic cocktails using homegrown herbs and spices.

104
Junichi Miyazaki | Lonely Planet ©

Tokyo › A collection of decorative sake barrels, called *kazaridaru* in Japanese, can be found within the grounds of Tokyo's Meiji-jingū shrine. The barrels have been donated by sake breweries and are offered to the gods every year.

105
Tina He | 500px ©

Tokyo › Daienji is a temple in the Tokyo neighbourhood of Meguro. The temple features many tiny stone *jizo* statues, which are said to be the protectors of children. Local women usually take care of the statues and dress them in knitted hats and red bibs.

106–107
Mint Images | Aurora Photos ©

Sagami › Sagamihara city, southwest of Tokyo, plays host to the Sagami Giant Kite Festival. The word 'giant' is appropriate considering that the kites, made from bamboo and handmade Japanese paper, can measure up to 15m x 15m and weigh 900kg.

108
cdrw | Shutterstock ©

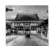

Tokyo › Sensō-ji in Tokyo's Asakusa neighbourhood is the city's most-visited temple. It's said to enshrine a golden image of Kannon (the Buddhist goddess of mercy). The temple complex is particularly atmospheric in the evening when the buildings are illuminated.

109
coward_lion | Getty Images ©

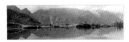

Hakuba › West of Nagano, Hakuba's several ski resorts hosted a variety of snow-based events for the 1998 Winter Olympics. It's a pilgrimage for hikers, too – a 1.5km climb from the chairlift station at 1820m will take you to Happo Ike, where 3000m peaks reflect in the pond.

110–111
Masayuki | Shutterstock ©

Niigata › On the western coast of Tōhoku, Niigata is famed for its outstanding ski fields and in winter it attracts hordes of powder fiends from Tokyo, which is just over a two-hour *shinkansen* (bullet train) journey away.

112–113
Yamata Katsuaki | 500px ©

Gokayama › The isolated, mountainous region of Gokayama is located in the Toyama prefecture between Takayama and Kanazawa. Goyakama and neighbouring Shirakawa-gō are known for their *gasshō-zukuri* farmhouses, a style of Japanese thatched-roof architecture.

114–115
Nor Gal | Shutterstock ©

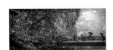

Takayama › A great base for exploring the Northern Alps, Takayama has become an increasingly popular destination in its own right in recent years. The town's 17th-century layout, many museums, galleries, temples and Meiji-era inns, and pretty riverside setting explain why.

116–117
zkruger | Shutterstock ©

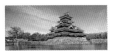

Matsumoto › An attractive, cosmopolitan city, Matsumoto has stunning Alpine views and is home to Japan's oldest wooden castle. Designated a cultural treasure, Matsumoto-jō is a must-see sight and affords impressive views from the top.

118 & 119
Oat Vaiyaboon | 500px ©

Chūbu › A *sugidama* is a ball of clipped cedar branches that hangs outside a shop to indicate that it specialises in sake. It's hung at the start of the brewing process when the leaves are green, and turns brown when the sake is ready.

120
mTaira | Shutterstock ©

Takayama › Sake, known as *nihonshū*, is an alcoholic beverage made with rice and water and fermented to convert starch into sugar. Traditionally it was brewed in wooden barrels made from *sugi*, Japanese cedar.

121
GUIZIOU Franck / hemis.fr | Alamy Stock Photo ©

Kanazawa › Floating lanterns at dusk (*tōrō nagashi*) are part of the celebration of Kanazawa's main annual festival, Hyakumangoku Matsuri, which takes place in early June. Locals in 16th-century costumes parade down the street and a special tea ceremony is held.

122–123
mTaira | Shutterstock ©

Yamanashi › Mt Fuji, respectfully known as Fuji-san in Japan, is one of the country's most-famed sights. The revered volcano takes on different personalities depending on the season and the perspective from which it is viewed.

124
structuresxx | Shutterstock ©

Shirakawa-gō › Shirakawa-gō, along with neighbouring Gokayama, is a remote mountainous region that sits between Takayama and Kanazawa. Winter brings heavy snowfall and blankets the famous thatched-roof farmhouses here, creating beautiful scenery.

125
Philip Lee Harvey | Lonely Planet ©

Yamanashi › Japan's most famous peak is notoriously elusive. Winter and spring are the best months to see it in all its glory but, even then, you might catch a quick glimpse before the clouds roll in and it hides away again.

126–127
cwljwc | 500px ©

Nagano › During calm weather, Kagami Ike perfectly reflects the Togakushi mountains, hence its name, which translates as 'mirror pond'. It's a popular detour for those visiting the nearby Shintō shrine, Chusha, where a sacred tree has stood for more than 700 years.

128-129
Pradchaya Promtanom | Shutterstock ©

Nagano › Jigokudani Monkey Park in the Nagano region is a popular spot to see macaques steaming it up in the man-made onsen (hot-spring bath); it's particularly photogenic in winter when the whole place is covered in snow.

130-131
Alan Tsai | Getty Images ©

Yamanashi › There's a Japanese proverb that says: "He who climbs Mt Fuji once is a wise man, he who climbs it twice is a fool." It's a gruelling ascent, yet about 300,000 people hike to the mountain's peak (3776m) every year.

132
SHOSEI | AFLO | 4Corners ©

Yudanaka › Deep snow transforms the hot-spring resort town of Yudanaka in the Nagano region into a winter wonderland. When it's freezing outside there's no better way of warming up than a piping-hot onsen.

133
Philip Lee Harvey | Lonely Planet ©

Takayama › The only surviving government office of the Tokugawa Shogunate, Takayama-Jinya was in use until 1969. Now functioning as a museum, its exhibits include ancient maps and documents, gardens, a 17th-century rice granary and even an interrogation room.

134-135
cowardlion | Shutterstock ©

Toyama › The brilliant mountain-ringed bay in Toyama is one of the 'Most Beautiful Bays in the World', as endorsed by Unesco in 2014. It's known for its unique *hotaruika* (firefly squid).

136 & 137
ma-mi | 500px ©; Name | Library ©

Mie › When the pace of city life gets too much, the Mie prefecture offers an escape to nature to reset the mind and body. The region is predominantly rural and is home to more than 1300 terraced rice paddies.

138
Fukushima | 4Corners ©

Wakayama › Almost two-millennia old, the ritual of the Mifune-matsuri festival involves the divine spirit of the Hayatama Taisha being loaded onto a ceremonial boat in a portable shrine. This is rowed around Mifune-jima island, accompanied by nine other vessels racing each other.

139
Nobutake Hayama | AFLO | 4Corners ©

Kyoto › The Imperial Palace in Kyoto was once the seat of the Emperor, but the main reason to visit is for its immaculately landscaped Edo-period gardens within the Palace Park, which is free to enter.

140-141
Olgysha | Shutterstock ©

Kyoto › In a city crammed with temples, Kyoto's popular Kiyomizu-dera, dating from the 8th century, manages to stand out from the pack. *Kiyomizu* means 'pure water', as the temple is built around a holy spring.

142-143
annoon028 | Shutterstock ©

Kyoto › One of Kyoto's most impressive sights, hundreds of red *torii* (shrine gates) are spread out across a forested mountain at Fushimi Inari-Taisha in the south of the city. The number of selfies taken here are countless.

144-145
Oliver Foerstner | Shutterstock ©

Kyoto › *Ukiyo-e* is the art of woodblock printing and is one of the most recognisable Japanese arts throughout the world. It takes a few highly skilled artists to make just one woodblock print – one person to draw, one to carve and one to print.

146 & 147
Jonathan Gregson | Lonely Planet ©

Kyoto › The gold-plated main hall of Kinkaku-ji (the 'Golden Pavilion') reflecting in the pond amid its stunning gardens is one of the most beautiful sights in all of Kyoto. Understandably, the temple draws huge crowds.

148-149
gowithstock | Shutterstock ©

Kyoto › Yasaka-jinja stands sentinel over Kyoto's famous Gion entertainment and geisha quarter. It's always buzzing with visitors and is a great spot to wander, following on up the hill to Maruyama park.

150
Vincent St. Thomas | Shutterstock ©

Kyoto › One of Japan's oldest shrines, Kamigamo-jinja is located in the north of Kyoto and is a Unesco World Heritage Site. The shrine is dedicated to the god of thunder and was established in 679, pre-dating the founding of Kyoto itself.

151
Lewis Liu | Shutterstock ©

Osaka › *Pachinko* parlours (a pinball-type game), gawdy neon signage, cheap eateries and colourful characters compete for space in Osaka's Shin-Sekai entertainment district. At its heart is the steel-frame tower, Tsūten-kaku, first completed in 1912 and rebuilt in 1956.

152-153
Watcharapong Thawornwichian | 500px ©

Kyoto › *Machiya* (traditional wooden townhouses) line Hanami-kōji, the main street in Kyoto's Gion entertainment district. The street fills with hordes of visitors hoping to catch a glimpse of geisha as they scurry to appointments in the early evening.

154
Greir | Shutterstock ©

Osaka › Osaka is a foodie heaven and one speciality is the street-food favourite, *takoyaki* – dumplings filled with octopus, grilled then served with mayonnaise and a savoury sauce and eaten with a toothpick. Watch out, they can be scalding hot!

155
Vincent St. Thomas | Shutterstock ©

Kyoto › *Matcha* is a high-grade green tea traditionally used in Kyoto for tea ceremonies. The tea leaves are ground, traditionally on a stone mill, until they have the consistency of a fine powder. *Matcha* has become popular worldwide for its reputed health benefits.

156
Larry Dale Gordon | Pacific Stock | Aurora Photos ©

Kyoto › The ancient art of the tea ceremony follows a highly ritualised sequence. The finer details are very important, from the utensils used, the way the bowl is held and the whisking of the *matcha* to turn it into the correct consistency for guests.

157
Toa55 | Shutterstock ©

Kyoto › Arashiyama is one of the most popular sightseeing areas in Kyoto, thanks to its famous bamboo grove. Seemingly endless thick bamboo stalks line the path, swaying in the breeze and catching the light in a beautiful way.

158-159
Abderazak Tissoukai | 500px ©

Kyoto › The Kamogawa river is a popular hangout for Kyotoites, particularly in the stifling summer when any cool breeze is a welcome relief. It's a stunning scene at night, when the *machiya* lining the banks are all lit up.

160-161
Sean Pavone | Shutterstock ©

Osaka › Once home to an amusement park, Shin-Sekai's current crop of gaming parlours give it a rather seedy air, but also a distinctive, retro cool that draws plenty of visitors to the area's cut-price eating and drinking establishments.

162
Tooykrub | Shutterstock ©

Kyoto › Visitors to Kyoto might be lucky to catch a glimpse of a geisha in the historic entertainment quarter of Gion. Geisha (known as *geiko* in Kyoto) are accomplished musicians and dancers, and they wear formal kimono that can be worth thousands of dollars.

163
Mint Images | Aurora Photos ©

Osaka › The beating heart of Osaka's nightlife is Dōtombori, whose name derives from the 400-year-old canal, Dōtombori-gawa. The streets here are a dizzying spectacle of neon billboards, bars, restaurants and the famous Glico running man sign.

164-165
GagliardiImages | Shutterstock ©

Nachi › The steep climb up to the Shintō shrine Nachi Taisha on the Kii Peninsula affords some breathtaking views of Japan's highest waterfall, Nachi-no-taki, nearby. The shrine is dedicated to the waterfall's *kami* (spirit god).

166
Sean Pavone | Shutterstock ©

Kyoto › A boat ride down the Katsura river is an ideal way to admire the beauty of Arashiyama's scenery, particularly in spring and autumn. Boatmen with long bamboo poles steer flat-bottom boats down the river through forested canyons and over mild rapids.

167
Patrick | 500px ©

Nachi › Seiganto-ji is an elegant old Buddhist temple that sits next to the Shintō shrine Nachi Taisha in the Kii Peninsula. The temple overlooks the 133m drop of Nachi-no-taki, Japan's highest waterfall.

168
Sean Pavone | Shutterstock ©

Hongū › Located in Hongū in the Wakayama prefecture, Kumano Hongū Taisha is one of the Kumano region's three famous Shintō shrines, which collectively comprise a Unesco World Heritage Site. The main building is reached by climbing more than 150 stone stairs.

169
LaChouettePhoto | Getty Images ©

Kyoto › The candy-floss-like cherry blossom that sweeps through the country in spring is richly symbolic in Japan. Many Japanese believe that the blooming of the trees represents the transience of time and it's a chance to reflect and look to the future.

170
Lottie Davies | Lonely Planet ©

Himeji › A national treasure and Unesco World Heritage Site, Himeji-jō is Japan's most spectacular castle. Its brilliant white exterior earned it the nickname 'White Heron Castle' and it features a five-storey main keep surrounded by a moat.

171
Richie Chan | Shutterstock ©

Kyoto › Any time from late March to mid-April, cherry blossoms begin to blanket parks throughout Japan and people gather for *hanami* (cherry-blossom viewing parties). Some good spots to see cherry blossoms in Kyoto include Maruyama Park and along the Path of Philosophy.

172-173
rudiuks | Getty Images ©

Iwakuni › The lovely high-arched Kintaikyo bridge in Iwakuni was first built in 1673, during the feudal era, when the only people allowed to cross it were members of the ruling class. The bridge linked the samurai quarters to the rest of the town.

174-175
m161m161 | Shutterstock ©

Hiroshima › The Atomic Bomb Dome in Hiroshima stands as a stark reminder of the destruction caused on that fateful day in 1945. One of the few buildings to remain near the epicentre of the explosion, it now serves as a memorial.

176-177
Luciano Mortula - LGM | Shutterstock ©

Hiroshima › Sadako Sasaki was 12 when she died from leukaemia, 10 years after the atomic bomb, inspiring the development of the Children's Peace Monument. Sadako believed folding 1000 paper cranes (representing longevity in Japan) would heal her. Sadly, she didn't reach her goal but her classmates finished the cranes for her.

178 f11photo | Shutterstock ©

Hiroshima › In the centre of Hiroshima's Peace Memorial Park, at one end of a pond, stands the curved concrete cenotaph monument listing the names of all the known victims of the atomic bomb.

179
Sean Pavone | Shutterstock ©

Okayama › Thanks to its beautiful expansive lawns, Edo-era buildings, ponds and teahouses, Okayama's Kōraku-en gardens is considered one of the three most beautiful in Japan. It's particularly photogenic in autumn when the maple leaves burn red and orange.

180-181
Artem Smetanin | 500px ©

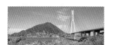

Hiroshima/Ehime › The cable-stayed Tatara Bridge is part of a chain of impressive bridges, known as the Shimanami Kaidō, over the Seto Inland Sea. The bridges link the town of Onomichi in Hiroshima prefecture with Imabari on Shikoku.

182-183
paprikaworks | Getty Images ©

Hiroshima › The Shimanami Kaidō bridges form a popular cycling route, as the entire chain linking Honshū to Shikoku is accessible to bikes. Cyclists breeze along on these remarkable feats of engineering, taking in views of the island-dotted sea below.

184-185
Rachin Mapanya | Shutterstock ©

Tottori › Tottori is best known for its sand dunes and sand sculpture museum. The dunes span 16km near to the city and were the setting for Hiroshi Teshigahara's classic 1964 film, *Woman in the Dunes*.

186-187
phichak | Shutterstock ©

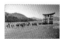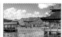

Miyajima › An easy day trip from Hiroshima, the island of Miyajima is a Unesco World Heritage Site and has one of Japan's best views – the vermilion *torii* (shrine gate) of Itsukushima-jinja, which seems to float on the water at high tide.

188-189 & 190-191
Loop Images | Howie Hill ©;
Sean Pavone | Shutterstock ©

Nagato › One hundred and twenty-three red *torii* lead up a cliffside overlooking the Sea of Japan in the city of Nagato in the Yamaguchi prefecture. Motonosumi Inari shrine is a smaller version of the famous Fushimi Inari-taisha in Kyoto.

192-193
Sean Pavone | Shutterstock ©

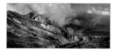

Tottori › Mt Daisen is a volcano in the Tottori prefecture that rises straight from sea level to a height of 1729m. Its summit is only about 10km from the coast and there is a popular five-hour climb that starts at Daisen-ji temple.

194-195
Hugo Tremoliere | 500px ©

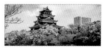

Hiroshima › Originally built in 1589, Hiroshima Castle (also known as Carp Castle) was an important seat of power in Western Japan. It was destroyed in the atomic bomb explosion but its keep was completely rebuilt in 1958.

196-197
Jorge Císcar | 500px ©

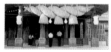

Izumo › One of the oldest Shintō shrines, Izumo Taisha is dedicated to the God of marriage and good fortune. Those who can toss a coin and lodge it in one of the enormous twisted straw ropes at its entrance are said to be blessed with great luck.

198-199
Hugo Tremoliere | 500px ©

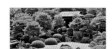

Yasugi › The Adachi Museum of Art features an excellent collection of works by 20th-century Japanese painters, including more than 100 paintings by Yokoyama Taikan. The attractive garden is considered one of the best in the country.

200-201
Takamex | Shutterstock ©

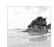

Izumo › On the west side of the famous Izumo Taisha Shintō shrine sits the picturesque Inasa beach, where a temple at the top of a craggy rock juts skywards from the water. It's the setting for many legends and stories.

202
michi96 | Shutterstock ©

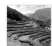

Shōdo-shima › Shōdo-shima is known for its mountains, sea views and scenic coastal drives. At the island's centre, the Nakayama rice fields are vibrant green terraces that cascade down the hills.

203
gyro | Getty Images ©

Shikoku › The smallest of Japan's four main islands, what Shikoku lacks in size it makes up for in incredible natural beauty. A scene such as this Japanese white-eye perched on a cherry blossom branch is just an example.

204
Mint Images | Aurora Photos ©

Tokushima › Following the blooming of cherry blossom trees is taken seriously in Japan. The trees usually bloom in the south first and make their way north during late March to early April. The Japan Meteorological Agency tracks their progress and provides forecasts.

205
Chng Shng Zhi | EyeEm | Getty Images ©

Iya Valley › Ōboke gorge on the Yoshino river is not only a magnificently scenic spot but a haven for outdoor enthusiasts. It offers excellent whitewater rafting on Class IV rapids, while scenic boat trips stick to the calmer waters.

206-207
PixHound | Shutterstock ©

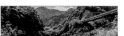

Iya Valley › The Iya Valley famously draws stressed urbanites seeking a break from the rat race and it's easy to see why. Steep gorges, mountain forests, hot springs and cliff-hugging trails form as tranquil a remove from the bustle as could be wished for.

208-209
bee32 | Getty Images ©

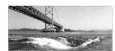

Naruto › In northeastern Shikoku, the Naruto whirlpools are well-known phenomena. The gushing pools occur underneath the impressive Ōnaruto suspension bridge when water squeezes through the narrow Naruto Strait between the Pacific Ocean and the Inland Sea.

210-211
10max | Shutterstock ©

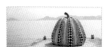

Naoshima › The small and tranquil island of Naoshima sits on the Seto Inland Sea and has become a place of pilgrimage for art lovers. The island is dotted with art, including open-air sculptures such as Yayoi Kusama's iconic 'Yellow Pumpkin', perched at the end of the pier.

212-213
Kenneth Dedeu | Shutterstock ©

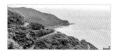

Ehime › Shikoku lends itself easily to relaxed road trips. Roads ribbon their way past dramatic coastal views and through forested landscape. There are plenty of enticing onsen to stop off at along the way.

214-215
Alban Fichet | 500px ©

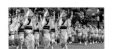

Tokushima › The largest *Bon* dance in Japan, the Awa Odori dance festival takes over the streets of Tokushima every August, drawing more than one million attendees. Dancers perform to the theme song 'Awa Yoshikono' while musicians play *taiko* (drums) and *shamisen* (three-stringed guitars).

216-217
Artem Mishukov | Shutterstock ©

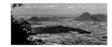

Kotohira › One of the most well-known sightseeing attractions of Shikoku can be found in the small town of Kotohira. Konpira-san is a Shintō shrine complex dedicated to the god of seafarers and involves a strenuous climb of 1368 steps to the top.

218-219
David Dubart | 500px ©

Shōdo-shima › Mountains, coastal views and scenic drives – Shōdo-shima is a great place to get away from the city and relax into a slower pace of life. The sandbar dubbed 'Angel Road' is a beautiful spot when its three islets connect at low tide.

220-221
Chunchi Lu | 500px ©

Iya Valley › Shikoku's Iya Valley is a pretty, magical place full of steep gorges and wooded forests. The Kazura-bashi is one of just three vine bridges still standing in the valley and it's truly remarkable.

222-223
Thanya Jones | Shutterstock ©

Takamatsu › Japan is home to many stunning gardens and Ritsurin-kōen in Takamatsu is considered to be one of the most beautiful. It took more than a century to complete and the park features ponds, tearooms, islands and bridges.

224-225
MrNovel | Shutterstock ©

Kōchi › In the compact city of Kōchi looms one of the few castles in Japan to have survived with its original keep. Kōchi-jō was originally completed in the 17th century and was largely rebuilt between 1748 and 1753 after it was damaged by fire.

226-227
MasaoTaira | Getty Images ©

Hirado › The Kawachi Pass, which lies west of central Hirado island in the Nagasaki prefecture, is a hilly hiking path that affords lovely views over both sides of the island.

228-229
TOMO | Shutterstock ©

Kumamoto › Created in 2010 as part of a campaign to draw tourists to the region, Kumamoto's Kumamon mascot became a national star and is now worth billions of yen. In spite of this impressive hay sculpture, Kumamon is usually black with rosy cheeks.

230
Shoichi Yamakawa | 500px ©

Fukuoka › Buddhism is one of the two main religions in Japan, the other being Shinto. The Pure Land teaching remains the most popular form of Buddhism in the country. You can find Japan's largest wooden Buddha statue at Tōchō-ji temple in Fukuoka.

231
Mint Images | Aurora ©

Yakushima › The dense and ancient cedar forests of Yakushima's interior helped to secure the mountainous island Unesco World Heritage status. It's hugely popular with hikers but be prepared if you plan to join them – Yakushima has some of the highest rainfall totals in Japan.

232
Gary Saisangkagomon | Shutterstock ©

Naha › Originally built in the 14th century, Shuri-jō is a reconstructed castle in the thriving city of Naha, the capital of Okinawa. There are great views over Naha and the Kerama Islands from its observation terrace.

233
Torasun | Shutterstock ©

Fukuoka › Kyūshū's largest town, Fukuoka is a contemporary city known for its tasty cuisine. Simple hawker-style food carts called *yatai* are dotted around the city with more than 150 in total. Grab a seat at the counter and engage in some friendly conversation.

234
TungCheung | Shutterstock ©

Fukuoka › Fukuoka (also known as Hakata, one of the area's names before the two parts of the city merged into one) is famous for Hakata-style ramen. Called tonkotsu rāmen, its hearty broth is made from pork bones.

235
Mint Images | Aurora Photos ©

Beppu › Situated in the Ōita prefecture, the town of Beppu is known for its steaming onsen and *jigoku* (boiling hot springs; literally 'hells') that pump out 100 million litres of hot water every day.

236
buttchi 3 Sha Life | Shutterstock ©

Miyazaki › Formed more than 120,000 years ago by a double volcanic eruption, the Takachiho Gorge is a truly impressive sight in the Miyazaki prefecture. Its waterfall cascades into emerald-green waters and the scenery can be admired on a 1km-long nature trail.

237
kan_khampanya | Shutterstock ©

Chiran › The town of Chiran on the Satsuma Peninsula is best known for its collection of restored samurai houses. Seven of the houses have lovely landscaped gardens that are open to the public.

238-239
kan_khampanya | Shutterstock ©

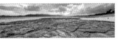

Okinawa › The largest of Japan's Southwest Islands, Okinawa is home to great cuisine, unique traditions, war memorials, incredible beaches and, of course, the occasional US Air Force jet flying overhead.

240-241
Sean Pavone | Shutterstock ©

Dazaifu › Dazaifu Tenman-gū in northern Kyushu is a Shintō shrine that's a popular day trip from Fukuoka. The shrine is the burial place of a poet-scholar who was deified as the god of culture and scholars. Students make offerings hoping to pass college exams.

242-243
Huanhua Chiang | 500px ©

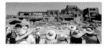

Nagasaki › Unesco-designated Hashima island has earned the nickname *Gunkan-jima* ('battleship island') due to its resemblance to the vessel from afar. The long-abandoned coal-mining centre appeared as the villain's lair in the James Bond film *Skyfall*.

244-245
Morten Falch Sortland | Getty Images ©

Ishigaki-jima › A man carves a wooden mask to be worn during the Kyubon Angama festival on Ishigaki-jima, one of the Yaeyama Islands in Japan's far southwest. The masks represent the spirits of the grandmother and grandfather in the festival procession.

246
Matt Munro | Lonely Planet ©

Ishigaki-jima › The Kyubon Angama festival is held over three days in summer and involves welcoming deceased ancestors back to the land of the living. The grandmother and grandfather spirits lead a group of costumed performers, or 'spirits', to find their loved ones' homes.

247
Matt Munro | Lonely Planet ©

Iriomote-jima › Okinawa's highest waterfall, Pinaisāra-no-taki, measures 55m high and is found at the back of the Funaura-wan bay on Iriomote island. At the right tide, it's possible to kayak to the base of the falls.

248
Matt Munro | Lonely Planet ©

Ishigaki-jima › Although no swimming is allowed here due to pearl cultivation, pretty Kabira Bay on Ishigaki island can be admired on one of the glass-bottomed boats that cruise around the islets.

249
Matt Munro | Lonely Planet ©

Tokashiki-jima › The blue waters of the Kerama Islands are a breeding sanctuary for humpback whales and grazing turtles. Tokashiki-jima is the largest of the islands and is very popular for its picturesque beaches.

250-251
Sean Pavone | Shutterstock ©

Kitakyūshū › During April and May, the Kawachi Wisteria Garden offers a botanical spectacle every bit as impressive as anything cherry blossom can offer. Its incredible tunnels of kaleidoscopic wisteria are now so popular that tickets must be booked in peak season.

252-253
Photographer studio sara | AFLO | 4Corners ©

Taketomi-jima › The Yaeyama Islands lie at the southwestern end of Japan's Southwest Islands, offering beautiful beaches and excellent diving and snorkelling. Subtropical jungles and mangrove swamps round out the authentic tropical paradise experience.

254-255
MIXA | Getty Images ©

Kumamoto › One of the world's largest volcanic calderas, the area of Aso-san can be found halfway between Kyūshū's Beppu and Kumamoto regions. Mt Aso is an active volcano, which erupted in October 2016 resulting in major damage to the surrounding areas.

256-257
naru7 | Shutterstock ©

Index

Index

Beautiful World Japan
May 2019
Published by Lonely Planet Global Limited
CRN 554153
www.lonelyplanet.com
10 9 8 7 6 5 4 3 2 1

Printed in China
ISBN 978 17886 8299 2
© Lonely Planet 2019
© photographers as indicated 2019

Managing Director, Publishing Piers Pickard
Associate Publisher & Commissioning Editor Robin Barton
Art Director Daniel Di Paolo, **Designer** Lauren Egan
Image re-touching Ryan Evans, **Writer** Kate Morgan
Editor Nick Mee

Cover and endpaper image: © Patryk Kosmider / Shutterstock

Lonely Planet Offices

Australia
The Malt Store, Level 3,
551 Swanston St, Carlton, Victoria 3053
T: 03 8379 8000

USA
124 Linden St, Oakland,
CA 94607
T: 510 250 6400

Ireland
Digital Depot, Roe Lane (off Thomas St),
Digital Hub, Dublin 8,
D08 TCV4

Europe
240 Blackfriars Rd,
London SE1 8NW
T: 020 3771 5100

STAY IN TOUCH lonelyplanet.com/contact

Paper in this book is certified against the Forest Stewardship Council™ standards. FSC™ promotes environmentally responsible, socially beneficial and economically viable management of the world's forests.

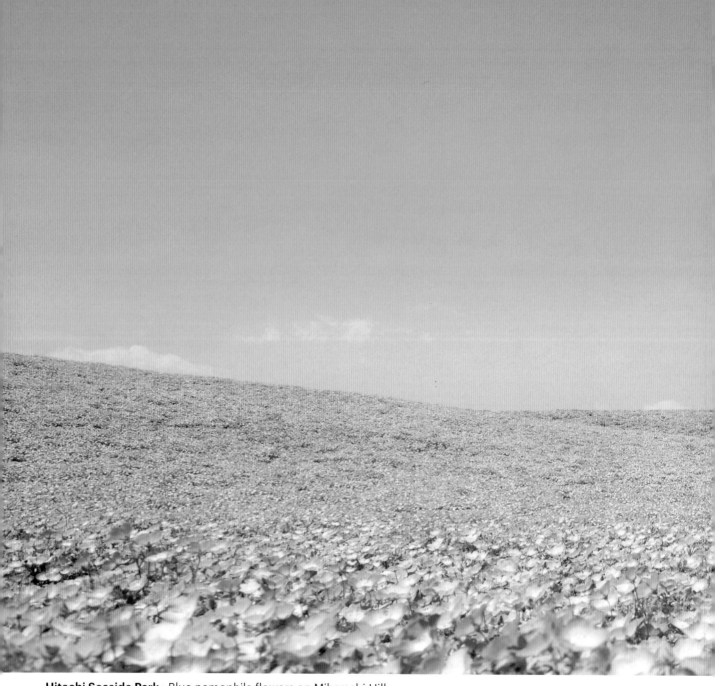

Hitachi Seaside Park › Blue nemophila flowers on Miharashi Hill